Glenn Ligon: Encounters and Collisions

Hilton Als
Stephen Andrews
Giovanni Anselmo
James Baldwin
Jean-Michel Basquiat
Joseph Beuys
The Black Panther Party
Alighiero Boetti
Jorge Luis Borges
Bruce Davidson
Beauford Delaney
Melvin Edwards
William Eggleston
Darby English
Robert Gober
Felix Gonzalez-Torres
Philip Guston
Stuart Hall
David Hammons
Jasper Johns
Jennie C. Jones
On Kawara
Adrienne Kennedy
Byron Kim
Franz Kline
Wayne Koestenbaum
Willem de Kooning
David Leeming
Zoe Leonard

Glenn Ligon
Audre Lorde
Dave McKenzie
Steve McQueen
Charles Moore
Robert Morris
Toni Morrison
Fred Moten
Bruce Nauman
Cady Noland
Chris Ofili
Adrian Piper
Jackson Pollock
William Pope.L
Marcel Proust
Ad Reinhardt
Richard Serra
Stephen Shames
Lorna Simpson
Sun Ra
Cy Twombly
Agnès Varda
Kara Walker
Kelley Walker
Andy Warhol
David Wojnarowicz
Martin Wong
Lynette Yiadom-Boakye

Glenn Ligon: Encounters and Collisions

Edited by Glenn Ligon, with
Alex Farquharson and Francesco Manacorda

Published by
Nottingham Contemporary and Tate
2015

Contents

Christie's is honoured to be sponsoring *Glenn Ligon: Encounters and Collisions* at Nottingham Contemporary, a unique, self-curated window on to the artist's remarkable practice. This show is the latest in a long line of thought-provoking exhibitions at Nottingham Contemporary, from David Hockney to *Kafou: Haiti, Art and Vodou*, to the more recent juxtaposition of Danh Võ and Carol Rama. The programme has always been highly innovative in its presentation and dialogue, and this exhibition is no exception.

Although it is hard to remember where and when, I can still recall the deep sense of mystery I felt when I first encountered Ligon's work. The thick texture of his painted surfaces and the oblique poetry of word and image immediately aroused my curiosity. Having now followed Ligon's work for a number of years, and become accustomed to the social, political and visual development of his practice, it is an intriguing moment to see the first major group exhibition he has curated, which presents us with a self-portrait of sorts. Juxtaposing his influences and inspirations with carefully selected examples of his work, Ligon invites us to experience his artistic journey through his own eyes. It is the journey of an African-American man through the ever-changing landscape of civil rights over the last fifty years.

Through this rare curatorial platform, Nottingham Contemporary gives voice to one of the most significant artistic figures of a generation redefined by these issues; issues that have inspired some of the most potent images of the twentieth and twenty-first centuries.

Francis Outred
Chairman & Head of Post-War & Contemporary Art,
Europe, Middle East, Russia, India
Christie's

CHRISTIE'S

The European Regional Development Fund (ERDF) in the North West is delighted to support *Glenn Ligon: Encounters and Collisions* at Tate Liverpool. The exhibition is being presented alongside *Jackson Pollock: Blind Spots* as part of the gallery's Summer 2015 season.

This exceptional exhibition, a curatorial debut for one of the most significant American artists of his generation, builds upon Tate Liverpool's outstanding reputation for bringing world-class art to Liverpool and will be a cultural highlight in the summer of 2015. Coinciding with a celebration across the city of the 175th anniversary of the world's first scheduled passenger and mail steamship transatlantic service, the exhibition further enhances the historic links between Liverpool and America.

ERDF has invested significantly in the local tourism and cultural sectors since 2007, recognising the important role they play in establishing the North West as a great place to live, work and visit, as well as the benefits they provide to the local economy. *Glenn Ligon: Encounters and Collisions* is one of a number of cultural projects being supported by ERDF locally, all of which aim to significantly enhance Liverpool's profile on a global stage and play their part in local economic growth.

Cllr Phil Davies
Local Management Committee Member for Merseyside
European Regional Development Fund North West

EUROPEAN UNION
Investing in Your Future
European Regional
Development Fund 2007-13

Preface

From time to time, at both Nottingham Contemporary and Tate Liverpool, we have invited artists to intervene in the curatorial work of our organisations, as a means of questioning and extending the conventions of exhibition making, and of occupying that space between artists and audiences usually mediated by the institutional curator and a range of other institutional filters.

We are honoured to be presenting Glenn Ligon's first major curatorial project, *Encounters and Collisions*, at our two institutions. The exhibition is a kind of ideal museum, as seen from the vantage point of Ligon's practice, which reflects his inspirations, his affiliations and the references he makes to others within his own work.

Ligon first found his voice as an artist in the late 1980s when he began basing his work on subtle and far-reaching methods of citation: direct citation of literary and critical texts; intentional echoing of stylistic and conceptual attributes of the work of other visual artists (especially from the post-war American canon); as well as myriad other references to cultural figures and transformative historical events. The words of Zora Neale Hurston, James Baldwin, Ralph Ellison, Gertrude Stein and Jean Genet, for example, converse in his work, as do allusions to the work of Jasper Johns, Andy Warhol, Richard Serra and Bruce Nauman. It is also populated by phenomena as diverse as the comedy of Richard Pryor, the rhetorical conventions of slave narratives, the culturally affirmative imagery of a 1970s colouring book aimed at African-American children, and critical commentary generated by a notorious series of photographs by Robert Mapplethorpe. Ligon often overlays two or more citations of different types (e.g. textual and visual) within a single work, orchestrating the interplay between them; removed from their original contexts and brought into new and different relationships, the original meanings of the referents (to the extent we can recall them) is subtly but powerfully changed.

Encounters and Collisions inverts and externalises – and, in a sense, literalises – the conversations with others that usually occur within the scope of Ligon's work. The exhibition also follows the lead of his writing practice – his essays on other artists and other topics. Starting out from a core of references located in his art and writings, *Encounters and Collisions* extends in several directions, revealing an even more expansive territory of interests and affiliations. A kind of autobiographical art history, this project opens up the archive of recent art history to a multitude of contact points with other cultural contexts and with contemporaneous sociopolitical upheavals whose legacies are

felt today. It is the realisation of Ligon's own imaginary museum, one that we expect will inspire a great many visitors and readers.

From April to June 2015, *Glenn Ligon: Encounters and Collisions* will occupy all four of Nottingham Contemporary's exhibition spaces. When it moves to Liverpool in July it will enter into dialogue with Tate Liverpool's exhibition of late works by Jackson Pollock, whose *Yellow Islands*, a work from 1952, features in *Encounters and Collisions*. A section of *Encounters and Collisions* will also be incorporated within Tate Liverpool's collection display, which is conceived in the form of 'constellations'. It will remain there for several months beyond the exhibition's end. There, Ligon's *Untitled* 2006 – a work made of neon letters painted black that spell out the word 'America' – will be the central point around which a number of works by other artists in *Encounters and Collisions* will gravitate.

Realising this exhibition and book has been a complex, and immensely rewarding, undertaking. Our gratitude, above all, goes to Glenn Ligon. It has been a true pleasure and privilege to work with him on a project of this scale and personal significance. We are grateful to Glenn for his tireless intellectual commitment to the project and for his many practical interventions in securing the necessary support of others. We also thank him for generously lending many works from his own collection, both by others and himself. Glenn's written contribution to the catalogue takes the form of letters to several of the exhibition's participants. He has also selected an extraordinary anthology of literary and critical texts that intersperse the sequences of images – an editorial extension of his curatorial role. We join Glenn in thanking the many writers, past and present, for their inspirational texts, together with the publishers for facilitating their inclusion here. We also take this opportunity to thank Kevin Downs and Megan Liberty at Glenn Ligon Studio for assisting in the realisation of the book and exhibition in many essential ways.

An exhibition of this scale is not possible without the remarkable generosity of many lenders – private collectors, museums, galleries and archives – and many other individuals who helped open doors. We are pleased to acknowledge their contribution by name at the end of the publication. In particular, we want to warmly thank Glenn's galleries for helping with our many enquiries, and for their generous support towards this publication, in particular Thomas Dane, François Chantala and Martine d'Anglejan-Chatillon at Thomas Dane Gallery; Shaun Caley Regen and Jennifer Loh of Regen Projects; and Lawrence Luhring, Roland Augustine and Lisa Varghese at Luhring Augustine Gallery.

We are delighted that this publication also features a major new essay by Gregg Bordowitz on his friend's work. We thank him for his passionate, profound response to the exhibition. We are also deeply grateful to Joseph Logan for his characteristically intelligent and elegant design of this publication, developed closely with the artist, as well as to Rachel Hudson at Joseph Logan Design. We also wish to thank Andrew Kirk and Sara Marcus for their invaluable editorial input.

Encounters and Collisions features many works of considerable value and the exhibition would not have been possible without the provision of insurance through the Government Indemnity Scheme. Nottingham Contemporary and Tate Liverpool thank HM Government for providing Government Indemnity and the Department for Culture, Media and Sport and Arts Council England for arranging the indemnity of works.

We also want to thank the supporters of our individual exhibitions. We are most grateful to Christie's for their generous sponsorship of the exhibition at Nottingham Contemporary. In particular, Nottingham Contemporary would like to thank Francis Outred, Chairman & Head of Post-War & Contemporary Art, Europe, Middle East, Russia, India, for his long-standing interest in the exhibition, and his colleagues at Christie's as well for their ongoing support of our artistic programme as Patrons.

At Tate Liverpool, we take this opportunity to gratefully acknowledge funding for the exhibition at our museum from the European Regional Development Fund, which has enabled us to foster a direct exchange of ideas between Glenn's expansive curatorial vision and the adjoining major survey exhibition, *Jackson Pollock: Blind Spots*, a project that aims to challenge our assumptions about Pollock's practice and processes.

We are, as ever, immensely grateful to our two teams for the skill and commitment with which they have made this complex project possible. At Nottingham Contemporary, our first thanks go to Laura Clarke, Assistant Curator, who has led the coordination of the exhibition at Nottingham Contemporary, supported by Irene Aristizábal, Head of Exhibitions, who also managed the editorial side of the publication. We are grateful to them both for their commitment and professionalism throughout the development and delivery of the exhibition. We are grateful too to our technical team, in particular David Thomas, Building and Facilities Manager, and Jim Brouwer, Technician (IT/AV), for the physical realisation of the exhibition in our spaces. We want to thank Lynn Hanna, Head of Communications and Development, and her team – in particular Vicky Godfrey, Marketing Manager, and Gareth Philippou, Development Manager – for their skilful management of the marketing and press around the exhibition, and the launch events. We are also grateful to Janna Graham, Head of Public Programmes and Research, together with Emma Moore, for realising a fascinating series of lectures, symposia and film screenings to accompany the exhibition, a programme funded by the University of Nottingham and Nottingham Trent University. We also wish to thank Kay Hardiman and her colleagues in Learning for their inspirational work with young people, families, schools and community groups based around the exhibition. At both our institutions, we are especially delighted that the exhibition coincides with Circuit, an ambitious four-year programme of work with young people led by Tate and funded by Paul Hamlyn Foundation. Nottingham Contemporary and Tate Liverpool are two of nine galleries and museums in Britain working together on this transformative programme.

We are also indebted to the dedicated staff of Tate Liverpool. Stephanie Straine's involvement as Assistant Curator has supported the realisation and delivery of this complex and ambitious project. Once again, Sivan Amar, Barry Bentley and Ken Simons managed the complicated shipping and extensive installation, working closely with Julie McDermott, Roger Sinek and our trusted team of art handling technicians. We would like to thank our colleagues in collection care and conservation for their expertise and consideration, and Jemima Pyne, Ian Malone and Laura Deveney for their efficiency and enthusiasm in supporting the production of this publication. Our Learning team, headed by Lindsey Fryer, has planned an invigorating programme of activities for children and young people, alongside study days and public programme events developed with our Research Curator, Isobel Whitelegg, to enable the ideas of this exhibition to reach and inspire the widest possible audience. Former Head of Exhibitions and Displays Tamsin Dillon was an invaluable supportive presence during the project's development throughout 2014, and we thank her for her indispensable contributions. Tate Liverpool's Development team led by Rebecca Muir have ably supported and fostered Tate Liverpool's roster of patrons, sponsors and donors. For managing the press and marketing of the exhibition at Tate Liverpool we thank Alison Cornmell and Jennifer Collingwood, together with Content Editor Mike Pinnington, who has developed the interpretation materials and in-gallery guide for our summer 2015 season of exhibitions.

Encounters and Collisions has been a true collaboration between our institutions, reflecting the wider ongoing partnership that Nottingham Contemporary and Tate Liverpool enjoy through Plus Tate, a dynamic network of leading visual arts institutions in the UK. This project particularly benefits from the network's access to the national collection of modern and contemporary art held by Tate, and we would like to take this opportunity to warmly thank Sir Nicholas Serota, Director, and Caroline Collier, Director, Tate National, for the support they have given to the network and to this exhibition in particular.

The title of this exhibition is a translation of the sentence embroidered in *Incontri e scontri* 1988 by Alighiero Boetti. This small work is illustrated on page 64. The phrase is a delicate but firm suggestion that an artist's practice, and by extension our sense of who we are, cannot and should not be determined by consensus and similarity. This is an exhibition of both encounters and collisions; encounters based on attraction and affiliation, and collisions resulting from antagonistic views of the world and the imperative that we question normative opinions. Contemporary art institutions, at best, offer civic space for such encounters and collisions. Glenn's own work, when presented in institutions, exemplifies this, and we are grateful to him for amplifying that ethos further with *Encounters and Collisions*.

Alex Farquharson, Director, Nottingham Contemporary
Francesco Manacorda, Artistic Director, Tate Liverpool
Andrea Nixon, Executive Director, Tate Liverpool

Introduction

Alex Farquharson

The idea of inviting Glenn Ligon to curate an exhibition of works of art that he has cited in his own work, of artists who have influenced him and of artists with whom he has an affinity was first suggested by *Yourself in the World*, a collection of his essays and interviews. Ligon belongs to that select category of artists who write, a tendency that first acquired momentum in the 1960s during and after minimalism, when the context of the work of art (spatial, institutional, ideological, societal, quotidian, etc.), was first conceived as part of its content. Ligon's essays, on both artists and wider culture, offer generous vistas on to the wider hinterland that informs, and is often distilled within, his practice; a hinterland of art, culture, political history and his own biography. The subjects of those essays, and the artworks illustrated, suggested the initial outline of a possible group exhibition – Willem de Kooning, Andy Warhol, David Hammons, William Pope.L, Felix Gonzalez-Torres, Lorna Simpson and Dave McKenzie reappear in *Encounters and Collisions*.

Yourself in the World was published to coincide with Ligon's acclaimed retrospective at the Whitney Museum of American Art in 2011.[1] *Encounters and Collisions* is also a kind of retrospective, but one that takes the paradoxical form of a group exhibition – a group exhibition that traces Ligon's relationships with others, through their works. As in *Yourself in the World* – and reflecting the wider, non-art-historical range of references Ligon makes in his work (to literature, to American history, to other art forms, to popular culture) – the exhibition is not limited to the work of artists. *Encounters and Collisions* includes photojournalism from the Civil Rights era, imagery relating to the Black Panther Party, and Sun Ra's and Jean Genet's experimental forays with film, for example. It overspills art history.

From the outset, it was important to us that Ligon's works also feature. Besides the sheer pleasure of presenting these works of amazing beauty and intelligence at our institutions for our publics, we felt it was important to offer viewers the opportunity to trace for themselves the possible connections between Ligon's work and the works of artists he has selected. As such, the presence of Ligon's own works in the exhibition acts as a curatorial and interpretative navigation system. Their presence also emphasises the sense that this is a group show unfolded from a solo practice, an image of unfolding we wanted to retain within the exhibition itself. Like many of the most experimental exhibitions curated by artists, *Encounters and Collisions* complicates the categorical divide between the solo and group exhibition that has persisted since Gustave Courbet inadvertently invented the solo exhibition when he organised a showing of forty

of his paintings in protest against the *Exposition Universelle*, after it rejected three of his paintings in 1855.

Although *Encounters and Collisions* is Ligon's first large-scale curatorial project, there is a sense in which his *oeuvre* already anticipated this project.[2] Since direct citation first entered his work in the late 1980s, each of Ligon's works has taken the form of a dialogue with the work or example of others – artists and writers in the main, but also musicians, filmmakers, a legendary comedian, as well as figures from history and the wider culture. Ligon's practice is singular, but its singularity emerges from the unique way it combines, incorporates and transforms the pre-existing voices, styles and experiences of others. His artistic practice, in part, involves procedures that are familiar to curatorial practice: research, selection, juxtaposition, framing, etc. The phrase 'yourself in the world' (used in passing by Hilton Als in a conversation featured in Ligon's book) disavows that notion of the sovereign self – a notion that artists are still too readily thought to exemplify. Ligon's work and writings suggest instead a sense of self that is uniquely constituted from the sum of specific encounters and collisions – with history, with culture, through relationships and in society. It is this, rather than the blurring of the distinction between copy and original, that his approach to appropriation explores.

Encounters and Collisions could be seen as a kind of autobiographical art history, one that, in particular, opens up the post-war American canon to the poetics and politics of difference, especially as articulated by artists who speak from subject-positions (black, feminist, Queer, working-class) variously marginalised by dominant culture. Its non-art-historical inclusions further amplify the exhibition's sense of worldliness – of being-in-the-world. We find ourselves considering, for example, the aesthetics in politics (as in the militant representational strategies of the Black Panther Party, for example) and, by contrast, the implicit politics of 'autonomous' aesthetic statements that seek to absent themselves from the social flux – one of many binaries that Ligon collapses, enfolds and subtly hybridises in his own work.

Ligon's art combines seductiveness and affect with conceptual strategies and criticality, and the selections he has made for *Encounters and Collisions* are done with precision and feeling. Admiration and affiliation underpins his choices. There is a sense of intimacy and relationality in *Encounters and Collisions* that belies the canonical status of many of the works of art featured. Ligon's written contribution to this publication underscores this. It takes the form of letters, mostly imaginary, addressed to several of the exhibition's participants (two are based on actual correspondence). They range in tone according to the extent that Ligon knows them personally, which in many cases is not at all. All are self-revelatory in articulating what that artist's work has meant to Ligon.

One of the letters is written to the playwright Adrienne Kennedy whose *People Who Led to My Plays* influenced how Ligon has approached this exhibition. Kennedy's book is a kind of autobiography that takes the form of a chronological cataloguing of everything – artistic and non-artistic, personal

and public – that has informed the development of her art: books, plays, family, friendships, formative experiences, world events, etc. The book was written as a means of addressing in full a question often asked of her, which she had always failed to answer well: who influenced your plays? It's a question asked of all artists, and to the extent that *Encounters and Collisions* is Ligon's own response to it, it shares with Kennedy qualities of precision and plenitude. Ligon, formally speaking, is a minimalist, but in terms of what his work refers to he is a maximalist (a tension we find in Gonzalez-Torres's work too). *Encounters and Collisions* offers a brief sighting of the larger, submerged part of the proverbial iceberg that underlies what Ligon makes concrete and visible in his work.

This book also goes beyond documenting the exhibition. As an extension of the exhibition, and of his role as curator, Ligon has also assembled an anthology of fifteen pre-existent texts. The anthology is literary as well as critical, and, like the exhibition, both contemporary and modern. It features many African-American voices, and several Queer ones (starting with Proust). The texts intersperse sequences of images. The anthology is less an interpretative framework, and more something to be read in parallel to the exhibition itself, with which it obliquely and suggestively interacts. The anthology reflects the importance that writing, and language in general, holds for Ligon's work, and for the wider intellectual convictions that inform his worldview. Specifically, the interplay of exhibition and anthology, and of curating and editing, evoke the oscillation between found text and painted mark that is so important to Ligon's work.

Ligon's is mostly a studio practice, but there is also sometimes a relational dimension to the research that underpins a number of his projects, and at times he part-delegates authorship to others. For *Notes on the Margin of the Black Book*, he asked some patrons of a drag bar, as well as artist friends, to comment on Robert Mapplethorpe's controversial erotic images of black men, and added these to the contradictory polyphony of published critical commentaries he assembled for this work. His series of colouring book paintings and drawings (three of which feature in the exhibition) were made after asking children of different cultural backgrounds, too young to recognise the imagery, to colour in images from a 1970s colouring book that featured varied celebrated African-American figures – including Harriet Tubman, Frederick Douglass, Malcolm X and Isaac Hayes – and other generally uplifting symbolism, originally given to black children. One inadvertently produced a white, Queer version of Malcolm X.[3]

Intersectionality – first developed by black feminists in America[4] to address the interactive dynamics that arise from more than one type of cultural marginalisation – runs through the politics and, by analogy, the aesthetics of Ligon's practice. For Ligon, as well as other critical practioners, intersectionality becomes a means of deconstructing essentialised positions. This is evident in his work on the interfaces of race and sexuality in America, and we can see it, in a different sense, at work in the interplays he sets up between, say, the word and the painted mark, writing and abstraction, abstract art and politics, painting and a plurality of other media (print, video, neon, installation, archive), the monochrome and the polychromatic, and the abstract and the symbolic values

of colour – including colour's ideologically symbolic role in racialising people of non-European descent within Western cultures.[5]

Ultimately, Ligon's work addresses the relationship of art and the world, as opposed to art and the art world. That relationship, as explored in the form and content of his work and the relationships produced between works he has curated in this exhibition, also has personal and institutional significance. What is the relationship of artworks to institutions, and what in turn is the relationship between art institutions and society? Were these questions Ligon asked himself, in the 1970s and 80s, when riding the subway from his family home in the Bronx to Manhattan's uptown citadels of modern art to see cherished works by the Abstract Expressionists (including works borrowed for this exhibition)?

Something of this is suggested by the image chosen by Ligon for the front cover, which shows three African-American kids, in the mid-1970s, occupying an elongated white cube whose ceiling has been entirely transformed by an astonishing polychromatic neon installation by Dan Flavin. The colour of their clothes rhymes with the colours of the neon, making for a close unity between the young people and the artwork. The photograph depicts a gallery space at Walker Art Center in Minneapolis, but this brilliantly lit recession could also be a corridor to a futuristic utopia (the image has a touch of Sun Ra). The kids advance casually, in their own way transforming this otherwise abstract space into a social space – a place they too own. It is a bold, upbeat image of what a museum can do and be. Ligon's *Encounters and Collisions* is, in effect, the realisation of the imaginary museum his practice evokes. It's over to viewers and readers now to enter and complete the picture.

NOTES
1. It was edited by the exhibition's curator, Scott Rothkopf, and published by the Whitney Museum of American Art, New York, and Yale University.
2. Ligon has also curated *Contact: Gordon Parks, Ralph Ellison and "Invisible Man"* at Howard Greenberg Gallery, New York, in 2012, and *Have Another Piece: Just a Little Piece … smaller … smaller*, an exhibition of artworks and artefacts curated from Andy Warhol's collection at The Andy Warhol Museum, Pittsburgh, coinciding with his retrospective exhibition *Glenn Ligon: Some Changes* there in 2006.
3. In the context of *Encounters and Collisions* this reminds one of the three months Jean Genet spent with the Black Panthers in 1970. A small white Malcolm painting, along with two other works by Ligon, featured in the group exhibition *Jean Genet, Act 2* at Nottingham Contemporary in 2011.
4. Including Audre Lorde, who features in this book's anthology.
5. A number of artists in the exhibition subvert the racialised semiotics of colour by evoking it in absurdly anti-naturalistic ways. Pope.L's literally coloured word poems make wildly incoherent claims for the attributes of people of different 'races', while Nauman's face paint performances, Warhol's Mao portraits and Ligon's white Malcolm paintings do so by employing/applying clearly exaggerated and incorrect colours for/to skin. In his *Synecdoche* series, Byron Kim takes the opposite approach to subverting the cultural constructedness of race, and its symbolic encoding in colour, by instead portraying the singularity of the colour of many different acquaintances' skin with the utmost chromatic precision in grids of subtly different abstract-looking painted panels.

We Are Many

Francesco Manacorda

In linguistic theory a 'performative speech act' is an utterance that, rather than simply describing, reporting or acknowledging a reality, changes the context that it addresses through its delivery. Examples of such speech acts are 'I accept your apology' or 'I sentence you to death' or 'I now pronounce you man and wife'.[1] Glenn Ligon's linguistic acts, whether painted, printed, rendered in neon or filmed, always aspire – and I would argue manage – to introduce some element of disruption into the world they address. Not all the sentences that he borrows from existing texts are strictly definable as performative utterance, but the treatments they are subjected to definitely bring about a series of interrogations and paradoxes that aims at altering first the original material, but ultimately the cultural as well as sociopolitical conditions of reality. In his practice, Ligon appropriates from a variety of sources strings of words that he transcribes sometimes verbatim, and at other times in a repeated sequence. The performative act in this case is not a vocal activity: the sentence is not spoken, and its public act does not take place when it is drawn or painted but rather when it is *exhibited* in a specific context: the gallery is used as an enunciation platform. Indeed, the conditions of visibility and 'speakability' within the visual art institution and beyond are what Ligon wants to change, problematising issues of gender, race and social access through the delivery of his speech acts. Uttering sentence fragments conceived and written by others is in itself a gesture that has a performative origin: legal sentences and religious rituals, for example, employ existing language in acts that are designed to bring about intersubjective change. Interestingly, even theatrical or musical performances involve the utterance of ready-made phrases (verbal or musical) conceived by others. In fact, in both of these disciplines the artistic merit of the event is shared between the writer and the performer: it is telling that there is a history of the interpretation of, say, Bertolt Brecht or Franz Schubert.

Ligon treats the linguistic units he selects in a variety of ways in order to extract from them further meaning and to layer them with extra references: writing Gertrude Stein's expression 'negro sunshine' in blackened neon or painting Zora Neale Hurston's 'I feel most colored when I am thrown against a sharp white background' in a repeated sequence using oil sticks through stencils on a white wooden door are acts that sharpen and expand the sentences' signifying potential. There are at least four kinds of intertextual layers: one generated by the specific medium the artist chooses and its relationship to the phrase borrowed; a second conjured up by the gradually reduced

readability of the text, which evokes a possible dissolution of language; a third brought about by the artist's editorial decisions: cropping, repetition or typographical layout can emphasise and distil meaning; and, finally, a fourth intertextuality linked to the fact that it is Glenn Ligon as an individual in a specific historical context who is performing the speech act. Each of these layers activates the group of words so as to manipulate and extract dormant or potential signification. The importance of the last layer – that connected to the artist's subjectivity – becomes more evident when we think of it from the point of view of the sequence of utterances, the archive of statements 'pronounced' by Ligon that, gathered together, generate additional, surplus meaning through their interaction with each other, rather like artworks in a group show.

The act of borrowing is obviously – even at the most banal procedural level – key to 'curatorial speech', intended as the use of already codified objects, ideas and linguistic contracts to produce a decodable metatext: the exhibition. Artworks are over-abundantly meaningful objects in themselves, and one of the most difficult but also most powerful tasks of curating as a profession is to bring together a number of these multi-layered signifiers in order to generate more meaning than the sum of the group's parts. This can involve allowing toned down, hidden or merely suggested resonances to become more prominent through contextual positioning, for example. Ligon's ability to collect and make use of phrasal fragments from existing sources makes his artistic practice intrinsically curatorial. The recent tendency for artists to become involved in curatorial projects has provided them with the occasion to reiterate some of their concerns, techniques or questions within the domain of exhibition making, often producing gestures that defy its conventions and self-imposed limitations. In the case of Ligon, this curatorial undertaking, rather than being an opportunity to experiment with new territories, seems a natural extension of his ongoing investment in the work of others. It is as if an already existing conversation built over time with a variety of persons, works, issues and contexts were extended to another level and performed simultaneously rather than over time in a gallery space.

Let us return to the notion of performance, and the theatrical in particular. While using other people's words, Ligon in one sense is also temporarily taking on a role, like an actor. He pronounces, through his work rather than his body and voice, selected lines; however, unlike in the majority of theatre, in his case the characters are actual people and the lines were not originally conceived as a script. The actor in a play temporarily becomes a character who is brought to life in front of an audience. In a similar way, Ligon has managed to be many different people through the variety of phrases that he has performed through his full body of work, on the one hand exposing his subjectivity as a crowd – as if he could only be Glenn Ligon because he is impersonating and inhabiting a group of people – on the other providing himself and therefore also his audience with fresh perspectives on the fragments he has used. In this sense art making is, for Ligon, also a way of thinking and learning, of becoming a question rather than an answer, a multiple identity rather than a singular.

We are many: the series of references that Ligon uses could be postulated as ways of forming his own identity as multiple, a multiple performance in which he takes the role of the different characters conjured up in the single play which is his work as a whole.

A similarly immersive activity was once described in an interview by French historian Arlette Farge in relation to her work on the archive and her collaboration with Michel Foucault. She revealed that when she studied handwritten documents such as letters sent to Bastille prisoners in the eighteenth century, she transcribed them in the utmost orthographic detail in order to feel the same sensations as the writer, to re-enact the same bodily gesture; in a way to become the writer, approximating his or her state of mind while travelling through time:

> the material that I was not acquainted with, and which I was trying to decode, seemed to me to be so rich that I forced myself – but I didn't mind that – to copy things, to venture into syntax and vocabulary, and I was quite convinced – which you will find thoroughly naive – that even the movement of my body as I was in the process of writing could only give me ideas![2]

Sometimes in the case of a document written by a scribe, she 'imagined voices and heard sounds' while transcribing. Rewriting sentences is for Arlette Farge a way of knowing intimately the material she is studying; to use her own words, 'my immersion was not anything imaginary; rather it was "being with"'. 'Being with' is an apt way to describe how Ligon borrows words and works to be with something or someone so as to understand them; this sense of heightened empathy is something that clearly emerges from the selection and arrangement of works that he has orchestrated for this exhibition. From this perspective, historiography is literally a way of writing history through affects, a personal attempt to find relevance, meaning and – maybe – order in the disorder of life. Sharing this process with an audience is ultimately an invitation to the public to become historians too, decoders of cultural artefacts through a specific kind of appropriation which involves a large degree of affective apprehension and elaboration.

Within the context of galleries and museums and their mission to make knowledge available to the general public, Ligon's intervention becomes even more poignant. 'Being with' is a particular epistemological position, a way of knowing something that has less to do with illustrating a linear evolution or developing a canon and more to do with the ability to bring together a choral story: something more akin to a temporary history built mainly through open questions. Ligon has an enviable ability in his practice to skip between personal and public issues, between biography and historiography, between the inside and outside worlds, allowing his private story to give resonance to sociopolitical commentary and vice versa. This characteristic makes it clear that his writing is not really separate from his artistic work, but is rather an

integral part of a larger conceptual project. Applied to the history-telling role of the museum, this offers a model for an autobiographical art history built with the purpose of undermining accepted canons and sedimented knowledge. Ligon's artworks already ask questions about his position as a black artist in a white-dominated art history, but in this exhibition such interrogative efforts expand to involve pillars of those canonical art histories – for example, work by the abstract expressionists – alongside peers and co-conspirators who have looked at, fought with and criticised the Euro-American-centric narrative of art and visual culture. Ligon is a canon reformer in spirit; in fact, one gets the sense that this is the ultimate goal of his cultural project. The possibility of drawing together 'his art history' provides the involved institutions with the potential to substitute the universal for the personal as a pathfinder for a different kind of public knowledge. This is a method of knowledge production that likens the museum to a collective intellectual, a subject channelling multiple voices – those of its real public – and as such it is an invitation to institutions to consider for their future the model of multiple subjectivity that is at the core of Ligon's art.

NOTES

1. The active principle of performative utterances was vividly described by the philosopher of language John Langshaw Austin, who first defined them: 'the uttering of the sentence is, or is a part of, the doing of an action, which again would not normally be described as saying something'; J. L. Austin, *How to Do Things with Words: The William James Lectures delivered at Harvard University in 1955* (Oxford: Clarendon Press, 1962), p. 5. Interestingly, this is also the origin of the use of the term 'performative' in visual art discourse: Kristin Stiles writes that 'the term "performative" [in art is taken] from J. L. Austin, who, in the mid-1950s, used the concept to describe a class of expressions that are not descriptive, have no truth value, but in their very utterance do something'; K. Stiles, 'Performance', in Robert S. Nelson and Richard Shiff (eds), *Critical Terms for Art History*, 2nd edn (Chicago and London: University of Chicago Press, 2003), p. 88.

2. Francesco Manacorda and Hans Ulrich Obrist, 'An Interview with Arlette Farge', *Manifesta Journal*, 6 (2005), pp. 317–18.

Gratitude (for Glenn Ligon)

Gregg Bordowitz

In short, how might psychoanalytic theories speak about 'race' as a self-consciously assertive reflexivity, and how might 'race' expose the gaps that psychoanalytic theories awaken?[1]

Any exit from the logic of language might be an entry in a symptomatic dictionary.[2]

> *we*
> *took from flies flying backward*
> *a kind of caviar, none of us wanting*
> *to say*
> *what soul*
> *was[3]*

Glenn Ligon is a scribe, a copyist. He renders texts – quotations, excerpts, fragments – as if the action of tracing and retracing letters could charge the meaning of each word with magic. Ligon is not indifferent to the texts he carefully selects to copy. The act of transcribing stages complicated encounters between the scrivener and the author. The copyist's motives are fraught with ambivalence. Ambivalence arises regarding the copyist's relation to predecessors and precedents. The scribe becomes the author of the copy. A copy can achieve the status of an original text only to be duplicated again by another scrivener. For the artist who copies texts, two opposed dispositions stand in conflict – envy and gratitude.

In her essay entitled 'Envy and Gratitude', psychoanalyst and theorist Melanie Klein writes that everyone experiences both of these emotions simultaneously towards love-objects.[4] Klein locates the origin of this polarity in the infant's early phantasies which arise through breast-feeding.[5] The infant relates to the mother as if her breast itself has intentions, alternately nurturing and sustaining, or withholding and cruel. The relation between the infant and its mother, or primary care-taker, sets the stage for all future object relations. (For Klein, the term 'objects' refers to people, things, phantasies or feelings.) Klein writes:

> One major derivative of the capacity for love is gratitude. Gratitude
> is essential in building up the relation to the good object and
> underlies also the appreciation of goodness in others and in oneself.

Gratitude is rooted in the emotions and attitudes that arise in the earliest stages of infancy, when for the baby the mother is the one and only object. I have referred to this early bond as the basis for all later relations with one loved person. While the exclusive relation to the mother varies individually in duration and intensity, I believe that, up to a point, it exists in most people. How far it remains undisturbed depends partly on external circumstances. But the internal factors underlying it – above all the capacity for love – appear to be innate. Destructive impulses, especially strong envy, may at an early stage disturb this particular bond with the mother. If envy of the feeding breast is strong, the full gratification is interfered with because, as I have already described, it is characteristic of envy that it implies robbing the object of what it possesses, and spoils it.[6]

In 'Envy and Gratitude', Klein refers to Shakespeare's *Othello* to refine the notion of jealousy into the more precise concept of envy. Othello kills the object he loves, motivated by a kind of 'greed stimulated by fear'.[7] Klein argues that envy is insatiable because it originates within the envious person himself and attaches willy-nilly to various objects. It is not contained within the object itself.

The all-too-human tendency to love what one hates and hate what one loves bears on every artist's relation to precedent. Artists want both to emulate and destroy their progenitors. There is a tremendous amount of anxiety when one acknowledges precedents. If love is strong enough, gratitude wins out and, as I will demonstrate, Ligon is an artist who loves with abundance, embracing art and texts with great generosity.

There's prior influence, and then there's Pryor influence. Ligon's paintings of quotations from comedian Richard Pryor, such as *Niggers Ain't Scared* 1996, attest to the rage suffused with hilarity that constitutes an African-American strategy for surviving the murderous envy that white people direct at black people. Pryor's quotations are taken from audio and film recordings of performances, and they are reproduced in Ligon's paintings with Pryor's slips, repetitions and ellipses of speech. Ligon's method of transcription, the very process of stencilling text on to canvas, produces anomalies that become artifacts of the painting. The following is the text from *Therapy #1*, 2004 (this particular painting is not in the exhibition):

Black people are frightened to death
of therapist. For some reason of all
the people on the planet in America,
we some motherfuckers that need
some therapy. You believe me, cause
we fucked up. We fucked up cause
we got to be insane cause we ain't
killed you motherfuckers.

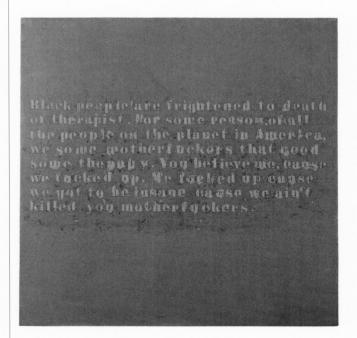

Ligon and I are close in age. We were listening to the same Richard Pryor
albums at approximately the same time in our lives. I can only imagine
what Ligon's first experiences were, mostly through the choices he made
for the Pryor paintings. However, I know that I laughed in spite of myself,
because Pryor's truths were so candid. They exposed my own feelings
of rage and guilt. Pryor gave voice to unspeakable feelings about racist
culture, unspeakable feelings of fury and frustration made sharper and funny
by his keen awareness of the absurdity of racism. Laughter often arises out
of discomfort when repressed material is exposed. I felt that Pryor held me
accountable to the situations he described. He spoke to two audiences at once,
black and white. Pryor delivered a truth that was scary. It rang true. 'We got
to be insane cause we ain't killed you motherfuckers.' I learned about my role
and responsibility in racist America by listening to Richard Pryor.

William Pope.L employs Pryor's two-fold address to both black and white
audiences, albeit using humour in an aphoristic form more cryptic than Pryor's
stand-up. The title and text of Pope.L's pen-and-marker drawing on paper,
Black People Are the Window and the Breaking of the Window 2004, concisely
diagnoses a destructive formula of white hatred. Black people are perceived as
transparent. White racists look through black people as if they are invisible,
like a pane of glass. The aphorism also suggests that black people are agents

GRATITUDE (FOR GLENN LIGON)

of change. They are perceived by whites as possible threats to property for example, through urban uprisings, with their broken shop windows – but these uprisings might also be part of the rebellion that overturns racial inequity. Pope.L's drawing *Black People Are the Glory of a Shared Piece of Candy* 2004 suggests that black people are the proud possession of white culture, sweet to taste, something to be shared and devoured. Many works pictured in this publication address the projections foisted on black people and the internalisations resulting from the mental illness of white racism. Adrian Piper's *Self Portrait Exaggerating My Negroid Features* 1981 is a comment on the incorporation of white racism, a mockery of the racist imaginary, or possibly both.

Ligon's work investigates how race is constructed sociologically, psychologically and historically. Critic Hortense Spillers provides an operative definition of race that serves well to describe his fundamental approach to the subject:

> Unhooked from land, custom, language, lineage, and clan/tribal arrangements, modern 'race' joins the repertoire of fetish names bolstered by legislative strategy, public policy, and the entire apparatus of the courts and police force. It appears to best advantage under the regime of exile, estrangement and struggle – in brief, where and when heterogeneous social subjects invoke their humanness and its orders under the sign of enmity and alienation.[8]

Glenn Ligon's 1990 work *Untitled (I Feel Most Colored When I Am Thrown Against a Sharp White Background* 1990) – with text drawn from Zora Neale Hurston – is exemplary of the way his *oeuvre* considers the effects of context on racial identification. *Untitled (I Am A Man)* 1988 and *Study for Condition Report* 2000 both take the famous civil rights era protest sign as their reference point for an investigation into painting's historical relation to the representation of black people *and* the lack of representation of black artists in the white-dominated art world.

As an artist, Ligon does not occupy the position of Othello. If his role as an artist performs the position of any character in Shakespeare's drama, it's Desdemona – the object of Othello's profound jealousy motivated by a dizzying cocktail of envy, greed, idealisation and misogyny. Contemplating the position of Desdemona demands further consideration of Ligon's work – and works by others included here – concerning gender position, sexuality and embodiment. *Malcolm X #1 (Small version #2)* 2003 – Ligon's infamous painting of a colouring book image depicting the revered black leader wearing pink lipstick – is one example in his corpus where feminising a black male hero provokes a 'queering' of history. It specifically calls into question the masculinism of some established accounts representing black history. Adrian Piper's video *The Mythic Being* 1973, featuring Piper in male drag, is a gender-bending strike against male supremacy – patriarchal authority exercised by white and black males. The video also examines the knotted interdependency among conventions of femininity, race and sexuality. So, too, the inclusion

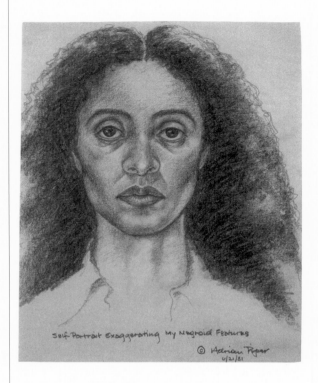

here of the Black Panther Party's promotional photograph of leader Huey Newton, a very handsome man, brilliant and also photogenic. The photo reminds us of the Black Power movement's masculine homosociality.[9] Stephen Shames's photograph of the well-known poster showing Newton seated in a cane chair holding a gun and spear, here pocked with bullet holes, suggests a connection between Newton's mystique and the violence perpetrated against him.[10] Another photo by Shames, *At Home, Huey P. Newton Listens to Bob Dylan's Highway 61 Revisited, Berkeley* 1970, reveals a shirtless Newton in a more casual pose. He is muscular, relaxed in his body.

How Newton's attractiveness was negotiated by envious haters and adoring admirers involves all the complexity of Klein's polarity between envy and gratitude. The inclusion of Black Panther promotional materials in this exhibition shows how the party made use of Newton's appeal as a sex symbol. He was therefore also unintentionally rendered a target for racist homophobia, whereby hatred of Newton on the part of male racists involved the repressed homosexual desire that his image stirred. This is not meant as a full explanation for the violence perpetrated against Newton. It is, however, a question suggested by Ligon's selections that requires more thorough consideration.

Many of the works here deal with homosexual desire directly. Jean Genet's film *Un Chant D'Amour* (1950) depicts the love between two male prisoners. One is perhaps North African, or of Arab descent, the other a seemingly white youth. Robert Gober, Felix Gonzalez-Torres, Zoe Leonard and David Wojnarowicz are all represented in this catalogue with works that refer more or less obliquely to homosexual desire.

Reaching far beyond race and sexuality, this collection is a testament to the artist's capacity to embrace worlds, galaxies, universes of ideas and forms. The exhibition confounds race and sexuality by refiguring both as coordinates for departure to a faraway place of objectless yearning. Pure yearning, where the object, bodies, parts, constructions, frames, paint, light – all sublate into the ether. Space is the place.[11] The inclusion here of the interplanetary travel-ler Sun Ra is significant. This Afrofuturist pioneer stands out as an example of the artist-scribe and explorer of gnostic texts. Ra was an Egyptologist, a Kabbalist. He was an artist with a capacious curiosity and a desire for dis-covering the secrets possessed by the word itself. As a writer of tracts and a composer of celestial music, Ra pointed the way to a universe apart from the racist nightmare of America.

Ligon may not share Ra's spiritualism, but the driving force behind the formation of Ligon's personal archive is not so far from Ra's gnosticism. Ligon's archive is a collection developed by a fugitive kind of scholarship pursuing an extra-mundane knowledge. His work uses words and words and words, yet it's possible that they say nothing. In many spiritual practices – Kabbalistic meditation, for example – the contemplation of nothingness by gazing into words is the most holy and the most dangerous of pursuits. It risks madness. Ligon as scribe makes words visceral. He gives them depth and thickness in oil stick and paint; or he illuminates phrases to make each word the brightest neon feature of the room. This methodology is danger-ous. One can thoroughly exhaust oneself to the point of nihilism in the ser-vice of nothingness's contemplation. Deep in the background, LeRoi Jones/ Amiri Baraka's "BLACK DADA NIHILISMUS" resounds.

> For tambo, willie best, dubois, patrice, mantan, the
> bronze buckaroos.
>
> For Jack Johnson, asbestos, tonto, buckwheat,
> billie holiday.
>
> For tom russ, l'overture, vesey, beau jack,
>
> (may a lost god damballah, rest or save us
> against the murders we intend
> against his lost white children
> black dada nihilismus[12]

Glenn Ligon, *Untitled (I Feel Most Colored When I am Thrown Against a Sharp White Background)*, 1990, oil stick, gesso, and graphite on wood, 203.2 × 76.2 cm, Collection of Eileen Harris Norton © Glenn Ligon, photograph by Dennis Cowley

All the gratefulness mixed with resentment and violence composed in Jones/Baraka's famous poem echoes in Ligon's archive. Yet Ligon, like Ra, does not mobilise from nihilism. And Ligon's meditations do not end with murderous intent, though these feelings are present in the exhibition selections. How could they not be? Murderous drives are part of the human psyche, and murderous phantasies are a justifiable element of black rage in a society ruled by white supremacy.

For all the relevance of Sun Ra here, an apt musical analogue for Ligon's *oeuvre* might be fusion-era Miles Davis. Ligon plays like Davis on the 1972 album *On The Corner*, adding notes precisely placed amid blissful disorientations.[13] Don't just look at the artwork. Listen to its muted trumpet, electrified, amplified rock guitar and bongo rhythms Black Power soundtrack. Contemplate how *cool* becomes cold fusion's hard-edge populist abstraction; how synthesizer effects yield virtuosic chaos. *Right on.* The scribe *writes on* the creamy field a downpour of thick letters, percussive downbeat ... and suddenly the influence of India. Sutras, scripture, philology, grammatology, graphology – exegeses – all serve Talmudic depth-analysis governed by a syncretic religion. Respect the record keeper, the theologian and the jurist. He is all.

Encounters and Collisions is a record, almost biblical in its genealogical listing. Ligon presides to adjudicate the relevance of each curatorial choice. It's impossible within the scope of this essay to unpack the complexity represented by the staggering checklist and table of contents. The work of Willem de Kooning is one of the most surprising inclusions. In a conversation with Ligon, I asked him about de Kooning. He said that when he was a young artist, de Kooning was the first to appear to him as a template for what art looks like. The abstract expressionists' style and approach are not easily visible within Ligon's art, but they remain there in the deep background. We discussed the mysterious ways that objects lay claim to our imaginations. Ligon said that some objects just 'light up certain regions of the brain'. I agreed, adding that the commanding presence of an object of desire remains a mystery, even in psychoanalytic theory. We don't choose our models, just as we don't choose who we desire. Desire chooses us, and we find our own paths towards and away from the foci of attraction. The interplay between envy and gratitude originating at the source of infantile phantasies is a paradigm for the appearance of objects prior to the acquisition of language. Objects emerge through phantasies and phantasies become objects.[14]

The idea of meditating on the role of envy in Ligon's work came from Ligon himself, who thoughtfully contemplated the role of envy in an interview with colleague and friend Byron Kim:

> Envy is a curious and fascinating word in this context. Why are
> black people, marginalized and disenfranchised, enviable? The
> eighteenth and nineteenth centuries (and the twentieth, I sup-
> pose) were not happy times for my people, yet we survived all

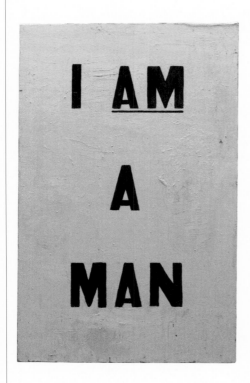

that and became Americans. If I have a well to dip into, it's filled with almost four hundred years' worth of permutations of what blackness has meant and speculations on what it might mean in the future. It's curious to me that our experience seems central, seems to be the quintessential American experience. Toni Morrison argues that blackness has been used by other groups to define their Americanness, blackness being placed at the limit of what it means to be American. So, obviously, exploring blackness as a subject matter tells you about what it means to be anything else in this country. Also, blackness – like Malcolm X said about whiteness – is a state of mind. There is no consensus on what it means, and each individual and generation has to renegotiate its meaning. I'm just adding my two cents to the debate.[15]

What was soul? To pose that question in the past tense is to mourn the passing of a form of survival and to perhaps commit an unwitting violence. Did soul die with Marvin Gaye? *What's Going On?*[16] lives in perpetuity as a recorded

message set to repeat. 'Save the babies. Save the babies', the singer exhorts with great sincerity, combining musical idiom, lyrics and profound social concern. Very few contemporary artists are capable of achieving that kind of grace. (Glenn, we are the generation Gaye was pleading to save.) No one can say what soul is. It's a feeling, a mood, transmitted through language, fashion, posture and attitude. It's a feeling that makes the body a site of individuation, as well as the ground for intimacy, contact, generosity: *Give me some skin.*

Before Desdemona is murdered by Othello, she sings a song that she learned from her mother's maid:

> *The poor soul sat (sighing) by a sycamore tree,*
> *Sing all a green willow*
> *Her hand on her bosom, her head on her knee*
> *Sing willow, willow, willow*
> *The fresh streams ran by her and murmured her moans*
> *Sing willow, willow, willow*
> *Her salt tears fell from her, and softened the stones*[17]

Glenn Ligon does not share the same grim fate as Desdemona. Yet his work bears witness to a profound sadness. Facing Othello, who is poised to kill her, Desdemona speaks: 'Since guiltiness I know not, but yet I feel I fear.'[18] 'Yet I feel I fear' is an apt formulation for describing the affective terrain of this catalogue. History does not settle. Terrors past and present commingle forever, each informing the others, no respite. In America, an armed white representative of the state can still murder a black citizen with impunity. As this essay is written, protests across the US continue against police brutality aimed at black people. In the face of this, we muster vigilance, mourning, reparation: all forms of gratitude that Ligon's art provides. Gratitude is a form of survival. Racism and homophobia persist, though great achievements have been made in spite of their overwhelming destructive force. Ligon's accomplishments are nothing less than the triumph of creation over destruction.

Ligon is not Desdemona. He's the scribe. He's Shakespeare. To make art using the most difficult aspects of the past, to generously acknowledge those who came before and, finally, to project one's appreciation far across the boundaries of tremendously violent history: that is gratitude. Gratitude's cause is nothing less than love. This exhibition is a testament to love's capacity to overcome the challenges posed by intimacy, relationships and legacy – the tragic ever-present possibility of attachment's dissolution. Sometimes gratitude derives not from joy but through sorrow and loss. Desdemona's song drops tears that soften stones. It takes years for trickling streams to crack a boulder. The pace is glacial and the planet cannot go on forever. The world is cleaving and we were warned. 'God gave Noah the rainbow sign. No more water, the fire next time!'[19] The final lines of James Baldwin's essay still haunt us today. Fresh urgencies emerge to play a part in prior embroilments. The apocalypse is upon us. Still, we are grateful for the present.

NOTES

1. Hortense J. Spillers, '"All the Things You Could Be By Now, If Sigmund Freud's Wife Was Your Mother": Psychoanalysis and Race', in *Black, White and in Color: Essays on American Literature and Culture* (Chicago: University of Chicago Press, 2003), p. 376.

2. Harryette Mullen, *Sleeping with the Dictionary* (Berkeley, CA: University of California Press, 2002), p. 67.

3. Nathaniel Mackey, 'Day After Day of the Dead', in *Nod House* (New Directions Publishing Corporation, 2011), http://www.poetryfoundation.org/poem/247622 (accessed 22 December 2014).

4. Melanie Klein, 'Envy and Gratitude,' 1957, in *Envy and Gratitude and Other Works 1946–1963* (New York: The Free Press, 1975), p. 183.

5. Following the practice of British theorists, the word 'phantasy' is spelled differently to the common English word 'fantasy' to distinguish the former from the latter. In psychoanalytic theory, 'Phantasy has a number of different modes: conscious phantasies or day dreams, unconscious phantasies like those uncovered by analysis as the structures underlying a manifest content, and primal phantasies.' The English word 'fantasy' was thought to carry connotations of 'whimsy, eccentricity, triviality, etc.' J. Laplanche and J.B. Pontalis, *The Language of Psychoanalysis* (New York: W.W. Norton & Co., 1974), p. 314.

6. Klein, 'Envy and Gratitude', pp. 187–88.

7. Klein, 'Envy and Gratitude', p. 182.

8. Spillers, '"All the Things You Could Be By Now"', p. 380.

9. Homosociality is defined here as same-sex desire arising in a context where close male bonding approaches but does not cross the threshold of consciously avowed homosexuality.

10. Stephen Shames, *Poster of Huey Newton Shot Up After Attack by Police on Panther Office, Berkeley, California*, c. 1968.

11. *Space is the Place*, film directed by John Coney, written by Sun Ra and Joshua Smith, featuring Sun Ra, 1974, http://www.imdb.com/title/tt0072195/ (accessed 22 December 2014).

12. LeRoi Jones, 'BLACK DADA NIHILISMUS', in *The Dead Lecturer* (New York: Grove Press, 1964), p. 64.

13. Miles Davis, *On The Corner*, Columbia Records, 1972. There are probably more appropriate musical comparisons to be made here, compositions by Thelonious Monk, Cecil Taylor, Jaki Byard or Jason Moran, all pianists whose playing can be described as exegetical. Here I'm thinking of Miles Davis's overall compositions fusing jazz, funk and rock to connect with young African Americans who had turned away from jazz towards more contemporary popular music. I also have in mind the method used to compose the album. The melodic parts were selected from hours of recorded improvisations. *On the Corner* was not a critical success when it was released, but its appreciation has grown with time. It significantly influenced later musical forms, such as post-punk, hip-hop, drum and bass, and electronic music. Interesting to note that Karlheinz Stockhausen was cited as an influence on Davis. http://en.wikipedia.org/wiki/On_the_Corner (accessed 5 January 2015).

14. Conversation with Glenn Ligon, 19 December 2014.

15. Glenn Ligon, 'Interview with Byron Kym', in *Yourself in the World: Selected Writings and Interviews*, ed. Scott Rothkopf (New Haven, CT: Yale University Press, 2011), pp. 97–99. Ligon's quote was prompted by Kym's preceding comments: 'As an African American artist concerned with biography and history, you have a limitless store of subject matter. To me, content is the most important part of art, and the most difficult to acquire as an artist. The black and white paradigm that frames the issue of race in this country is basically constructed by white people, but I still sort of envy the idea that any time you need subject matter you just dip down into the well of blackness. I can't do that. I should be critical of the whole setup, which I am, but the setup strangely benefits you as an artist, even if its relationship to you as a human being is more complicated.'

16. Marvin Gaye, *What's Going On?*, Motown, 1971.

17. William Shakespeare, *Othello*, Act 4, Scene 3, Folger Shakespeare Library (New York: Simon and Schuster, 2004), p. 215.

18. *Othello*, Act 5, Scene 2, p. 239.

19. James Baldwin, *The Fire Next Time* (New York: Dell Publishing, 1964), p. 141.

Encounters and Collisions

Dear Ms. Kennedy,

My name is Glenn Ligon and I am an artist. I was introduced to your work in 1990 by the playwright Suzan-Lori Parks, whom I met when one of her first plays, "The Death of the Last Black Man in the Whole Entire World," was performed at BACA Downtown, a small theater space in Brooklyn that had a gallery off the lobby where I was showing text paintings based on a Zora Neale Hurston essay. Suzan-Lori said that when she was in college a professor handed her a copy of your play "Funnyhouse of a Negro," and that from reading your work she concluded that one could do anything one wants in the theater. I bought a copy of *People Who Led to My Plays* in 1996 from a bookstand in the lobby of the Public Theater here in New York during the intermission of a performance of Suzan-Lori's astonishing play "Venus." The book has since served as a model for me in considering how one's artistic practice is rooted and thrives in the soil of the past and how an artist uses history (with a small and a large "h") as the raw material for one's practice, molding and transforming and bringing it into the present.

I am writing to you about a museum exhibition I am curating titled *Encounters and Collisions*. It juxtaposes my paintings, drawings, and neons with works from approximately fifty other artists who have had an impact on my practice. A key element of the exhibition is the catalogue, which will include an anthology of writings by authors such as James Baldwin, Toni Morrison, Hilton Als, Fred Moten, Jorge Luis Borges and Adrian Piper. My work is often inspired by literature; I have been just as profoundly influenced by writers as by visual artists. I see the anthology as a curatorial project, one that runs parallel to the actual exhibition. An excerpt from *People Who Led to My Plays* occupies a key place in the anthology, as it is the first text I decided to include in it and is the text that most closely mirrors the curatorial ideas behind the entire exhibition. I feel lucky to have read your book at a formative moment in my career and lucky to be able to bring it to new audiences through this catalogue. I thank you for your extraordinary work in unpacking black life on the stage and showing us how truly rich and strange it is.

Sincerely,

Glenn Ligon

Glenn Ligon, *Untitled (I Lost My Voice I Found My Voice)*, 1991

I LOST MY VOICE I FOUND MY VOICE I
LOST MY VOICE I FOUND MY VOICE I LO
ST MY VOICE I FOUND MY VOICE I LOST
MY VOICE I FOUND MY VOICE I LOST MY
VOICE I FOUND MY VOICE I FOUND MY V
OICE I LOST MY VOICE I FOUND MY VOIC
E I LOST MY VOICE I FOUND MY VOICE I
LOST MY VOICE I FOUND MY VOICE I LO
ST MY VOICE I FOUND MY VOICE I LOST
MY VOICE I FOUND MY VOICE I LOST M
Y VOICE I FOUND MY VOICE I LOST
MY VOICE I FOUND MY VOICE I FOUND
MY VOICE I LOST MY VOICE I FOUND MY
VOICE I LOST MY VOICE I FOUND MY VO
ICE I LOST MY VOICE I FOUND MY VOI
CE I LOST MY VOICE I FOUND MY VOICE I
LOST MY VOICE I FOUND MY VOICE I LOS
T MY VOICE I FOUND MY VOICE I FOUND
MY VOICE I LOST MY VOICE I FOUND MY
VOICE I LOST MY VOICE I FOUND MY VOI
CE I LOST MY VOICE I FOUND MY VOICE
I LOST MY VOICE I FOUND MY VOICE I
LOST MY VOICE I FOUND MY VOICE I

People Who Led to My Plays

Adrienne Kennedy

ELEMENTARY SCHOOL
1936 – 1943

Fairy tales
My family
The radio
Jesus
My teachers
The movies, dolls, paper dolls
Hitler
JANE EYRE

More and more often as my plays are performed in colleges and taught in universities, people ask me why I write as I do, who influenced me. When they ask this they are usually referring to my original one-act plays, *Funny-house of a Negro*, *The Owl Answer*, *A Rat's Mass* and *A Movie Star Has to Star in Black and White*, and not to the commissioned work I've done in the last decade for Julliard (*Electra* and *Orestes*), the Mark Taper Forum (*The Life of Robert Johnson*), or the Empire State Youth Institute (*Chaplin's Childhood*). But they do continue to ask. Who influenced you to write in such a nonlinear way? Who are your favorite playwrights?

After I attempt to answer, naming this playwright or that one, as time progresses I realize I never go back far enough to the beginning. So I decided to.

People on Old Maid cards (1936, age five):
Through make-believe one could control people on a small scale.

Paper dolls:
You could invent enchantment with paper.

THE BLUE BIRD (1940 movie):
Somewhere, if I could find them, there were some steps, many, many steps, that led to the Blue Bird of Happiness. But I would have to climb them and they sort of sat just in the middle of the sky. It would be worth it, though. I wondered if they were in another city. What city?

Jack and Jill:
Went up a hill to fetch a pail of water. Jack fell down and broke his crown and Jill came tumbling after. What's a crown? I asked my mother. His *head*, she said.

Blondine:
A heroine in a fairy tale who went through trials and hectic adventures to find happiness, until she befriended a tortoise who helped her destroy her nemesis, a wicked king. I had never seen a tortoise and didn't know anyone who had one. I wondered if I had to confront an evil king—who would help me?

Elves:
I asked my mother, could we leave milk for the elves that came out at night?

Burglars:
They broke into our house one night when my mother and father and brother and I were asleep. One had a gun and put it to my mother's side and took her wedding ring. Then they took the cash from the dresser. My father, who was a YMCA secretary, had just gotten paid that day. The police later discovered the burglars had followed my father home from the bank and had taken a side stairway to the attic and hidden there until almost midnight.

Goldilocks and the Three Bears, Cinderella, Jack and the Beanstalk, Little Red Riding Hood, Hansel and Gretel, The Pied Piper of Hamelin:
There was a world that existed where unusual terror reigned, a world my parents and friends couldn't reach.

Joe Louis (the heavyweight champ):
We listened to his fights on the radio. His fame and popularity crossed racial boundaries.

June and Jean:
Twins in my class in kindergarten. They walked to school on the same street as I did. I walked as close to them as possible so I could study these two people who looked exactly alike.

Miss Elbert:
She said I was the best reader in the first grade.

My mother:
Some of her sayings—
"Every dog has their day."
"You gotta get up before morning to fool me."
"Don't be a greedy pig" (when, at age six, I tried to eat a whole chocolate cake).
"Lord doesn't love ugly."
"Be a lady."

Jim:
The hero of the 1930s song.

Our family:
We took drives in my father's Plymouth every Sunday (unless there was a blizzard) after dinner, which was at three o'clock ... in the summer, fried chicken, in the winter, pork roast or roast beef. We started from Mount Pleasant, where we lived, drove out Kinsman, up Lee Road to Shaker Heights, through the winding streets of Tudor mansions. Sometimes we drove downtown to Cedar Avenue, where my father had his office at the Y. The Y had a "ballroom," a large room painted blue where I would one day have my wedding reception, and where, as a teenager, I saw my father give many talks at Y banquets. Down the hall from the "ballroom" were rooms where guests at the Y stayed ... small single bedrooms with plaid bedspreads and a desk. My brother and I peeked into the rooms that were empty. How could I or any of us know that it would be in one of these rooms where my father would spend the last days of his life, sick from emphysema, divorced from my mother and bereaved of his second wife?

But we didn't know that then as we peeked in the rooms, and ran down the hallway to the stairway that led to the main floor and the reception room, past the office that had a plaque on the door with my father's name.

My father would greet us, rushing out of his office, smiling, and we'd climb back into the 1937 Plymouth, where my mother sat waiting.

"Let's drive by Lake Erie," we'd say, and so we would drive along the lake until it got dark. "They're going to build this lake up one day," my father always said. My mother would finally announce that we should go home. And when we got home, she, my brother and I had chilled jello with bananas and vanilla wafers that my mother had carefully made the night before. My father smoked a cigar. I was excited and happy because soon Jack Benny would come on the radio, and we all loved Jack Benny and Eddie Anderson (Rochester).

My mother:
When we came back from the Imperial Theatre after seeing movies like *Hold Back the Dawn* or *Kitty Foyle*, she'd sit in her favorite maroon-colored chair

in the corner of the living room and light a cigarette … a Lucky Strike … and talk about why she liked the movie. "When I was in school I acted in plays," she'd say wistfully.

My brother:
We swung on the big swings and the baby swings, we climbed the parallel bars and rode a chained affair called the merry-go-round. We played in the sandbox and we played baseball. And we walked to the theater every Saturday to see Hopalong Cassidy, Charlie Chan, Gloria Jean and Donald O'Connor while we ate pretzels and potato chips.

People in nursery rhymes:
Humpty Dumpty, Jack Sprat, Little Bo Peep. People did illogical things that had a deeper, more puzzling meaning.

People in fairy tales:
There was a journey in life that was dark and light, good and evil, and people were creatures of extreme love, hatred, fear, ambition and vengefulness, but there was a reward if one kept seeing the light and hoping.

Fairy tales:
Stories of people could hypnotize.

Fairies:
They waved magic wands and everything became different.

People in the Bible:
Life was old.

Comic strips—Little Orphan Annie, Blondie and Dagwood, Bringing Up Father:
Our family laughed over their doings.

People in the movies:
Whom I saw every Saturday afternoon from the time I was six to thirteen (especially Charles Boyer).

Santa Claus:
Up on the housetop, click click click; down through the chimney comes good St. Nick. He called me up once right after I came home from school and asked me what I wanted for Christmas. I wondered how Santa knew our phone number. I was eleven years old before my mother told me that "Santa" had been my father.

Sabu, Turban Bey:
Two people in the movies who were *not* white.

A few others I saw:
Ella Fitzgerald (one movie); Pearl Bailey (one movie); Butterfly McQueen (one movie); Stepin Fetchit (many movies).

Myself:
Why did I have to wear long plaid dresses, knee socks and Buster Brown shoes? And a big bow tied at the top of my braid?

My Aunt Mary Lee often laughed at me and asked why did I stare at everyone so.

Virginia (our family friend):
One Saturday afternoon she took me downtown on the streetcar to see *The Wizard of Oz* and afterward bought me a chocolate ice cream soda, the first I'd ever had. How I loved that afternoon.

Souls, witches, magicians, Sleeping Beauty:
I hoped no one would put me to sleep for a hundred years. For when I woke up where would my parents and brother be?

Mrs. Filetti:
My fifth-grade teacher gave me the role of the Virgin Mary in our Christmas play, where I learned the thrill of the attention and interest that came from wearing a costume and standing onstage pretending.

Charlotte Brontë:
I read *Jane Eyre* and learned that life was to be a great journey and it was a journey that would be spelled out with love, loyalty, devotion, loneliness, madness, sacrifice and happiness, and that very life had been experienced by an English girl one century before.

Spirituals:
I learned that I belonged to a race of people who were in touch with a kingdom of spirituality and mystery beyond my visible sight.

Paul Robeson:
My father took me to hear and see him. After hearing Robeson I realized that one person could inspire many people to strength, to courage, to believing.

Freddy Jamison:
The boy I fell in love with at eight. He could talk in long funny monologues about people.

Jesus:
He could endure, and as a "Negro" I needed that quality.

God (as a child):
I thought He lived in the sky and looked over and protected me.

"White people":
They tried to hold you back. That implied a great challenge existed in life.

The minister in our church:
He spoke the sermon in a way that said there was a rage inside religion.

Dr. Benjamin Mays (president of Morehouse College):
My father introduced me to him when I was six years old. He told me Mays was a "great man." A great man, I remember thinking, what is a great man and why is he a great man?

My mother (1937):
I was brought to her room by a neighbor who had been in the house all morning. My parents' door had been closed. And I was told to stay in my room. Suddenly I heard a loud siren. My mother's door burst open, another neighbor had been inside her room. My father came running through the house followed by two men with a stretcher. The neighbor said, Adrienne, your mother wants to talk to you. My mother was lying in bed, her face wet, her hair limp. She looked like she was dying ... the color of her skin almost purple.

"Be a good girl," she said and the men lifted her onto a white stretcher and carried her to a large white ambulance.

My father disappeared with them. The siren sounded and the ambulance took my mother away. I fled to the closet in my room, closed the door and started weeping. The neighbor made me open the door. "Your mother will be all right," she said. It was years before I learned my mother had lost a child and had almost died.

My Italian classmates:
I would sit on the front porch and watch them as they went to communion, extraordinarily beautiful in their white communion dresses, with their catechism books, their rosaries.

Mrs. Filetti:
Long before Mrs. Rosebaugh told us about Caesar, Mrs. Filetti, our music teacher, taught us Italian melodies. "Funiculi Funicula."

Leslie Howard (GONE WITH THE WIND):
He had an English accent. How wonderful!

LITTLE HOUSE ON THE PRAIRIE:
L. I. Wilder book which we read in fifth grade. Laura in her little house on the

prairie, reading and talking to her family and dreaming of growing up, led a life similar to mine in the dark, long Cleveland winters.

Mr. Kuzamano:
He ran the drugstore and gave us an extra dip of ice cream on our cones.

Jesus:
Jesus loves me, this I know, for the Bible tells me so. Little ones to Him belong, they are weak, but He is strong.

People in the constellations:
Wonder.

Zombies, mummies, the Cat Woman, ghouls, ghosts, vampires, monsters, werewolves:
And Boris Karloff and Lon Chaney (the single most frightening movie monster), the Wolf Man.

 Because of the Wolf Man I asked my mother many questions about what would happen to "a person" while sleeping. And I asked her these questions for a long time. The Wolf Man held a power over me. Metamorphosis and that change of identity would, twenty years later, become a theme that would dominate my writing. The characters in my plays and stories would also change personae at an alarming rate.

The people in my mother's red scrapbook:
I yearned to know them.

Dreaming of my parents as children:
Both my parents knew all the people in the red scrapbook, because my parents had known each other since they were children. My mother told me they met walking along the road near my father's house and my father said hello to her. Summers when I stayed at my grandmother's house I would sit on the steps looking at the road trying to picture my parents meeting. It was tiring, so I'd pick a peach from the huge peach tree in the yard and go back to reading *Modern Screen*.

 I started to read *Modern Screen* in the summer, because the movie changed only once in the one movie theater during the July and August months my brother and I were at my grandmother's house in Montezuma. When I took the magazine home, my mother disapproved of my reading a movie magazine. I had to hide it under the mattress, which was where I also kept my secret diary.

Favorite childhood belongings:
Candy cigarettes
My leggins

Fingernail polish
Turquoise ring
My doll, Gloria Lou
My green ballerina dress
My jacks and ball
My blue velvet dress with the silver buttons
My roller skates
My blue mittens and my white mittens

Hated things:
Buster Brown shoes
My plaid school dresses

More favorites:
My silk hair ribbons
My barrettes
My Easter eggs

I LOVE A MYSTERY:
To be frightened with Jack, Doe and Reggie in their adventures while my brother and I did our homework was wonderful.

Lowell Thomas:
A voice, from the brown mahogany radio with gold lettering "Philco," announced events from the entire world. And he determined what kind of day the world had had. My father and his friends often talked about what Lowell Thomas said.

Snow White (the movie, age eight):
I thought after seeing this movie that somehow in some way we were all sleeping and had to be awakened before we could really live.

Pinocchio:
If you lied, something happened inside your body that made you change and people saw it. It didn't have to be a nose.

Judy Garland:
When she sang "Dear Mr. Gable," I knew someone else was full of yearning just like myself.

Marian Anderson, Eleanor Roosevelt, Mary Bethune, Helen Keller:
My father talked constantly of how great these women were, and urged me to be like them.

Marian Anderson:
She was a model of behavior.

Mary Bethune:
She and Eleanor Roosevelt were models of worthy deeds.

Billie Holiday:
She sang in a sad way I yearned to understand.

Kids who signed my autograph book:
It was a red book I brought at Kresge's with embossed flowers on the borders and sheets of pastel-colored paper. I carried it in my school bag. "To a Sweet Kid." "I'll never forget you." "To my best friend always." "To the greatest kid in the world."

My father (again):
He let me sing "Deep Purple" to him when he came home from work.

My mother:
My mother once bought long false braids to wear to a Halloween party. She dressed as a gypsy. After Halloween she put the long thick braids in her dresser drawer. When I didn't think anyone was looking, I'd take out the long braids and attach them to my hair and put on my mother's lipstick and her fingernail polish.

My grandmother:
She got up at dawn and worked tirelessly.

My grandfather:
He told me stories about people in the town, both white and black.

Our minister, Rev.— :
He was always angry when he finished preaching, and the congregation seemed angry. I was afraid of him. He had dark eyes and dressed in black robes. He seemed evil.

Snow White:
I often thought, why did Snow White's stepmother want her killed in the woods and to have her heart brought back in a box? To be the "fairest" in the kingdom must be very important.

My great-aunt and my grandmother, their landscape:
Their houses, surrounded by petunias, hedges, sunflowers, magnolia trees, their wells, their blue-and-white dishes, the dippers and bucket, their potbellied stoves, the porches with wicker furniture, the smell of wood burning in the stoves, the way the houses sat on the Georgia roads ... the picket fences ... these houses with their vistas of cornfields, vegetable gardens, fig trees, flower gardens that faced the road, the porch that wound around

the house, the stone paths that led to the steps ... these houses were the most beautiful houses in the world to me.

My great-aunt:
It was next to her house that the one-room store with the Coca-Cola sign on the front sat. She ran the store when she wasn't working in the M— household. My mother said people said Aunt Mary Lee had "a pretty penny although she was close-mouthed about it."

It was impossible for me to see that this Georgia landscape became in my mind what "landscape" was.

My mother and Jane Eyre:
My mother often told me that she had been sent away to boarding school at the age of five and remained there until she was seventeen. Her mother was dead and her father thought boarding school was the best course for her. On holidays, she said, she would get very lonely and the headmaster of the school (in Fort Valley, Georgia) would invite her to his house. I thought my mother's childhood life very strange. Everyone I knew went to a public school and I had never ever seen a boarding school, that "one" was sent away to. It was very difficult for me to imagine even though my mother spoke of it often. Finally when I was eleven I took a book out of the school library that was gray with green designs—a pretty book, I thought—and it was called *Jane Eyre*.

Almost before the first chapter was concluded, it was decided that the heroine, Jane Eyre, would be "sent away to boarding school." How excited I was as I sat in the small rocking chair in my room. Here was a little girl who had a life like my mother's. It was so thrilling that I read the first section about Jane Eyre at Lowood many times. I began to envy my mother's exotic upbringing. It wasn't fair that I would go every day to Lafayette Public School when she had lived a life like Jane Eyre's.

As much as it was possible I used to imagine that I had been my mother when she was a little girl. I think after *Jane Eyre*, when she told me stories, I almost believed they had happened to me: her life at boarding school, her pictures in the red scrapbook of herself in white organdy dresses standing by a Model T Ford, the people in her dreams and maybe most of all her incredibly pretty hair that everyone commented on. I think now that I often thought they were mine. They all belonged to me.

Years later my obsession with hair would again and again reveal itself in my work.

Mary in THE SECRET GARDEN:
She too, like Jane Eyre, was "sent away," as my mother had been "sent away." How wonderful my mother was that she so resembled people in books. My life seemed drab next to her life. When I grew up I had to do "something" ... "something" like the people in these books.

I wanted to be in books too.

Dear Beauford,

We have never met, but I am an artist living in New York who greatly admires your work. I first encountered it in a terrific show titled "The Color Yellow" at the Studio Museum in Harlem many years ago, and through "The Amazing and Invariable Beauford Delaney," a monograph Henry Miller wrote on you. We also have a mutual friend in the gallerist Paula Cooper, who said she spent a glorious afternoon with you in Paris in the mid-1960s. She mentioned that you seemed sad when she was with you. I think she probably caught you in the middle of working on some major paintings and was observing the sadness that settles in the studio when one is working intensely. It is the price of the ticket, so to speak. We also have a touchstone in common in James Baldwin, a close buddy of yours but someone I know only through his magnificent essays and novels. It would have been great to be able to spend time with the two of you in Paris. What stories I would have told when I showed photos of us eating soul food in Pigalle or hanging out at Café de Flore, nursing coffees against the winter chill.

I am writing because I am curating a show titled *Encounters and Collisions*, and it juxtaposes my work with the work of many other artists. I have been in touch with a gallery here in New York that has a sublime portrait of Baldwin you made in the '50s as well as a yellow abstraction that would work perfectly in the exhibition. I am including these pieces in the show not only because of the crucial place Baldwin occupies in our lives—I've seen numerous portraits you painted of him, and his essay "Stranger in the Village" is the basis of a major cycle of paintings I have created—but also because your figurative and abstract work finds deep inspiration in jazz and the blues, an inspiration Baldwin and I also share.

In your paintings, the line between figuration and abstraction is always porous. That has inspired a similar fluidity in my paintings, which often turn text (a kind of figuration, I suppose) towards abstraction. To tease out that connection is one of the things *Encounters and Collisions* aims to do.

I hope this letter isn't too presumptuous. As I said, we've never met, but I wanted to use this opportunity to tell you how much I love your paintings, which occupy such a vital place in the history of postwar art and have been so meaningful to me personally.

Sincerely,

Glenn Ligon

Glenn Ligon, *Stranger #23*, 2006

51

Franz Kline, *Meryon*, 1960-61

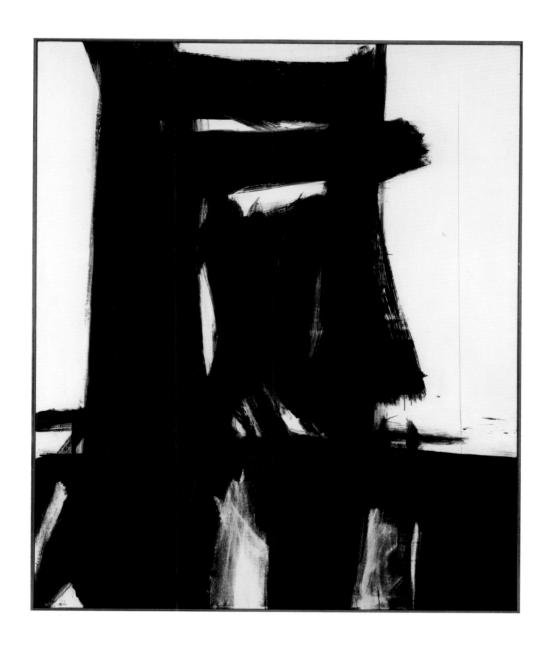

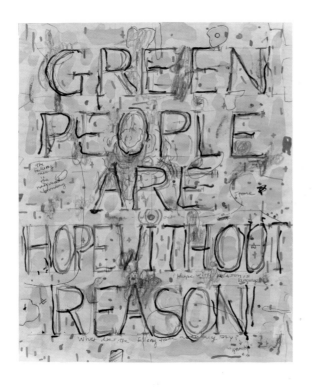

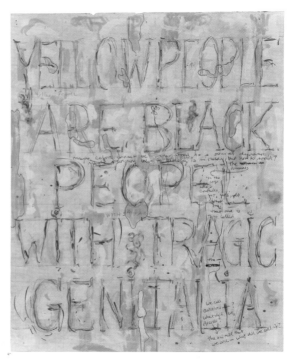

Left: William Pope.L, *Skin Set Drawing: Green People Are Hope Without Reason*, 2004
Right: William Pope.L, *Skin Set Drawing: Yellow People are Black People With Tragic Genitalia*, 2004

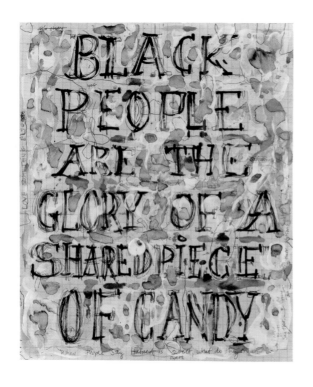
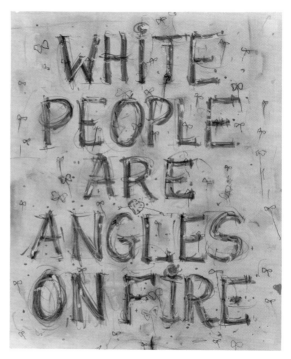

Left: William Pope.L, *Skin Set Drawing: Black People Are the Glory of a Shared Piece of Candy*, 2004
Right: William Pope.L, *Skin Set Drawing: White People Are Angles On Fire*, 2004

On Kawara, *NOV. 22, 1978*, 1978

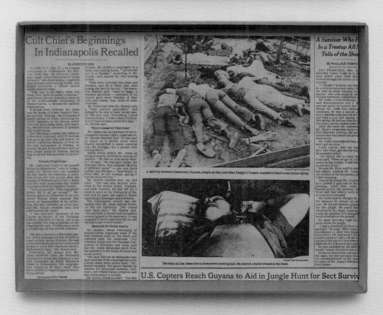

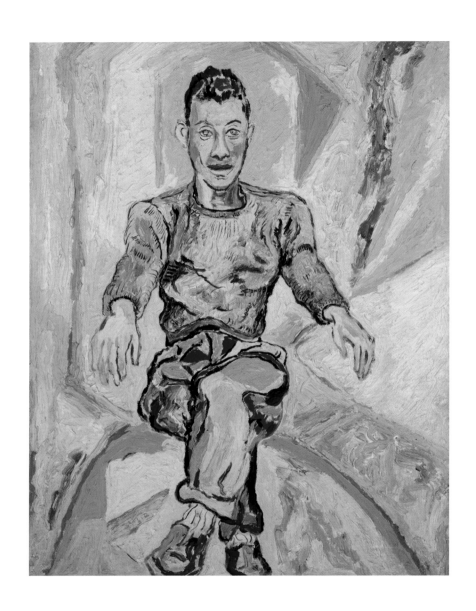

Above: Beauford Delaney, *James Baldwin*, c.1955
Opposite: Beauford Delaney, *Untitled*, c.1958

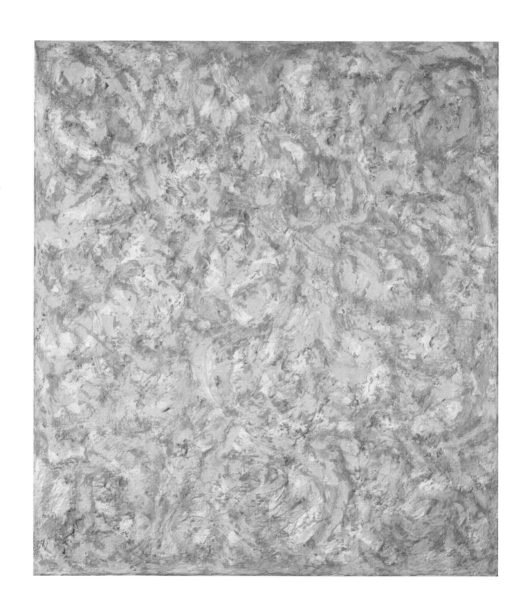

Richard Serra, *Solid #2*, 2007

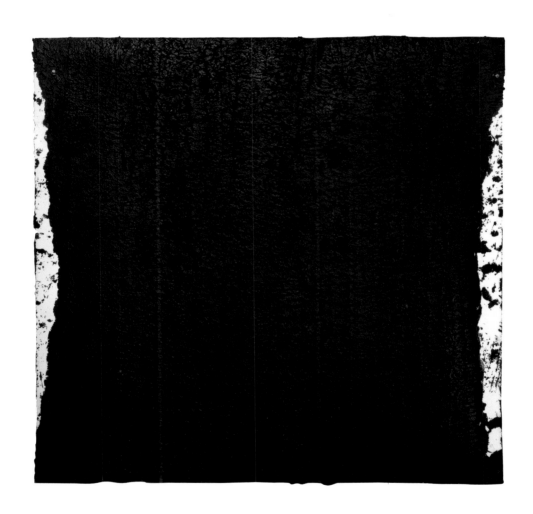

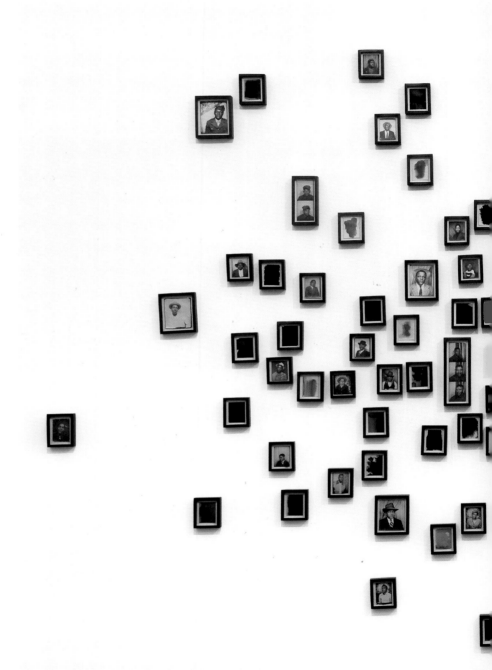

Lorna Simpson, *Photo Booth*, 2008

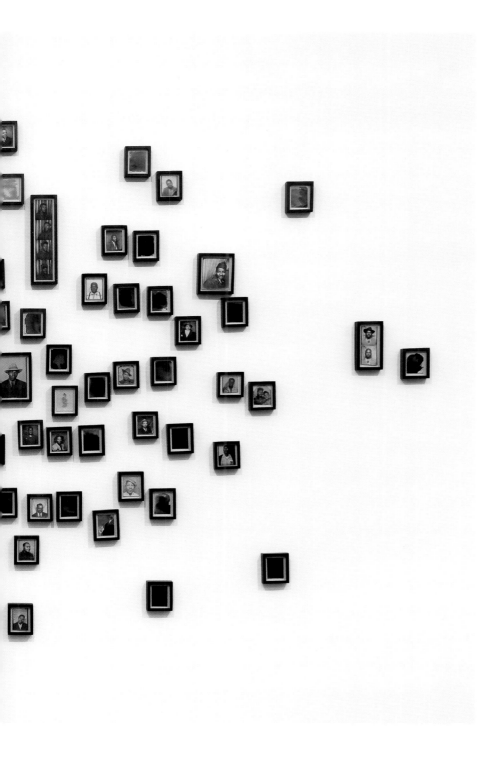

Above: Alighiero Boetti, *Incontri e Scontri*, 1988
Opposite: Alighiero Boetti, *Mappa*, 1990–91

Ad Reinhardt, *Abstract Painting No. 5*, 1962

Amazing Grace: A Life of Beauford Delaney

David Leeming

James Baldwin had been in Istanbul for several months working on a novel. I was working for him as a secretary-assistant and in June he sent me to New York with part of his manuscript. On the way back I planned to stop in Paris to take delivery of a car I had bought. Baldwin asked that I collect a friend named Richard in London on my way to Paris and that in Paris I pick up Beauford Delaney. I knew Richard as an eccentric young poet of American-Russian-English ancestry whom Baldwin had met in London earlier in the year. I had only heard of but not met Beauford and asked Baldwin to describe him: "He's a cross between Brer Rabbit and St. Francis of Assisi," he said and sent me on my way.

On July 1, having deposited Richard with a cousin of his in Paris and picked up my car, I made my way to 53 rue Vercingétorix. I found a Zolaesque courtyard guarded by an ancient female concierge dressed in black. She pointed to the corner entryway when I asked for M. Delaney and I climbed several stories, passing dark, sour smelling corridors before reaching the landing on which there was a door with a note announcing in bold script, "Welcome David." Clearly Jimmy had warned his friend of my coming. I knocked on the door and a soft, musical voice answered, "Come in, David." The vision that greeted me can only be called mysterious. There was whiteness everywhere—the walls and furniture were covered with sheets and the carrier of the voice was dressed in a white shirt and white trousers; in the midst of all that whiteness was a round, dark, quizzical but smiling face illumined by the yellow sunlight that poured through the large window. I thought of Baldwin's description, and of St. Francis in his hermitage. After his greeting, Beauford's first words to me were, "Won't you lie down." Somehow at the time the suggestion, accompanied by a gentle movement of one hand toward a sheet-draped cot along the wall, did not seem strange. I immediately lay down on the cot and Beauford reclined on the one in line with mine along the east wall.

Essentially we stayed head to head on those cots for three days and nights except for visits to the latrine in the outside corridor and brief moments of canned tuna nourishment. Sometimes we slept, but when we did not we talked. Beauford knew why I was there but he had no intention of getting into a car with me to drive anywhere until he knew who I was and I knew who he was. Day and night had little effect on our interview—sometimes Beauford's soft voice came out of the darkness, sometimes out of the light. We talked about everything—our childhoods, our loves, our work, Baldwin, the artist's difficult quest for survival. We talked about life as an "apprenticeship" rather than an end, about the works of Proust, about Zen. Beauford's was a sad but loving voice—soft, with a slight southern melody to it; it was a voice that probed difficult and even painful places. When the three days were over and Beauford said, "Shall we go to Jimmy now?"—as if he were across the street—I felt at once exhausted and somehow sated, as if we had had three days and nights of energetic intimacy. Before leaving I asked to see the paintings and when the sheets were lifted was given my first showing of the art of Beauford Delaney—an amazing profusion of yellow abstractions intermingled with extraordinary portraits whom the painter identified as Walter Anderson, James Baldwin, Bernard Hassell, and many others.

We picked up Richard and started out. The trip was a terrifying experience. I had been told nothing of Beauford's paranoia, and his "voices" had not been included in our three-day conversation. The first day and night were fine, if a bit bizarre because of Richard's cries of appreciation for odd objects he noticed along the road—old shoes, discarded cans and tires. Beauford smiled at these remarks; if I had read Baldwin's introduction to the Lambert show I would have tried to find the "light" in those objects as well.

The first real trouble came in Yugoslavia after a difficult border crossing—difficult because the customs officials were upset by Richard's voided British passport containing his picture at age six and because we were an unlikely trio, probably importing drugs. As we drove along the road Beauford, sitting next to me in the front seat, asked in his usual quiet voice, "Did you hear what they said?" When I inquired "Who?" Beauford pointed back at the car that just passed us. Trained in the processes of blind reason by years of schooling, I pointed out that, given the fact of two cars traveling at sixty miles an hour in opposite directions with the windows closed and that the people in the other car were almost certainly speaking Serbo-Croatian if they were speaking anything, Beauford could have heard nothing at all.

"Maybe you didn't hear them, but I did."

"OK, what did they say?"

"They said, 'Look at that old black faggot driving with those two white boys'."

"Those people were Yugoslavian, Beauford."

"I don't care what they were; that's what they said, and I'm getting out."

I managed to grab Beauford by the arm before he could do just that, the car now speeding along with the door unlatched.

That night the three of us fell asleep early on cots lined up side by side in a transit passengers' dormitory containing perhaps twelve cots for several other men. When I awoke later to find Beauford gone I suddenly understood something strange Baldwin had said before I left Istanbul. "Don't lose him," he urged, "just don't lose him."

Outside in the village square I found my charge—now clearly Brer Rabbit—accusing the confused but somewhat angry Yugoslavian villagers of trying to kill him. I took Beauford back into the dormitory and did the only thing, short of tying him up, I could do both to sleep and not "lose" him again. I got into his cot with him and together, in each other's arms, we held off the voices, which by now I had begun to hear, too. I wondered what kind of picture we must have made to the men staring at us the next morning—an elderly black man of 65 and a white man of 29 (who looked 18) wrapped in each other's arms in bed. No one seemed to care, however, and we finally arrived in Istanbul on July 7.

For several days Beauford continued to be disoriented and could only sleep if I lay with him—as a platonic lover, but certainly as a lover; by then I loved him as I had rarely loved anyone. I had seen him as St. Francis, witnessed him as Brer Rabbit, and had listened to his voices with him and no longer doubted their reality. Clearly James Baldwin had sent me to Beauford Delaney hoping that through contact with him I would learn directly a lesson I could not learn in books about the loneliness and pain brought about by sexual and racial deprivation and bigotry.

During the stay in Istanbul Beauford gradually regained his equilibrium. He loved living with Jimmy, Richard, and me in the little house on the Bosphorus. There were nights out eating *meze* with Baldwin's and my circle of friends—including singer Bertice Redding, who was in town. Beauford sang spirituals and the blues with Bertice, and he smoked Turkish cigarettes with special pleasure. He painted portraits of us all (see Color Plate 15 and the portrait of the author on the jacket), did watercolors of the hills of Asia across the straits, bestowed a much needed aura of peace on the usually tumultuous Baldwin scene, and became an object of veneration among our Turkish friends, who would come to him each afternoon as to a wise guru. Beauford loved everything he saw: "Being in Turkey is more exciting to me than being in Venice … there are ancient essences … the weather and the light are beyond my power to resist" (to Miller, July 27, 1966).

Baldwin and I, followed by several carloads of Delaney admirers, took Beauford to the plane to fly back to Paris at the end of August. He left sadly, carrying a kilim and several tiles and copper pots given him by new Turkish friends. I saw Beauford only one more time after that, at the end of December 1967 when my wife and I took him, at his request, to one of Josephine Baker's many farewell concerts at the Olympia in Paris. We corresponded until the early 1970s.

Voices/Forces

Fred Moten

Voices/Forces

Here's the instrument as small band: Beauford Delaney, Antonin Artaud, Billy Strayhorn.

> Time became different—not just an hour by the clock but a mysterious aliveness from the tips of your toes to the top of your head, touching everything and everyone. This began to be Paris for me. The dilemma of the human experience never lost its sorrow or joy; it simply had a way of existing for long periods immune to both, and all as if one was moving along a musical score to the orchestration of a complete poem of the emotions, hearing and living the music of the place called Paris.[1]

> Insane asylums are conscious and premeditated receptacles of black magic, and it is not only that doctors encourage magic with their inopportune
> and hybrid therapies,
> it is how they use it.[2]

> … a week in Paris will ease the bite of it …[3]

The idea of the avant-garde is embedded in a theory of history. This is to say that a particular geographical ideology, a geographical-racial or racist unconscious, marks and is the problematic out of which or against the backdrop of which the idea of the avant-garde emerges. The specter of Hegel reigns over and animates this constellation. His haunting, haunted formulations constitute one of the ways racism produces the social, aesthetic,

political-economic, and theoretical surplus that is the avant-garde. There is a fundamental connection between the (re)production and performance of the surplus and the avant-garde.[4] This connection is bound to others or operates in a cumulative, ruptural unity with other such connections, the most crucial of which is that between fetishization and the avant-garde or, more precisely, between certain reconstructions of the theory of value (more precisely, an irruption of the foundations of the science of value, an epistemological break and sexual cut that arises in the middle of the nineteenth century as the codification of aesthetic and political energies that emerge out of the specific condition of possibility of modernity, namely, European colonialism) and chattel slavery. This relation of fetishization to the avant-garde must be thought with some precision. It must be situated in relation to a universalization of ritual that rears its head in the invocation of roots or of tradition or interculturalism or appropriation, all of which are made possible by the ongoing development of Northern hegemony. Such invocation unsurprisingly occurs in an era imprecisely characterized as post-cold war (where the nature of the cold war has never or only vaguely been thought) or *newly* globalized (where globalization is thought, somehow, as other than what it has actually been up to now, "a strategy for maximum exclusion," as Masao Miyoshi says). This is to say that the conditions necessary for the production of the surplus remain, that the remainder remains and not only in and as the effects of reproduction. Precision demands that in the encounter with a series of graphic reproductions we *listen*.

What I've been specifically interested in here is how the idea of a black avant-garde exists, as it were, oxymoronically—as if black, on the one hand, and avant-garde, on the other hand, each depends for its coherence upon the exclusion of the other. Now this is probably an overstatement of the case. Yet it's all but justified by a vast interdisciplinary text representative not only of a problematically positivist conclusion that the avant-garde has been exclusively Euro-American, but of a deeper, perhaps unconscious, formulation of the avant-garde as necessarily not black. Part of what I'm after now is this: an assertion that the avant-garde is a black thing (that, for the sake of argument, Richard Schechner wouldn't understand) and an assertion that blackness is an avant-garde thing (that, for the sake of argument, Albert Murray wouldn't understand).

For Murray, the avant-garde is fundamentally determined by its expendability.[5] Focusing on the military connotations of the term, Murray understands the avant-garde as continually submitting itself to a sacrificial experimentalism whose value exists only in what it opens for and echoes of what is essential to the tradition. In his case the tradition is a certain convergence of black cultural expression and a Malrauxvian "museum without walls," the location of a distilled, cross-cultural, aesthetic, and political universality that both culminates in and is saved by America, the apotheosis of the West, and blackness, the West's most iconic creation.

Meanwhile, Schechner invests in a formulation of the end of the avant-garde, one structured by the absence or impossibility of the new in the face of a technologically induced exhaustion, a malaise brought on by a general inability to escape the strictures of reproduction, of the fetishization and commodification reproduction fosters.[6] And further, in the spirit of contemporary American triumphalism wherein the end of the avant-garde is an effect and echo of the end of ideology, Schechner says, who cares if no other Artaud comes along. One can only imagine that Murray would say amen. I want to think about why it is that we ought to care about the (second or ongoing) coming (upon) of the avant-garde. To do this I need to try to fill in Schechner's outline of the historical avant-garde, disturb the borders of Murray's conception of blackness, and stage an encounter between Artaud and some others that follow and anticipate him.

This requires a trip to Paris. The trip moves by way of Harlem and the Village, by way of the out extension of renaissance. Actually, the trip has an uncountable number of points of embarkation, none of which is originary, and is made on a railroad both aleatory and underground. Finally, the destination is also subject to cut and augmentation. This requires a trip through Paris.

This is when Harlem is no longer a point of arrival. This constellation is initially marked by a particular black modernist response to the capital of national cosmopolitanism-in-primitivism, Paris. But this response is itself understood as the echo or recording of other, earlier migrations, arrivals, or (re)births. This mode of response is exemplified by Delaney and his work, his movement in the multiply sited encounter between the European and African diasporas. In Delaney's case (as in every other), one site of this encounter (in his case Paris, and the exilic or expatriate movement to it) is always prefigured. Similarly, the natal occasion such an encounter represents is always anticipated. Paris and the movement to Paris echoes Greenwich Village and the movement to Greenwich Village, itself the repetition with differences of Harlem, Boston, Knoxville, Tennessee, and on and on, always, finally, before even Delaney himself. In spite of the uncountable instances of such geographic activity, this encounter is most often conceived of as driven by an agency that moves in only one direction. Whereas a powerful strain of postcolonial theory structures itself as *the reversal* of that direction and its gaze, I'm interested in the discovery of a necessary *appositionality* in this encounter, an almost hidden step (to the side and back) or gesture, a glance or glancing blow, that is the condition of possibility of a genuine aesthetic representation and analysis—in painting and prose—of that encounter.

Something in Delaney's Parisian paintings and autobiographical writings helps to illuminate the necessary connection between black political reason, the possibility of a cosmopolitan and/or geopolitical aesthetic and the rehabilitation of the very idea of the avant-garde. This connection is often and most interestingly made at the site of emergence of what he alternatively called voices and forces, the painted sounds of the thought of the outside, the visual

manifestation of phonic substance and the content it bears, the disruption of the border between what could be thought as a debilitating psychic, political, and sexual illness, on the one hand, and—with regard to these same categories—an enabling and invaginative health, on the other. I'm interested in how what might be thought as the merely gestural is given as the *appositional force* that manifests itself in Delaney's paintings and texts as irreducible phonic substance, vocal exteriority, the extremity that is often unnoticed as mere accompaniment to (reasoned) utterance. To refer to this exteriority, after, say, Artaud, simply as madness is no longer possible. Madness is, rather, that understanding of Artaud that moves outside of any reference to Delaney, to their mediated, seemingly impossible encounter. Their encounter is one of space-time separated coincidence and migrant imagination, channels of natal prematurity as well as black rebirth, modernism as intranational as well as international relocation, and the politico-aesthetics of a surplus of content irreducible to identity in or for itself, but held, rather, in identity's relation to a general upheaval. So that this is about the force that animates and awaits release from texts and canvases that represent the itineraries and locales of modernism and modernity.

Is Harlem a privileged place in this chain of renaissance? One must consult Billy Strayhorn here. Strayhorn, with a song called "Lush Life" among a good bit of other compositions he'd penned in his hometown of Pittsburgh, arrives in Harlem around 1940, roughly a decade after Delaney exited the train from Boston there before quickly moving down to the Village. And though Delaney's destinations required taking the A-train in the direction opposite to that which Strayhorn famously recommends, their connection is crucial specially at the site of a certain dream of Paris, even if, for Strayhorn, the dream is only of a week, rather than a more permanent sojourn, in Paris. Of course Delaney and Strayhorn—whose name is so suggestive especially when we hear him sing, the outness or uncontrollability of his voice or horn, itinerant, stray like the brass and winds of Ellington's (and Strayhorn's) "instrument"—share (according to their biographers) in the outness of their (homo)sexuality and their movements, on the A-train and more widely, as "Lush Life" suggests, what it is to be driven by the paradoxically hidden extremity and necessary unrequitedness of love.[7] They are driven to and by a fugitivity that, according to Nathaniel Mackey, is disruptively essential to the music that Delaney's paintings will strive to represent, most especially by way of abstraction, most fundamentally in what might be called a kind of glossolalian application of paint to the canvas. One thinks here, too, of a chain of surplus spellings and christenings (De Laney, Strayhorne) that moved in some space-time separated synchrony with that of Artaud, who signed certain letters—like one, for instance, to the doctor who treated him during his long confinement at the mental institution in Rodez, France, Gaston Ferdière, about whom more in a minute—"Antonin Nalpas," the fictional surname here being the maiden name of his mother, given as if somehow more originary, marking something like that final and impossible return that Ellington points to in the title of his

tribute album for Strayhorn, *And His Mother Called Him Bill*. Such renaming also marks a propensity to wander or migrate or stray that is always animated by desire. Think of James Baldwin, Delaney's protégé and object of desire, following Delaney's move from or through Harlem to the Village as the prefiguring of Delaney's following Baldwin to Paris; or think of those hushed voices, about which more in a minute, that later, on the road to Istanbul, in the midst of another tracing of Baldwin's steps, Delaney will overhear as he rides in the back seat of a car. Those voices emanate from a car whose path Delaney and some companions crossed somewhere in Yugoslavia. The car sped toward the one in which Delaney was riding and somehow he heard its passengers, always already translated, say "Look at that little black faggot riding with those two white boys".[8]

Gaston Ferdière was Beauford Delaney's doctor, too. Delaney's biographer, who is also Baldwin's biographer, David Leeming, informs us:

> On December 20 [1961] Solange du Closel and her husband drove Beauford to the Nogent clinic where he was placed under the care of the well-known psychiatrist Dr. Ferdière, whose specialty was depression. Ferdière quickly confirmed the diagnosis of acute paranoia and gave Beauford anti-depressant medicine that stopped the hallucinations. He warned Beauford that alcohol would negate the benefits of the treatment. Ferdière spoke English and had a good knowledge of painting and the arts—he had treated the mental disorders of the dramatist Antonin Artaud and had written a book critical of the handling of Vincent Van Gogh's depression.[9]

Delaney, Strayhorn, and Artaud share some transatlantic maternal machinery (as Artaud might say). Forces. Voices. Leeming records them for us in his citation of Delaney's 1961 journals, written, at Ferdière's prescription, as part of Delaney's therapy. I want to refer to two passages from that journal and argue for their interconnection. In the first, Delaney recalls his beloved older sister, Ogust Mae, whom he lost when she was only nineteen; in the second, Delaney thinks the relation between his paintings and black music:

> Sister was older than me and we were very close. As we grew older there were ever increasing needs for money and mama began to go out in service cooking, or nursing, or being a general housekeeper which meant that Sister with our help had to carry on at home. She was very bright and good natured, although her health was frail, and we were devoted to her and tried in our clumsy way to save her, but we did not know how, we were all so young and so unaware of the pain and unspoken intensity of our home and community life. Sister was full of fun and in no way pretentious—she sang

beautifully—it was a joy to hear her. Mama being away from home, all her chores fell upon Sister who never complained—but she was always sick. We became alarmed because [from] the first time the doctor came it was always something the matter with Sister. Mama would would quit her job and come home, the house became very quiet and we were awake all night [talking] in hushed voices in fear for Sister's recovery. She was strong willed and survived most difficulties and would seem to be well and we would rejoice. So much of the sickness [Ogust Mae's and others] came from improper places to live—long distances to walk to school improperly heated—a walk twice a day [they came home for lunch]—too much work at home—natural conditions common to the poor that take the bright flowers like terrible cold in nature.[10]

Life in Paris gives me an anonymity and objectivity to release long stored up memories of [the] beauty and sorrows of the difficult work of orchestrating and releasing into a personal form of color and design what seems to me a long apprenticeship to jazz and spiritual songs augmented by the deep hope given to my people in the deep south at home. I gave myself to these experiences devotedly.[11]

With gratitude for his recovery of this text, one moves against or through Leeming's seemingly necessary bracketed interpolations and the primacy of interpretation, of the imposition of meaning, they imply. Listen to the sentence break or break down after the invocation of Sister's singing. That breakdown is not the negative effect of grammatical insufficiency but the positive trace of a lyrical surplus, counterpart to a certain tonal breakdown heard in Strayhorn's performance of "Lush Life" when the word "madness" is uttered with some uncontrollable accompaniment, the internal exteriority of a voice which is and is not his own. It is the possession of Delaney's text by Ogust Mae and all of that for which she substitutes. We've got to think, then, what it means to "lay awake all night in hushed voices," think the political implications and history of the primal overhearing of a phonic materiality always tied to the ongoing loss or impossible recovery of the maternal. Leeming will go on to discuss what he records Delaney as sometimes calling "my forces," pointing out that these voices/forces were in existence as far back as the Knoxville of Delaney's boyhood, but they are indexed to an already existing kernel of the illness which becomes more and more insistent in Delaney and which will prompt, finally, the text above.[12] At the same time, the voices/forces also emerge, according to Leeming, as the concrete form of and response to a compartmentalization of Delaney's life that became increasingly severe over the course of his migrations and their punctuation in interracial and homosexual encounters. But the materiality of these voices not only exists before any development or decay purely internal to Delaney, it is irreducible to Delaney's illness as well. This black-

advanced surplus is sexual and paranoid light and multiplied thick color, impasto—the laying on of color thickly, one possible painterly equivalent of something Mackey, with reference to Eric Dolphy, refers to as the "multiply tongued," something generally thought, in relation to Artaud, as glossolalia. This music is not only the "last resort" of "wounded kinship," but is also, precisely as that last resort, the emergence from broken matrilinearity of an insistent reproductive *mater*iality. And we know how the long apprenticeship to the black music that the paintings represent is a long apprenticeship to the *mater*iality of voices that the music represents. You should listen to Strayhorn represent right now.[13]

> ... *not once more will/I be found with beings/who swallowed the rail of life//And one day I found myself with beings/who swallowed the nail of life/—as soon as I lost my matrix mamma,//and the being twisted under him,/and god poured me back to her/(the motherfucker)* ...[14]

> I used to go to all the very gay places/those come what may places/ relaxing on the axis of the wheel of life/to get the feel of life.[15]

Impasto and glossolalia. Hearing the painting, Artaud is not formless. And the surplus in Strayhorn: too much rhyme (as in "Ci-git" but Strayhorn's performance—live, recorded, him now "dead" as if this weren't that very deconstruction of or improvisation through the opposition of life and death, that silent, surplus e) but the voice is all over, strained or fragile till strong g doubles up with and like the bass—the quickened disruption of the irreducible phonic substance, which is where universality lies. Here lies universality: in this break, this cut, this rupture. Song cutting speech. Scream cutting song. Frenzy cutting scream with silence, movement, gesture. The West is an insane asylum, a conscious and premeditated receptacle of black magic. Every disappearance is a recording. That's what resurrection is. Insurrection. Scat black magic, but to scat or scatter is not to admit formlessness. The aftersound is more than a bridge. It ruptures interpretation even as the trauma it records disappears. Amplification of a rapt countenance, stressed portraiture. No need to dismiss the sound that emerges from the mouth as the mark of a separation. It was always the whole body that emitted sound: instrument and fingers, bend. Your ass is in what you sing. Dedicated to the movement of hips, dedicated by that movement, the harmolodically rhythmic body. Artaud's description of torture in Maryland was published in 1845, mama's gone.

What if we understand the geographical history of the New York avant-garde chorographically, by way of the turning point? We could think it choreographically, bringing the aesthetic back on line, by way of a rhythm analysis that would inject some choreographic play of encounter into our

analytic, making certain folks meet in the city. Turning point might then become vanishing point, where the absent presence of the performance becomes the absent and structuring center of perspectival urban space. We could think this in relation to the desire for bohemian space and the way that desire is activated in and as the displacement of the ones who had been there. Such displacement is the carryover of those regimes of property from whence certain avant-garde Puritans had fled as the silencing of that internal antinomian difference that will have always been both the renewal, expansion, invagination of the avant-garde and the recrudescence of enclosure and all that cuts it, before the fact of another mode of thinking that might be structured by and as a collaboration with what and who had been there before. This is the spatial politics of the avant-garde. This is to say that the avant-garde is not only a temporal-historical concept but a spatial-geographical concept as well. Again, Hegel would have understood this. Constraint, mobility, and displacement are, therefore, conditions of possibility of the avant-garde. Deterioration is crucial to the avant-garde, as well: as a certain aesthetics, as an effect of disinvestment, as a psychic condition: the decay of form and the internal and external environment of regenerative aesthetic production: turning, vanishing, enclosing, invaginating.[16]

But there's re*mater*ialization of bourgeois space-time that is also what and where the avant-garde is. This avant-garde disrupts the phantasmatically solipsistic space of bourgeois aesthetic production and reception with some brought noise, voices/forces, mobilizing through enforced hermeticisms. And this works with but also outside of Alain Locke's formulation of a black migratory modernity; not outside but past. And so a second and third move is what interests me here: a certain movement through Harlem and beyond renaissance, a post-maturity of rebirth and removal, to Bohemia, to the Village, to Paris. Beauford Delaney exemplifies not only this move but another, the outest move of all, with and to and through Artaud you might say. This move could be thought as what Billy Strayhorn imagined: lush life as its own antidote, Paris refigured as a kind of bright magic mountain. But all this movement is not simply felicitous. To move further and further into the heart of lightness, the city of light, is to more fully immerse oneself in the vast asylum of the West, "a conscious and premeditated receptacle of black magic." Still, something is given off in these encountering migrations, the gesture in sound or the sound in painting of another liberty awaiting activation, the politico-economic, ontological, and aesthetic surplus. Such production—such radically ensemblic, radically improvisational objection—is the unfinished, continually re-en-gendered, actively re-en-gendering project of the black (and blue and sentimental) avant-garde.

NOTES
1. Quoted in David Leeming, *Amazing Grace: A Life of Beauford Delaney* (New York: Oxford University Press, 1998), 112.
2. Antonin Artaud, "Artaud the Mômo," in *Watchfiends & Rack Screams: Works from the Final Period*, ed. and trans. Clayton Eshleman with Bernard Budor (Boston: Exact Change, 1995), 161.

3. Billy Strayhorn, "Lush Life," Tempo Music, 1936.

4. I make this assertion by way of Randy Martin's brilliant work in *Critical Moves* (Durham, N.C.: Duke University Press, 1998). On pp. 205–6 he writes: "By extending a productionist model to domains not generally associated with an economy oriented toward exchange, I want to take seriously Marx's understanding of capitalism. He treats it as forcibly constituting, by the very organizing boundaries it erects and then transgresses, in pursuit of increasing magnitudes of surplus, the global collectivity, the 'combination, due to association,' that he understood as the socialization of labor. The extension of Marx's concept of socialization to a widening range of practices deepens rather than detracts from the power and aims of his analysis. To take the production of surplus seriously in these other domains should not reduce practices to mere instruments of the ends of domination where race, gender, or sexuality are in turn nothing more than products in a profit-taking market. Rather, the emphasis on surplus identifies what is productive in race, gender, and sexuality such that the proprietary claims of the dominant position in each system are exposed as emerging only through what dominance subordinates through appropriation. The unacknowledged dependence recurs along different dimensions of dominance on what it subordinates through appropriation. This dependency of the dominant is one reason that whiteness is both the hatred of and the desire for blackness, that misogyny aspires to the rape and the reverence of the feminine, and that homophobia is the rejection of sameness and the need for it. In short, the appropriation not only produces the divide between dominance and subalternity but also the demand for further appropriation as a very condition of social reproduction. That race, class, gender, and sexuality, as the very materiality of social identity, are also produced in the process indicates the practical generativity—the ongoing social capacity to render life as history—necessary for any cultural product. Therefore, it is not that a productionist approach assigns race, class, gender, and sexuality the same history, political effects, or practical means. Instead, this approach is intended to imagine the context for critical analysis that would grant these four articulating structures historicity, politics, and practice in relation to one another, that is, in a manner that is mutually recognizable.

"To speak of practices rather than objects of knowledge as what disciplines serve privileges the capacity for production over the already given product-object as a founding epistemological premise. The focus on practices also allows production to be named historically so as to situate it with respect to existing political mobilizations. If the older set of disciplinary formations constantly had to ask, 'Knowledge for what?' it was because the autonomy of knowledge from other social relations was assumed. The practices of cultural studies imply commitments that are constitutional to knowledge as such and can therefore be used to ask how one set of practices could be articulated with another."

I would briefly add a couple of small formulations:

· The epistemological shift that Marx allows, wherein practices are thought as if for the first time, as if in eclipse of objects, can itself be thought as an irruption of or into the sciences of value. The black avant-garde is an anticipatory manifestation of that shift/irruption.

· The black avant-garde works the second "as if" above in a specific way. The eclipse of objects by practices is a head, a necessary opening that vanishes here in the work of those who are not but nothing other than objects themselves. (Black) performance is the resistance of the object and the object is in that it resists, is in that it is always the practice of resistance. And if we understand race, class, gender, and sexuality as the materiality of social identity, as the surplus effect (and cause) of production, then we can also understand the ongoing, resistive force of such materiality as it plays itself out in/as the work of art. This is to say that these four articulating structures must be granted not only historicity, politics, and practice, but aesthesis as well. This is also to say that the concept of the object of performance studies is (in) practice precisely at the convergence of the surplus (in all the richness with which Martin formulates it—as, in short, the ongoing possibility or hope of a minoritarian insurgence that would be keyed to Deleuze and Guattari, on the one hand, and, say, Adrian Piper, on the other) and the aesthetic.

5. This paraphrases remarks of his given at a meeting of the Ford Foundation Jazz Study Group at Columbia University in 1999.

6. In an essay called "The Five Avant-Gardes Or ... Or None," in *The Twentieth-Century Performance Reader*, ed. Michael Huxley and Noel Witts (New York: Routledge, 1996), 308–25.

7. Leeming and, in Strayhorn's case, David Hajdu. See Hajdu's *Lush Life: A Biography of Billy Strayhorn* (New York: North Point Press, 1996).

8. Leeming, *Amazing Grace*, 169.

9. Ibid., 151.

10. Ibid., 12–13.

11. Ibid., 157.

12. Ibid., 143.

13. Check his own version of the song—he accompanies his voice on piano, but there is already an interior accompaniment of the voice—recorded live at Basin Street East, New York City and released as Billy Strayhorn, "Lush Life," rec. 14 January 1964, *Lush Life*, Red Baron, 1992.

14. Artaud, "Ci-gît/Here Lies," *Watchfiends & Rack Screams*, 211.

15. Strayhorn, "Lush Life."

16. I mean to place in some sort of resonant relation to one another the following texts: Neil Smith, Betsy Duncan, and Laura Reid, "From Disinvestment to Reinvestment: Mapping the Urban 'Frontier' in the Lower East Side," in *From Urban Village to East Village: The Battle for New York's Lower East Side*, ed. Janet L. Abu-Lughod et al. (Oxford: Blackwell Publishers, 1994), 149–67; Susan Howe, "Incloser," in *The Birth-Mark: Unsettling the Wilderness in American Literary History* (Hanover, N.H.: University Press of New England, 1993), 43–86; and Marcia B. Siegel, *At the Vanishing Point: A Critic Looks at Dance* (New York: Saturday Review Press, 1972).

Stranger in the Village

James Baldwin

From all available evidence no black man had ever set foot in this tiny Swiss village before I came. I was told before arriving that I would probably be a "sight" for the village; I took this to mean that people of my complexion were rarely seen in Switzerland, and also that city people are always something of a "sight" outside of the city. It did not occur to me—possibly because I am an American—that there could be people anywhere who had never seen a Negro.

It is a fact that cannot be explained on the basis of the inaccessibility of the village. The village is very high, but it is only four hours from Milan and three hours from Lausanne. It is true that it is virtually unknown. Few people making plans for a holiday would elect to come here. On the other hand, the villagers are able, presumably, to come and go as they please—which they do: to another town at the foot of the mountain, with a population of approximately five thousand, the nearest place to see a movie or go to the bank. In the village there is no movie house, no bank, no library, no theater; very few radios, one jeep, one station wagon; and, at the moment, one typewriter, mine, an invention which the woman next door to me here had never seen. There are about six hundred people living here, all Catholic—I conclude this from the fact that the Catholic church is open all year round, whereas the Protestant chapel, set off on a hill a little removed from the village, is open only in the summertime when the tourists arrive. There are four or five hotels, all closed now, and four or five *bistros*, of which, however, only two do any business during the winter. These two do not do a great deal, for life in the village seems to end around nine or ten o'clock. There are a few stores, butcher, baker, épicerie, a hardware store, and a money-changer—who cannot change travelers' checks, but must send them down to the bank, an operation which takes two or three days. There is something called the *Ballet Haus*, closed in the winter and used for God knows what, certainly not ballet, during the summer. There seems to be only one schoolhouse in the village, and this for the quite young children;

I suppose this to mean that their older brothers and sisters at some point descend from these mountains in order to complete their education—possibly, again, to the town just below. The landscape is absolutely forbidding, mountains towering on all four sides, ice and snow as far as the eye can reach. In this white wilderness, men and women and children move all day, carrying washing, wood, buckets of milk or water, sometimes skiing on Sunday afternoons. All week long boys and young men are to be seen shoveling snow off the rooftops, or dragging wood down from the forest in sleds.

The village's only real attraction, which explains the tourist season, is the hot spring water. A disquietingly high proportion of these tourists are cripples, or semi-cripples, who come year after year—from other parts of Switzerland, usually—to take the waters. This lends the village, at the height of the season, a rather terrifying air of sanctity, as though it were a lesser Lourdes. There is often something beautiful, there is always something awful, in the spectacle of a person who has lost one of his faculties, a faculty he never questioned until it was gone, and who struggles to recover it. Yet people remain people, on crutches or indeed on deathbeds; and wherever I passed, the first summer I was here, among the native villagers or among the lame, a wind passed with me—of astonishment, curiosity, amusement, and outrage. That first summer I stayed two weeks and never intended to return. But I did return in the winter, to work; the village offers, obviously, no distractions whatever and has the further advantage of being extremely cheap. Now it is winter again, a year later, and I am here again. Everyone in the village knows my name, though they scarcely ever use it, knows that I come from America—though, this, apparently, they will never really believe: black men come from Africa—and everyone knows that I am the friend of the son of a woman who was born here, and that I am staying in their chalet. But I remain as much as a stranger today as I was the first day I arrived, and the children shout *Neger! Neger!* as I walk along the streets.

It must be admitted that in the beginning I was far too shocked to have any real reaction. In so far as I reacted at all, I reacted by trying to be pleasant—it being a great part of the American Negro's education (long before he goes to school) that he must make people "like" him. This smile-and-the-world-smiles-with-you routine worked about as well in this situation as it had in the situation for which it was designed, which is to say that it did not work at all. No one, after all, can be liked whose human weight and complexity cannot be, or has not been, admitted. My smile was simply another unheard-of phenomenon which allowed them to see my teeth—they did not, really, see my smile and I began to think that, should I take to snarling, no one would notice any difference. All of the physical characteristics of the Negro which had caused me, in America, a very different and almost forgotten pain were nothing less than miraculous—or infernal—in the eyes of the village people. Some thought my hair was the color of tar, that it had the texture of wire, or the texture of cotton. It was jocularly suggested that I might let it all grow long and make myself a winter coat. If I sat in the sun for more than five minutes some daring

creature was certain to come along and gingerly put his fingers on my hair, as though he were afraid of an electric shock, or put his hand on my hand, astonished that the color did not rub off. In all of this, in which it must be conceded there was the charm of genuine wonder and in which there was certainly no element of intentional unkindness, there was yet no suggestion that I was human: I was simply a living wonder.

I knew that they did not mean to be unkind, and I know it now; it is necessary, nevertheless, for me to repeat this to myself each time that I walk out of the chalet. The children who shout *Neger!* have no way of knowing the echoes this sound raises in me. They are brimming with good humor and the more daring swell with pride when I stop to speak with them. Just the same, there are days when I cannot pause and smile, when I have no heart to play with them; when, indeed, I mutter sourly to myself, exactly as I muttered on the streets of a city these children have never seen, when I was no bigger than these children are now: *Your* mother *was a nigger.* Joyce is right about history being a nightmare—but it may be the nightmare from which no one *can* awaken. People are trapped in history and history is trapped in them.

There is a custom in the village—I am told it is repeated in many villages—of "buying" African natives for the purpose of converting them to Christianity. There stands in the church all year round a small box with a slot for money, decorated with a black figurine, and into this box the villagers drop their francs. During the *carnaval* which precedes Lent, two village children have their faces blackened—out of which bloodless darkness their blue eyes shine like ice—and fantastic horsehair wigs are placed on their blond heads; thus disguised, they solicit among the villagers for money for the missionaries in Africa. Between the box in the church and the blackened children, the village "bought" last year six or eight African natives. This was reported to me with pride by the wife of one of the *bistro* owners and I was careful to express astonishment and pleasure at the solicitude shown by the village for the souls of black folk. The *bistro* owner's wife beamed with a pleasure far more genuine than my own and seemed to feel that I might now breathe more easily concerning the souls of at least six of my kinsmen.

I tried not to think of these so lately baptized kinsmen, of the price paid for them, or the peculiar price they themselves would pay, and said nothing about my father, who having taken his own conversion too literally never, at bottom, forgave the white world (which he described as heathen) for having saddled him with a Christ in whom, to judge at least from their treatment of him, they themselves no longer believed. I thought of white men arriving for the first time in an African village, strangers there, as I am a stranger here, and tried to imagine the astounded populace touching their hair and marveling at the color of their skin. But there is a great difference between being the first white man to be seen by Africans and being the first black man to be seen by whites. The white man takes astonishment as tribute, for he arrives to conquer and to convert the natives, whose inferiority in relation to himself is not even to be questioned; whereas I, without a thought of conquest, find myself among a people

whose culture controls me, has even, in a sense, created me, people who have cost me more in anguish and rage than they will ever know, who yet do not even know of my existence. The astonishment with which I might have greeted them, should they have stumbled into my African village a few hundred years ago, might have rejoiced their hearts. But the astonishment with which they greet me today can only poison mine.

And this is so despite everything I may do to feel differently, despite my friendly conversations with the *bistro* owner's wife, despite their three-year-old son who has at last become my friend, despite the *saluts* and *bonsoirs* which I exchange with people as I walk, despite the fact that I know that no individual can be taken to task for what history is doing, or has done. I say that the culture of these people controls me—but they can scarcely be held responsible for European culture. America comes out of Europe, but these people have never seen America, nor have most of them seen more of Europe than the hamlet at the foot of their mountain. Yet they move with an authority which I shall never have; and they regard me, quite rightly, not only as a stranger in their village but as a suspect latecomer, bearing no credentials, to everything they have—however unconsciously—inherited.

For this village, even were it incomparably more remote and incredibly more primitive, is the West, the West onto which I have been so strangely grafted. These people cannot be, from the point of view of power, strangers anywhere in the world; they have made the modern world, in effect, even if they do not know it. The most illiterate among them is related, in a way that I am not, to Dante, Shakespeare, Michelangelo, Aeschylus, Da Vinci, Rembrandt, and Racine; the cathedral at Chartres says something to them which it cannot say to me, as indeed would New York's Empire State Building, should anyone here ever see it. Out of their hymns and dances come Beethoven and Bach. Go back a few centuries and they are in their full glory—but I am in Africa, watching the conquerors arrive.

The rage of the disesteemed is personally fruitless, but it is also absolutely inevitable; this rage, so generally discounted, so little understood even among the people whose daily bread it is, is one of the things that makes history. Rage can only with difficulty, and never entirely, be brought under the domination of the intelligence and is therefore not susceptible to any arguments whatever. This is a fact which ordinary representatives of the *Herrenvolk*, having never felt this rage and being unable to imagine it, quite fail to understand. Also, rage cannot be hidden, it can only be dissembled. This dissembling deludes the thoughtless, and strengthens rage and adds, to rage, contempt. There are, no doubt, as many ways of coping with the resulting complex of tensions as there are black men in the world, but no black man can hope ever to be entirely liberated from this internal warfare—rage, dissembling, and contempt having inevitably accompanied his first realization of the power of white men. What is crucial here is that, since white men represent in the black man's world so heavy a weight, white men have for black men a reality which is far from being reciprocal; and hence all black men have toward all white men an

attitude which is designed, really, either to rob the white man of the jewel of his naïveté, or else to make it cost him dear.

The black man insists, by whatever means he finds at his disposal, that the white man cease to regard him as an exotic rarity and recognize him as a human being. This is a very charged and difficult moment, for there is a great deal of will power involved in the white man's naïveté. Most people are not naturally reflective any more than they are naturally malicious, and the white man prefers to keep the black man at a certain human remove because it is easier for him thus to preserve his simplicity and avoid being called to account for crimes committed by his forefathers, or his neighbors. He is inescapably aware, nevertheless, that he is in a better position in the world than black men are, nor can he quite put to death the suspicion that he is hated by black men therefore. He does not wish to be hated, neither does he wish to change places, and at this point in his uneasiness he can scarcely avoid having recourse to those legends which white men have created about black men, the most usual effect of which is that the white man finds himself enmeshed, so to speak, in his own language which describes hell, as well as the attributes which lead one to hell, as being as black as night.

Every legend, moreover, contains its residuum of truth, and the root function of language is to control the universe by describing it. It is of quite considerable significance that black men remain, in the imagination, and in overwhelming numbers in fact, beyond the disciplines of salvation; and this despite the fact that the West has been "buying" African natives for centuries. There is, I should hazard, an instantaneous necessity to be divorced from this so visibly unsaved stranger, in whose heart, moreover, one cannot guess what dreams of vengeance are being nourished; and, at the same time, there are few things on earth more attractive than the idea of the unspeakable liberty which is allowed the unredeemed. When, beneath the black mask, a human being begins to make himself felt one cannot escape a certain awful wonder as to what kind of human being it is. What one's imagination makes of other people is dictated, of course, by the laws of one's own personality and it is one of the ironies of black–white relations that, by means of what the white man imagines the black man to be, the black man is enabled to know who the white man is.

I have said, for example, that I am as much a stranger in this village today as I was the first summer I arrived, but this is not quite true. The villagers wonder less about the texture of my hair than they did then, and wonder rather more about me. And the fact that their wonder now exists on another level is reflected in their attitudes and in their eyes. There are the children who make those delightful, hilarious, sometimes astonishingly grave overtures of friendship in the unpredictable fashion of children; other children, having been taught that the devil is a black man, scream in genuine anguish as I approach. Some of the older woman never pass without a friendly greeting, never pass, indeed, if it seems that they will be able to engage me in conversation; other women look down or look away or rather contemptuously smirk. Some of

the men drink with me and suggest that I learn how to ski—partly, I gather, because they cannot imagine what I would look like on skis—and want to know if I am married, and ask questions about my *métier*. But some of the men have accused *le sale nègre*—behind my back—of stealing wood and there is already in the eyes of some of them that peculiar, intent, paranoiac malevolence which one sometimes surprises in the eyes of American white men when, out walking with their Sunday girl, they see a Negro male approach.

There is a dreadful abyss between the streets of this village and the streets of the city in which I was born, between the children who shout *Neger!* today and those who shouted *Nigger!* yesterday—the abyss is experience, the American experience. The syllable hurled behind me today expresses, above all, wonder: I am a stranger here. But I am not a stranger in America and the same syllable riding on the American air expresses the war my presence has occasioned in the American soul.

For this village brings home to me this fact: that there was a day, and not really a very distant day, when Americans were scarcely Americans at all but discontented Europeans, facing a great unconquered continent and strolling, say, into a marketplace and seeing black men for the first time. The shock this spectacle afforded is suggested, surely, by the promptness with which they decided that these black men were not really men but cattle. It is true that the necessity on the part of the settlers of the New World of reconciling their moral assumptions with the fact—and the necessity—of slavery enhanced immensely the charm of this idea, and it is also true that this idea expresses, with a truly American bluntness, the attitude which to varying extents all masters have had toward all slaves.

But between all former slaves and slave-owners and the drama which begins for Americans over three hundred years ago at Jamestown, there are at least two differences to be observed. The American Negro slave could not suppose, for one thing, as slaves in past epochs had supposed and often done, that he would ever be able to wrest the power from his master's hands. This was a supposition which the modern era, which was to bring about such vast changes in the aims and dimensions of power, put to death; it only begins, in unprecedented fashion, and with dreadful implications, to be resurrected today. But even had this supposition persisted with undiminished force, the American Negro slave could not have used it to lend his condition dignity, for the reason that this supposition rests on another: that the slave in exile yet remains related to his past, has some means—if only in memory—of revering and sustaining the forms of his former life, is able, in short, to maintain his identity.

This was not the case with the American Negro slave. He is unique among the black men of the world in that his past was taken from him, almost literally, at one blow. One wonders what on earth the first slave found to say to the first dark child he bore. I am told that there are Haitians able to trace their ancestry back to African kings, but any American Negro wishing to go back so far will find his journey through time abruptly arrested by the signature

on the bill of sale which served as the entrance paper for his ancestor. At the time—to say nothing of the circumstances—of the enslavement of the captive black man who was to become the American Negro, there was not the remotest possibility that he would ever take power from his master's hands. There was no reason to suppose that his situation would ever change, nor was there, shortly, anything to indicate that his situation had ever been different. It was his necessity, in the words of E. Franklin Frazier, to find a "motive for living under American culture or die." The identity of the American Negro comes out of this extreme situation, and the evolution of this identity was a source of the most intolerable anxiety in the minds and the lives of his masters.

For the history of the American Negro is unique also in this: that the question of his humanity, and of his rights therefore as a human being, became a burning one for several generations of Americans, so burning a question that it ultimately became one of those used to divide the nation. It is out of this argument that the venom of the epithet *Nigger!* is derived. It is an argument which Europe has never had, and hence Europe quite sincerely fails to understand how or why the argument arose in the first place, why its effects are so frequently disastrous and always so unpredictable, why it refuses until today to be entirely settled. Europe's black possessions remained—and do remain—in Europe's colonies, at which remove they represented no threat whatever to European identity. If they posed any problem at all for the European conscience, it was a problem which remained comfortingly abstract: in effect, the black man, *as a man*, did not exist for Europe. But in America, even as a slave, he was an inescapable part of the general social fabric and no American could escape having an attitude toward him. Americans attempt until today to make an abstraction of the Negro, but the very nature of these abstractions reveals the tremendous effects the presence of the Negro has had on the American character.

When one considers the history of the Negro in America it is of the greatest importance to recognize that the moral beliefs of a person, or a people, are never really as tenuous as life—which is not moral—very often causes them to appear; these create for them a frame of reference and a necessary hope, the hope being that when life has done its worst they will be enabled to rise above themselves and to triumph over life. Life would scarcely be bearable if this hope did not exist. Again, even when the worst has been said, to betray a belief is not by any means to have put oneself beyond its power; the betrayal of a belief is not the same thing as ceasing to believe. If this were not so there would be no moral standards in the world at all. Yet one must also recognize that morality is based on ideas and that all ideas are dangerous—dangerous because ideas can only lead to action and where the action leads no man can say. And dangerous in this respect: that confronted with the impossibility of remaining faithful to one's beliefs, and the equal impossibility of becoming free of them, one can be driven to the most inhuman excesses. The ideas on which American beliefs are based are not, though Americans often seem to think so, ideas which originated in America. They came out of Europe. And

the establishment of democracy on the American continent was scarcely as radical a break with the past as was the necessity, which Americans faced, of broadening this concept to include black men.

This was, literally, a hard necessity. It was impossible, for one thing, for Americans to abandon their beliefs, not only because these beliefs alone seemed able to justify the sacrifices they had endured and the blood that they had spilled, but also because these beliefs afforded them their only bulwark against a moral chaos as absolute as the physical chaos of the continent it was their destiny to conquer. But in the situation in which Americans found themselves, these beliefs threatened an idea which, whether or not one likes to think so, is the very warp and woof of the heritage of the West, the idea of white supremacy.

Americans have made themselves notorious by the shrillness and the brutality with which they have insisted on this idea, but they did not invent it; and it has escaped the world's notice that those very excesses of which Americans have been guilty imply a certain, unprecedented uneasiness over the idea's life and power, if not, indeed, the idea's validity. The idea of white supremacy rests simply on the fact that white men are the creators of civilization (the present civilization, which is the only one that matters; all previous civilizations are simply "contributions" to our own) and are therefore civilization's guardians and defenders. Thus it was impossible for Americans to accept the black man as one of themselves, for to do so was to jeopardize their status as white men. But not so to accept him was to deny his human reality, his human weight and complexity, and the strain of denying the overwhelmingly undeniable forced Americans into rationalizations so fantastic that they approached the pathological.

At the root of the American Negro problem is the necessity of the American white man to find a way of living with the Negro in order to be able to live with himself. And the history of this problem can be reduced to the means used by Americans—lynch law and law, segregation and legal acceptance, terrorization and concession—either to come to terms with this necessity, or to find a way around it, or (most usually) to find a way of doing both these things at once. The resulting spectacle, at once foolish and dreadful, led someone to make the quite accurate observation that "the Negro-in-America is a form of insanity which overtakes white men."

In this long battle, a battle by no means finished, the unforeseeable effects of which will be felt by many future generations, the white man's motive was the protection of his identity; the black man was motivated by the need to establish an identity. And despite the terrorization which the Negro in America endured and endures sporadically until today, despite the cruel and totally inescapable ambivalence of his status in his country, the battle for his identity has long ago been won. He is not a visitor to the West, but a citizen there, an American; as American as the Americans who despise him, the Americans who fear him, the Americans who love him—the Americans who became less than themselves, or rose to be greater than themselves by virtue of the fact that the

challenge he represented was inescapable. He is perhaps the only black man in the world whose relationship to white men is more terrible, more subtle, and more meaningful than the relationship of bitter possessed to uncertain possessor. His survival depended, and his development depends, on his ability to turn his peculiar status in the Western world to his own advantage and, it may be, to the very great advantage of that world. It remains for him to fashion out of his experience that which will gave him sustenance, and a voice.

The cathedral at Chartres, I have said, says something to the people of this village which it cannot say to me; but it is important to understand that this cathedral says something to me which it cannot say to them. Perhaps they are struck by the power of the spires, the glory of the windows; but they have known God, after all, longer than I have known him, and in a different way, and I am terrified by the slippery bottomless well to be found in the crypt, down which heretics were hurled to death, and by the obscene, inescapable gargoyles jutting out of the stone and seeming to say that God and the devil can never be divorced. I doubt that the villagers think of the devil when they face a cathedral because they have never been identified with the devil. But I must accept the status which myth, if nothing else, gives me in the West before I can hope to change the myth.

Yet, if the American Negro has arrived at his identity by virtue of the absoluteness of his estrangement from his past, American white men still nourish the illusion that there is some means of recovering the European innocence, of returning to a state in which black men do not exist. This is one of the greatest errors Americans can make. The identity they fought so hard to protect has, by virtue of that battle, undergone a change: Americans are as unlike any other white people in the world as it is possible to be. I do not think, for example, that it is too much to suggest that the American vision of the world—which allows so little reality, generally speaking, for any of the darker forces in human life, which tends until today to paint moral issues in glaring black and white—owes a great deal to the battle waged by Americans to maintain between themselves and black men a human separation which could not be bridged. It is only now beginning to be borne in on us—very faintly, it must be admitted, very slowly, and very much against our will—that this vision of the world is dangerously inaccurate, and perfectly useless. For it protects our moral high-mindedness at the terrible expense of weakening our grasp of reality. People who shut their eyes to reality simply invite their own destruction, and anyone who insists on remaining in a state of innocence long after that innocence is dead turns himself into a monster.

The time has come to realize that the interracial drama acted out on the American continent has not only created a new black man, it has created a new white man, too. No road whatever will lead Americans back to the simplicity of this European village where white men still have the luxury of looking on me as a stranger. I am not, really, a stranger any longer for any American alive. One of the things that distinguishes Americans from other people is that no other people has ever been so deeply involved in the lives of

black men, and vice versa. This fact faced, with all its implications, it can be seen that the history of the American Negro problem is not merely shameful, it is also something of an achievement. For even when the worst has been said, it must also be added that the perpetual challenge posed by this problem was always, somehow, perpetually met. It is precisely this black–white experience which may prove of indispensable value to us in the world we face today. This world is white no longer, and it will never be white again.

Dear Zoe,

I saw Bennett Simpson for a minute when he was in New York last week, and I am excited to hear that he will be working on an exhibition with you. Great news, and great that Bennett is doing it.

I am writing to tell you about an exhibition I'm curating. Alex Farquharson, the director of Nottingham Contemporary, initiated the project after reading *Yourself in the World*, a collection of my writings and interviews. He thought an interesting curatorial project could be developed around the artists that I write about in the book and other artists who have had an influence on my practice. The catalogue will have texts written by me, Farquharson, and Francesco Manacorda, along with a major text by our friend Gregg.

Initially I thought I was going to use pieces of yours that I already own and love, but then I started thinking that in the context of the show it might be more useful for the viewer to think about the photos I first saw when I was discovering your work: the fashion shoot images. I saw them at a moment when I was beginning to think very carefully about the politics of looking and trying to process my ambivalence around one of my own pieces, "Notes on the Margin of the Black Book," which is an investigation of Robert Mapplethorpe's images of black men. By making a piece that used Mapplethorpe's photos to critique his project, I worried that I was just putting his images center stage again. When I first saw your work, I realized that not only were you making work that was offering a strong critique of the history of photographic representations, but you were making images that I wanted to keep looking at, that brought new things to the table every time I saw them. Those key early investigations, your subsequent photo and installation work, and the restlessness of your intellectual inquiry have kept you in the fore-front of any discussion about photography and its future.

Anyway, a long email to say that yours is an important presence for the exhibition and that the precision and fierceness of your work and the generosity of your spirit have been an inspiration for me.

XO,

Glenn

Glenn Ligon and Michael Duffy, *Study for Condition Report*, 2000

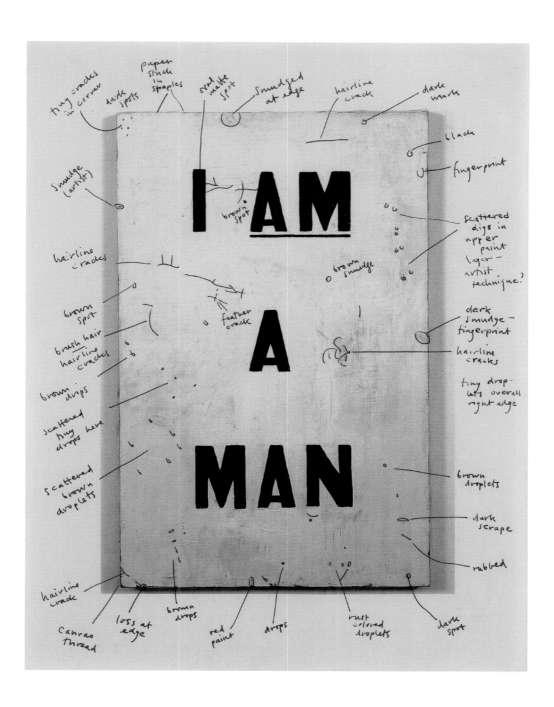

David Hammons, *John Henry*, 1990

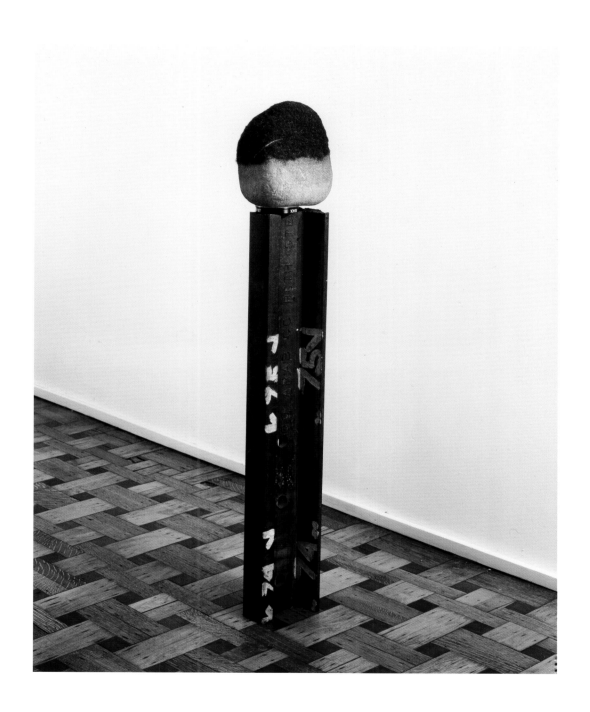

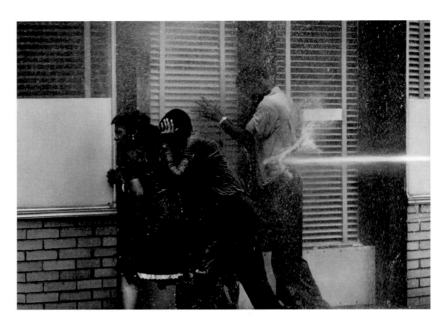

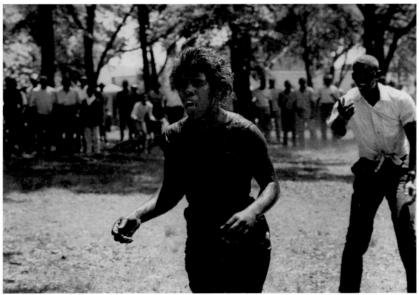

Above: Charles Moore, *Alabama Fire Department Aims High-Pressure Water Hoses at Civil Rights Demonstrators, Birmingham*, May 1963
Below: Charles Moore, *Protests*, May 1963

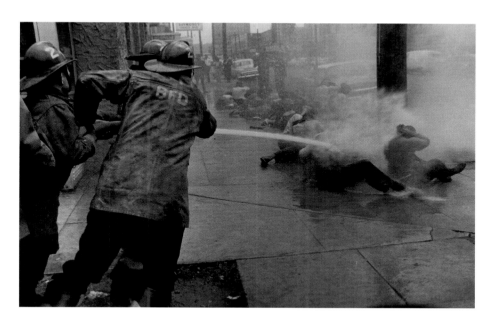

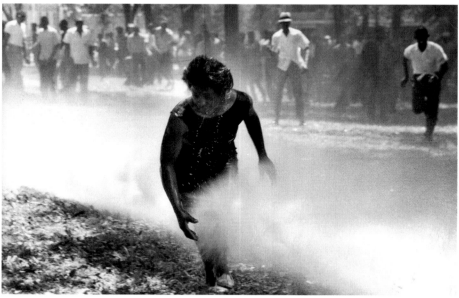

Above: Charles Moore, *Demonstrators Lie on the Sidewalk While Firemen Hose Them, Birmingham Protests,* May 1963
Below: Charles Moore, *Young Demonstrator Evading Policemen, Birmingham Protests,* May 1963

Philip Guston, *Untitled*, 1968

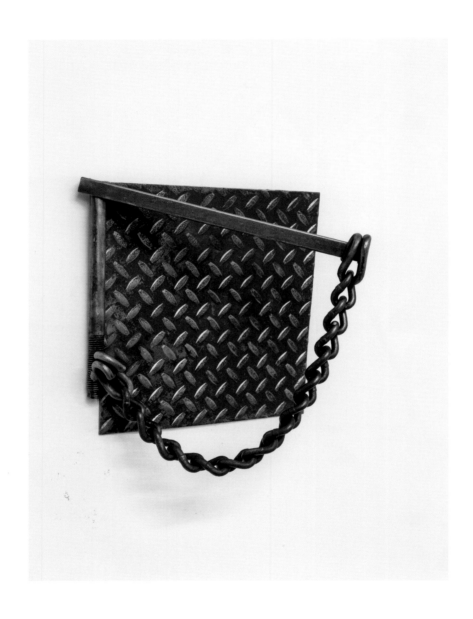

Above: Melvin Edwards, *Chain and Diamond?*, 1979
Opposite: Melvin Edwards, *Art Education*, 2002

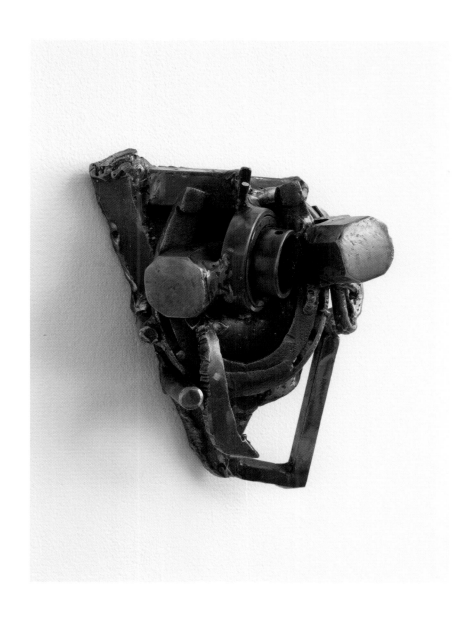

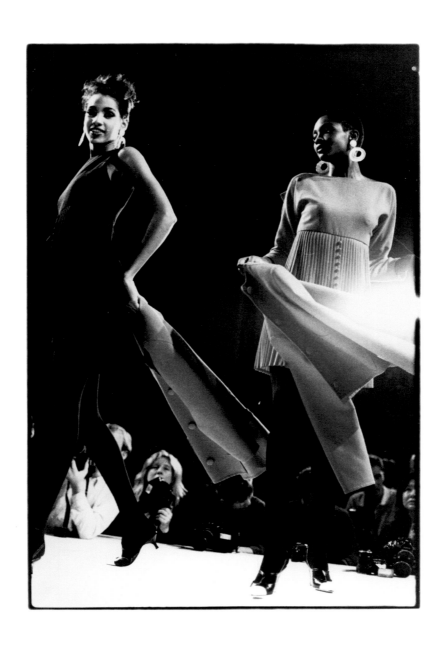

Above: Zoe Leonard, *One Woman Looking at Another*, 1990
Opposite: Zoe Leonard, *View From Below, Geoffrey Beene Fashion Show*, 1990

Steve McQueen, *Bear*, 1993

Above and opposite: Jean Genet, *Un Chant d'Amour*, 1950

Felix Gonzalez-Torres, *"Untitled" (Perfect Lovers)*, 1987–90

Lynette Yiadom-Boakye, *11pm Tuesday*, 2010

Felix Gonzalez-Torres: Interview with Tim Rollins

Tim Rollins: I would like to talk about theory. I think we both come from backgrounds where books were considered with suspicion.

Felix Gonzalez-Torres: It's a queer thing, I mean, at least from my background.

TR: I think it's about wanting a larger world. I think it's about wanting to be involved with the world of ideas and it takes a certain amount of courage to really go into that other land. That's the danger of being too involved in theory, you get to a certain level in your education where you equate theory with practice.

FGT: Tim, I must say that without reading Walter Benjamin, Fanon, Althusser, Barthes, Foucault, Borges, Mattelart, and others, perhaps I wouldn't have been able to make certain pieces, to arrive at certain positions. Some of their writing and ideas gave me a certain freedom to see. These ideas moved me to a place of pleasure through knowledge and some understanding of the way reality is constructed, of the way the self is formed in culture, of the way language sets traps, and of the cracks in the master narrative—those cracks where power can be exercised. It is also about influences and role models.

　Films-as-texts, such as movies by Godard, have been very influential to me. There is also, of course, Yvonne Rainer's *Journeys from Berlin* and a movie by Sarah Gomez called *One Way or Another*, which is a feminist view of the Cuban revolution, Santeria, and other issues. This movie is very interesting because it's also about the meaning of love during a particular historical period. I saw that movie the same week that I saw *Hiroshima Mon Amour*.

TR: That's a great movie about love.

FGT: No, it's about meaning and how meaning is dependent on the context. Last but not least, Brecht is an influence. I think if I started this list of

influences again I would start with Brecht. I think this is really important because as Hispanic artists we're supposed to be very crazy, and colorful—extremely colorful. We are supposed to "feel," not think. Brecht says to keep a distance to allow the viewer, the public, time to reflect and think. When you get out of the theater you should not have had a catharsis, you should have had a thinking experience. More than anything, break the pleasure of representation, the pleasure of the flawless narrative. This is not life, this is just a theater piece. I like that a lot: *This is not life, this is just an artwork*. I want you, the viewer, to be intellectually challenged, moved, and informed.

TR: Love and fear seem to be the two great themes of your work.

FGT: It's funny you say that because I was just thinking … earlier I mentioned *Hiroshima Mon Amour*, it took me a long time to understand the opening sequence. The female character says: "You are good for me because you destroy me," I finally understand what that means. You can be destroyed because of love and as a result of fear. Love is very peculiar because it gives a reason to live but it's also a great reason to be afraid, to be extremely afraid, to be terrified of losing that love.

It's not as if I have different bodies of work, I think I just have many fronts. It's almost like being in drag. I'm in a different drag persona as needed. Sometimes I make the stacks, sometimes I do the curtains, sometimes I do text pieces, sometimes I do canvases, sometimes the light strings, sometimes billboards or photos. There are pieces that grow and change all the time. There's a piece where I mail the owner something every so often and it goes into this big box. This piece should never be shown. I don't know if you know about that piece.

TR: Explain it some more. Who gets these things?

FGT: The person who buys this empty box gets these things in the mail.

TR: How does this person get the box?

FGT: They buy it from Andrea. This piece is not meant to be shown. There are other pieces that are not only meant to be shown but are meant to be taken all over the place. I like working with contradictions: making completely private, almost secretive work on the one hand, and on the other, making work that is *truly* public and accessible. As we know, some so-called public art is really outdoor art. Just because it's out on the street doesn't make it public.

TR: I've heard a lot of grumbling, Felix, about the lack of an overt political or Latino content in your work.

FGT (laughing): Well, I just want to start by saying that the "maracas"

sculptures are next! I'm not a good token. I don't wear the right colors. I have my own agenda. Some people want to promote multiculturalism as long as they are the promoters, the circus directors. We have an assigned role that's very specific, very limited. As in a glass vitrine, "we"–the "other"–have to accomplish ritual, exotic performances to satisfy the needs of the majority. This parody is becoming boring very quickly. Who is going to define my culture? It is not just Borges and Gacia Marquez, but also Gertrude Stein and Freud and Guy Debord–they are all part of my formation.

The best thing for me to do with those people is to ignore them, because I question someone who tells me what I'm supposed to do or be. I always feel like asking them why don't they do it? I think the same thing happened with you and K.O.S. It's very elegant for some Calvinist critic to judge your project. Anyway people criticize some of the contradictions–as if there are things in life that don't come with contradictions. Everything is part of a contradiction, there are just different levels of contradictions. You decided to do something, something other than just teach art to young kids. You decided to push the limits. It is very exciting to take something out, to give that ordinary object or situation a new meaning with a great economy of means.

I had a problem just recently in Copenhagen where I went to give a lecture. A man in the audience immediately started talking about winning the battle for multiculturalism. I said: "Look, okay, first I have trouble with that kind of language about winning battles. That's too male-oriented for me. That's too macho, that's too much about war." Then he said something about numbers–a certain amount of women, a certain amount of Hispanics, etc. No, multiculturalism is not about numbers, it's about inclusion. It's about opening up the terms of the argument, opening up the terms of the discourse so that everybody can participate with equal footing. It's not about naming two female, three Hispanics, four whites, five blacks... It's not about quotas. Sometimes quotas are necessary when it comes to concrete things like businesses, but in culture it's more complex. It's about opening up the terms of the argument, and it's about re-addressing the issue of quality and who dictates and defines "quality."

TR: Some artists regress with success. When do you get to the point that you make what you want to make as opposed to making what you think you need to make or what society needs to have out there? This is a dialectic or contradiction that Brecht suffered as well. All artists who are interested in social change labor under the tyranny of necessity.

FGT: How do I define the need? It could be a personal need and / or a political need. I'm a person who lives in this society and I'm a product of this society and this culture. I'm not only a reflection, I'm that culture itself, and therefore whatever I make ... I hope that everything that I make is needed by my culture. I always think that when culture foregrounds something it is because it *is* needed. It could be an idea, an object, whatever. It could have been there

for a long, long time but it is only when culture feels that it is *ready* that this object or idea becomes important.

I always tell my students that as cultural producers we should be very aware of what the culture is doing. We must read the newspaper, we should watch the news, we should be finding out what is new, because even if we don't take them on as issues that stuff will affect us one way or another. For example, what is happening right now in Yugoslavia with men in uniform killing innocent people, I think that should also be part of the studio. I think that should also be a part of your "inspiration" the way that the horror of being the homeless person down on the street should be part of your life. Artists should be well informed.

TR: You are a political person yet you're very concerned with form and you're not apologetic about it.

FGT: I love formal issues. Actually they have a very specific meaning. Forms gather meaning from their historical moment. The minimalist exercise of the object being very pure and very clean is only one way to deal with the form. Carl Andre said, "My sculptures are masses and their subject is matter." But after twenty years of feminist discourse and feminist theory we have come to realize that "just looking" is not *just* looking but that *looking* is invested with identity: gender, socioeconomic status, race, sexual orientation. Looking is invested with lots of other texts.

Minimalist sculptures were never really primary structures, they were structures that were embedded with a multiplicity of meanings. Every time a viewer comes into the room these objects become something else. For me they were a coffee table, a laundry bag, a laundry box, whatever. So I think that saying that these objects are only about matter is like saying that aesthetics are not about politics. Ask a few simple questions to define aesthetics: whose aesthetics? at what historical time? under what circumstances? for what purposes? and who is deciding quality, et cetera? Then you realize very quickly that aesthetic choices are politics. Believe it or not I am a big sucker for formal issues, and yes, someone like me—the "other"—can indeed deal with formal issues. This is not a white-men-only terrain, sorry boys.

TR: You've taught at several colleges, right? Doesn't it disturb you that there are so few Spanish-speaking students?

FGT: When I went to art school at New York University there weren't any Hispanics around except for the elevator man. When I started to teach at N.Y.U. in 1987 I used to joke that the elevator man's name got onto the teachers' list by accident. On the list of fifty-five teachers, I had the only Hispanic-sounding name.

TR: So obviously that bothers you.

FGT: Of course it bothers me. As a young man I didn't think that being an artist was a viable thing to do because there were not many role models. Now that has changed, and it is great to see the variety of voices. I see the practice of teaching as an integral part of my work. Teaching for me is a form of cultural activism, a form of creative change at a very basic level, and it is a way of redeeming the profession of art teaching. As a student you always got these teachers telling you what is right and what is wrong without any doubt or questioning. I want my students to learn the tools of critical thought and to always doubt, to learn how to doubt themselves and to be self-critical. Only through acts of self-criticism are we able to discern which work is better or worse, hopefully. It's based on the Brechtian model. It is not about good or bad. You try to give them the ability, the tools, to see for themselves what is important, what is needed, what is moving, and what is not. I also make very clear to them that they should not trust me—I'm not the voice of authority. I make mistakes, I might be wrong. I do have a very clear agenda and that is a desire to make this place a better place, and I'm an artist, that is the position where I speak from. But I'm an artist who tries to redefine the role of the artist. I see myself as an instigator, someone who questions not only the function of the art object and the practice but also the act of teaching art. Is it valid to teach art in the late twentieth century? I constantly question my voice, my opinions, my suggestions. What do I know? I don't give my students the comfort of expecting me to be the voice of knowledge, the father, the master narrative. Even if I wanted to I couldn't.

Zami, A New Spelling of My Name

Audre Lorde

To whom do I owe the power behind my voice, what strength I have become, yeasting up like sudden blood from under the bruised skin's blister?

My father leaves his psychic print upon me, silent, intense, and unforgiving. But his is a distant lightning. Images of women flaming like torches adorn and define the borders of my journey, stand like dykes between me and the chaos. It is the images of women, kind and cruel, that lead me home.

To whom do I owe the symbols of my survival?

Days from pumpkin until the year's midnight, when my sisters and I hovered indoors, playing potsy on holes in the rosy linoleum that covered the living-room floor. On Saturdays we fought each other for the stray errand out of doors, fought each other for the emptied Quaker Oats boxes, fought each other for the last turn in the bathroom at nightfall, and for who would be the first one of us to get chickenpox.

The smell of the filled Harlem streets during summer, after a brief shower or the spraying drizzle of the watering trucks released the rank smell of the pavements back to the sun. I ran to the corner to fetch milk and bread from the Short-Neck Store-Man, stopping to search for some blades of grass to bring home for my mother. Stopping to search for hidden pennies winking like kittens under the subway gratings. I was always bending over to tie my shoes, delaying, trying to figure out something. How to get at the money, how to peep out the secret that some women carried like a swollen threat, under the gathers of their flowered blouses.

To whom do I owe the woman I have become?

DeLois lived up the block on 142nd Street and never had her hair done, and all the neighborhood women sucked their teeth as she walked by. Her crispy hair twinkled in the summer sun as her big proud stomach moved her on down the block while I watched, not caring whether or not she was a poem. Even though I tied my shoes and tried to peep under her blouse as she passed by, I never spoke to DeLois, because my mother didn't. But I loved her, because she moved like she felt she was somebody special, like she was somebody I'd like to know someday. She moved like how I thought god's mother must have moved, and my mother, once upon a time, and someday maybe me.

Hot noon threw a ring of sunlight like a halo on the top of DeLois's stomach, like a spotlight, making me sorry that I was so flat and could only feel the sun on my head and shoulders. I'd have to lie down on my back before the sun could shine down like that on my belly.

I loved DeLois because she was big and Black and special and seemed to laugh all over. I was scared of DeLois for those very same reasons. One day I watched DeLois step off the curb of 142nd Street against the light, slow and deliberate. A high yaller dude in a white Cadillac passed by and leaned out and yelled at her, "Hurry up, you flat-footed, nappy-headed, funny-looking bitch!" The car almost knocking her down. DeLois kept right on about her leisurely business and never so much as looked around.

To Louise Briscoe who died in my mother's house as a tenant in a furnished room with cooking privileges—no linens supplied. I brought her a glass of warm milk that she wouldn't drink, and she laughed at me when I wanted to change her sheets and call a doctor. "No reason to call him unless he's real cute," said Miz Briscoe. "Ain't nobody sent for me to come. I got here all by myself. And I'm going back the same way. So I only need him if he's cute, real cute." And the room smelled like she was lying.

"Miz Briscoe," I said, "I'm really worried about you."

She looked up at me out of the corner of her eyes, like I was making her a proposition which she had to reject, but which she appreciated all the same. Her huge bloated body was quiet beneath the grey sheet, as she grinned knowingly.

"Why, that's all right, honey. I don't hold it against you. I know you can't help it, it's just in your nature, that's all."

To the white woman I dreamed standing behind me in an airport, silently watching while her child deliberately bumps into me over and over again. When I turn around to tell this woman that if she doesn't restrain her kid I'm going to punch her in the mouth, I see that she's been punched in the mouth already. Both she and her child are battered, with bruised faces and blackened eyes. I turn, and walk away from them in sadness and fury.

To the pale girl who ran up to my car in a Staten Island midnight with only

a nightgown and bare feet, screaming and crying, "Lady, please help me oh please take me to the hospital, lady…" Her voice was a mixture of overripe peaches and doorchimes; she was the age of my daughter, running along the woody curves of Van Duzer Street.

I stopped the car quickly, and leaned over to open the door. It was high summer. "Yes, yes, I'll try to help you," I said. "Get in."

And when she saw my face in the streetlamp her own collapsed into terror.

"Oh no!" she wailed. "Not you!" then whirled around and started to run again.

What could she have seen in my Black face that was worth holding onto such horror? Wasting me in the gulf between who I was and her vision of me. Left with no help.

I drove on.

In the rear-view mirror I saw the substance of her nightmare catch up with her at the corner—leather jacket and boots, male and white.

I drove on, knowing she would probably die stupid.

To the first woman I ever courted and left. She taught me that women who want without needing are expensive and sometimes wasteful, but women who need without wanting are dangerous—they suck you in and pretend not to notice.

To the battalion of arms where I often retreated for shelter and sometimes found it. To the others who helped, pushing me into the merciless sun—I, coming out blackened and whole.

To the journeywoman pieces of myself.
Becoming.
Afrekete.

[…]

I have often wondered why the farthest-out position always feels so right to me; why extremes, although difficult and sometimes painful to maintain, are always more comfortable than one plan running straight down a line in the unruffled middle.

What I really understand is a particular kind of determination. It is stubborn, it is painful, it is infuriating, but it often works.

My mother was a very powerful woman. This was so in a time when that word-combination of *woman* and *powerful* was almost unexpressable in the white american common tongue, except or unless it was accompanied by some aberrant explaining adjective like blind, or hunchback, or crazy, or Black. Therefore when I was growing up, *powerful woman* equaled something else quite different from ordinary woman, from simply "woman." It certainly

did not, on the other hand, equal "man." What then? What was the third designation?

As a child, I always knew my mother was different from the other women I knew, Black or white. I used to think it was because she was my mother. But different how? I was never quite sure. There were other West Indian women around, a lot in our neighborhood and church. There were also other Black women as light as she, particularly among the low-island women. *Redbone*, they were called. *Different how?* I never knew. But that is why to this day I believe that there have always been Black dykes around—in the sense of powerful and women-oriented women—who would rather have died than use that name for themselves. And that includes my momma.

I've always thought that I learned some early ways I treated women from my father. But he certainly responded to my mother in a very different fashion. They shared decisions and the making of all policy, both in their business and in the family. Whenever anything had to be decided about any one of the three of us children, even about new coats, they would go into the bedroom and put their heads together for a little while. *Buzz buzz* would come through the closed door, sometimes in english, sometimes in patois, that Grenadian poly-language which was their lingua franca. Then the two of them would emerge and announce whatever decision had been arrived upon. They spoke all through my childhood with one unfragmentable and unappealable voice.

After the children came, my father went to real-estate school, and began to manage small rooming-houses in Harlem. When he came home from the office in the evening, he had one quick glass of brandy, standing in the kitchen, after we greeted him and before he took off his coat and hat. Then my mother and he would immediately retire into the bedroom where we would hear them discussing the day's events from behind closed doors, even if my mother had only left their office a few hours before.

If any of us children had transgressed against the rule, this was the time when we truly quaked in our orthopedic shoes, for we knew our fate was being discussed and the terms of punishment sealed behind those doors. When they opened, a mutual and irrefutable judgment would be delivered. If they spoke of anything important when we were around, Mother and Daddy immediately lapsed into patois.

Since my parents shared all making of policy and decision, in my child's eye, my mother must have been *other* than woman. Again, she was certainly not man. (The three of us children would not have tolerated that deprivation of womanliness for long at all; we'd have probably packed up our *kra* and gone back before the eighth day—an option open to all African child-souls who bumble into the wrong milieu.)

My mother was different from other women, and sometimes it gave me a sense of pleasure and specialness that was a positive aspect of feeling set apart. But sometimes it gave me pain and I fancied it the reason for so many of my childhood sorrows. *If my mother were like everybody else's maybe they would*

like me better. But most often, her difference was like the season or a cold day or a steamy night in June. It just *was*, with no explanation or evocation necessary.

My mother and her two sisters were large and graceful women whose ample bodies seemed to underline the air of determination with which they moved through their lives in the strange world of Harlem and america. To me, my mother's physical substance and the presence and self-possession with which she carried herself were a large part of what made her *different*. Her public air of in-charge competence was quiet and effective. On the street people deferred to my mother over questions of taste, economy, opinion, quality, not to mention who had the right to the first available seat on the bus. I saw my mother fix her blue-grey-brown eyes upon a man scrambling for a seat on the Lenox Avenue bus, only to have him falter midway, grin abashedly, and, as if in the same movement, offer it to the old woman standing on the other side of him. I became aware, early on, that sometimes people would change their actions because of some opinion my mother never uttered, or even particularly cared about.

My mother was a very private woman, and actually quite shy, but with a very imposing, no-nonsense exterior. Full-bosomed, proud, and of no mean size, she would launch herself down the street like a ship under full sail, usually pulling me stumbling behind her. Not too many hardy souls dared cross her prow too closely.

Total strangers would turn to her in the meat market and ask what she thought about a cut of meat as to its freshness and appeal and suitability for such and such, and the butcher, impatient, would nonetheless wait for her to deliver her opinion, obviously quite a little put out but still deferential. Strangers counted upon my mother and I never knew why, but as a child it made me think she had a great deal more power than in fact she really had. My mother was invested in this image of herself also, and took pains, I realize now, to hide from us as children the many instances of her powerlessness. Being Black and foreign and female in New York City in the twenties and thirties was not simple, particularly when she was quite light enough to pass for white, but her children weren't.

In 1936–1938, 125th Street between Lenox and Eighth Avenues, later to become the shopping mecca of Black Harlem, was still a racially mixed area, with control and patronage largely in the hands of white shopkeepers. There were stores into which Black people were not welcomed, and no Black salespersons worked in the shops at all. Where our money was taken, it was taken with reluctance; and often too much was asked. (It was these conditions which young Adam Clayton Powell, Jr., addressed in his boycott and picketing of Blumstein's and Weissbecker's market in 1939 in an attempt, successful, to bring Black employment to 125th Street.) Tensions on the street were high, as they always are in racially mixed zones of transition. As a very little girl, I remember shrinking from a particular sound, a hoarsely sharp, guttural rasp, because it often meant a nasty glob of grey spittle upon my coat or shoe an

instant later. My mother wiped it off with the little pieces of newspaper she always carried in her purse. Sometimes she fussed about low-class people who had no better sense nor manners than to spit into the wind no matter where they went, impressing upon me that this humiliation was totally random. It never occurred to me to doubt her.

It was not until years later once in conversation I said to her: "Have you noticed people don't spit into the wind so much the way they used to?" And the look on my mother's face told me that I had blundered into one of those secret places of pain that must never be spoken of again. But it was so typical of my mother when I was young that if she couldn't stop white people from spitting on her children because they were Black, she would insist it was something else. It was so often her approach to the world: to change reality. If you can't change reality, change your perceptions of it.

Both of my parents gave us to believe that they had the whole world in the palms of their hands for the most part, and if we three girls acted correctly— meaning working hard and doing as we were told—we could have the whole world in the palms of our hands also. It was a very confusing way to grow up, enhanced by the insularity of our family. Whatever went wrong in our lives was because our parents had decided that was best. Whatever went right was because our parents had decided that was the way it was going to be. Any doubts as to the reality of that situation were rapidly and summarily put down as small but intolerable rebellions against divine authority.

All our storybooks were about people who were very different from us. They were blond and white and lived in houses with trees around and had dogs named Spot. I didn't know people like that any more than I knew people like Cinderella who lived in castles. Nobody wrote stories about us, but still people always asked my mother for directions in a crowd.

It was this that made me decide as a child we must be rich, even when my mother did not have enough money to buy gloves for her chilblained hands, nor a proper winter coat. She would finish washing clothes and dress me hurriedly for the winter walk to pick up my sisters at school for lunch. By the time we got to St. Mark's School, seven blocks away, her beautiful long hands would be covered with ugly red splotches and welts. Later, I remember my mother rubbing her hands gingerly under cold water, and wringing them in pain. But when I asked, she brushed me off by telling me this was what they did for it at "home," and I still believed her when she said she hated to wear gloves.

At night, my father came home late from the office, or from a political meeting. After dinner, the three of us girls did our homework sitting around the kitchen table. Then my two sisters went off down the hall to their beds. My mother put down the cot for me in the front bedroom, and supervised my getting ready for bed.

She turned off all the electric lights, and I could see her from my bed, two rooms away, sitting at the same kitchen table, reading the *Daily News* by a kerosene lamp, and waiting for my father. She always said it was because the

kerosene lamp reminded her of "home." When I was grown I realized she was trying to save a few pennies of electricity before my father came in and turned on the lights with "Lin, why you sitting in the dark so?" Sometimes I'd go to sleep with the soft chunk-a-ta-chink of her foot-pedal-powered Singer Sewing Machine, stitching up sheets and pillow-cases from unbleached muslin gotten on sale "under the bridge."

I only saw my mother crying twice when I was little. Once was when I was three, and sat on the step of her dental chair at the City Dental Clinic on 23rd Street, while a student dentist pulled out all the teeth on one side of her upper jaw. It was in a huge room full of dental chairs with other groaning people in them, and white-jacketed young men bending over open mouths. The sound of the many dental drills and instruments made the place sound like a street-corner excavation site.

Afterwards, my mother sat outside on a long wooden bench. I saw her lean her head against the back, her eyes closed. She did not respond to my pats and tugs at her coat. Climbing up upon the seat, I peered into my mother's face to see why she should be sleeping in the middle of the day. From under her closed eyelids, drops of tears were squeezing out and running down her cheek toward her ear. I touched the little drops of water on her high cheekbone in horror and amazement. The world was turning over. My mother was crying.

The other time I saw my mother cry was a few years later, one night, when I was supposed to be asleep in their bedroom. The door to the parlor was ajar, and I could see through the crack into the next room. I woke to hear my parents' voices in english. My father had just come home, and with liquor on his breath.

"I hoped I'd never live to see the day when you, Bee, stand up in some saloon and it's drink you drinking with some clubhouse woman."

"But Lin, what are you talking? It's not that way a-tall, you know. In politics you must be friendly-friendly so. It doesn't mean a thing."

"And if you were to go before I did, I would never so much as look upon another man, and I would expect you to do the same."

My mother's voice was strangely muffled by her tears,

These were the years leading up to the Second World War, when Depression took such a terrible toll, and of Black people in particular.

Even though we children could be beaten for losing a penny coming home from the store, my mother fancied a piece of her role as lady bountiful, a role she would accuse me bitterly of playing years later in my life whenever I gave something to a friend. But one of my earlier memories of World War II was just before the beginning, with my mother splitting a one-pound tin of coffee between two old family friends who had come on an infrequent visit.

Although she always insisted that she had nothing to do with politics or government affairs, from somewhere my mother had heard the winds of war, and despite our poverty had set about consistently hoarding sugar and coffee

in her secret closet under the sink. Long before Pearl Harbor, I recall opening each cloth five-pound sack of sugar which we purchased at the market and pouring a third of it into a scrubbed tin to store away under the sink, secure from mice. The same thing happened with coffee. We would buy Bokar Coffee at the A&P and have it ground and poured into bags, and then divide the bag between the coffee tin on the back of the stove, and the hidden ones under the sink. Not many people came to our house, ever, but no one left without at least a cupful of sugar or coffee during the war, when coffee and sugar were heavily rationed.

Meat and butter could not be hoarded, and throughout the early war, my mother's absolute refusal to accept butter substitutes (only "other people" used margarine, those same "other people" who fed their children peanut butter sandwiches for lunch, used sandwich spread instead of mayonnaise and ate pork chops and watermelon) had us on line in front of supermarkets all over the city on bitterly cold Saturday mornings, waiting for the store to open so we each could get first crack at buying our allotted quarter-pound of unrationed butter. Throughout the war, Mother kept a mental list of all the supermarkets reachable by one bus, frequently taking only me because I could ride free. She also noted which were friendly and which were not, and long after the war ended there were meat markets and stores we never shopped in because someone in them had crossed my mother during the war over some precious scarce commodity, and my mother never forgot and rarely forgave.

Dear Sun Ra,

A while ago I read an article in the *New York Times* where Snoop Dogg said, "I don't rap, I just talk." Hearing Snoop rap reminds me of your voice in *Space Is the Place*, which is so matter-of-fact, almost affectless in its delivery, but the words you utter are devastating. Like in the movie when you are talking to the kids at the youth center in Oakland and you say, "I'm not real, I'm just like you. You don't exist in this society. If you did, your people wouldn't be seeking equal rights." To escape all that, you propose transporting us to another planet through your music. Maybe under different stars we could get our vibrations back in order. "There was no one to talk to on planet Earth who would understand," you said. Still isn't. Ra, you are not a rapper, but you do drop science.

I read some of your broadsides the other day. They are punning and precise; they play with language beautifully. You used to hand them out on the street in Chicago, trying to be "of service," as my church-raised grandfather would have said. Seeing you on the corners must have been like seeing those guys in their crisp suits and bow ties in Harlem selling issues of *Final Call* and bean pies outside the mosque on 116th Street. "Yakub, the mad scientist" and "tricknology," remember? I was sure I didn't want to live in the future they imagined, but I would live in yours.

Someone took photos of you in Oakland when you were shooting *Space Is the Place*. You are in your splendor: multicolored robes, ancient Egyptian headpiece, jewelry. It's like you were here on Earth for just long enough to take us somewhere else. Music is always a vehicle for transport. "I came from a dream that the black man dreamed long ago," you said. "I'm actually a present sent to you by your ancestors." Better to be from outer space than from here. Still is.

I'm curating a show in a museum. It is about the present and the past, or the past in the present. Maybe it's about the future too. I'm putting *Space Is the Place* in it along with stills from the set. It's about starting a conversation. Who knows what ears it will reach, who will answer back. Even if there is no one to talk to, we still have a responsibility to speak.

Sincerely,

Glenn Ligon

Glenn Ligon, *When Black Wasn't Beautiful #2*, 2004

I remember when black wasn't beautiful. Black men come through tha neighborhood saying "Black is beautiful! Africa is your home! Be proud to be black!

My parents go "That nigger crazy,"

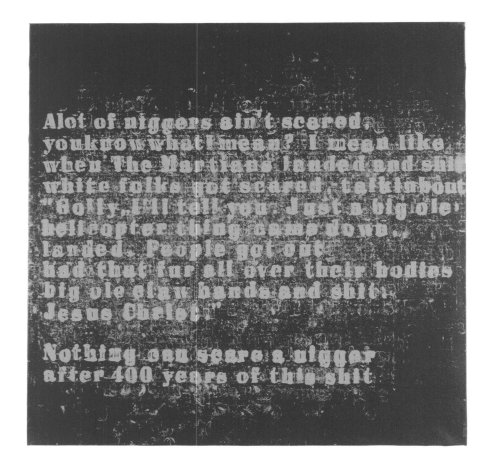

Above: Glenn Ligon, *Niggers Ain't Scared*, 1996
Opposite: Glenn Ligon, *Mudbone (Liar)*, 1993

Niggers had the biggest dicks in the world, and they was trying to find a place where they could have they contest. And they wasn't no freak, they didn't want everybody looking. So they walking around looking for a secret place. So they walked across the Golden Gate Bridge and the nigger seen that water and made him wanna piss. One said, "Man, I got to take a leak." And he pulled his thing out and was pissing. Other nigger pulled his out, took a piss.

One nigger said, "Goddamn, this water cold!"
The other nigger say, "Yeah, and it's deep too!"

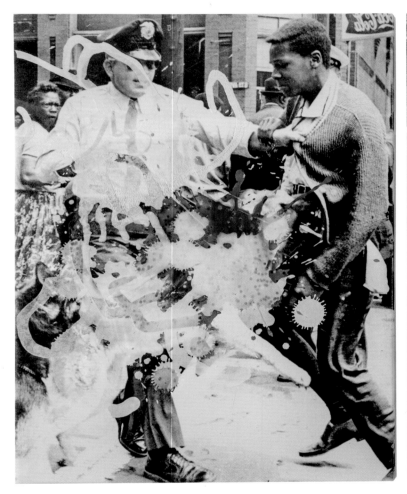

Kelley Walker, *Black Star Press (triptych)*, 2005

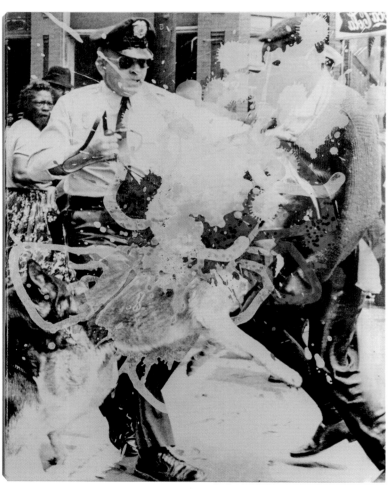

Agnès Varda, *Black Panthers*, 1968

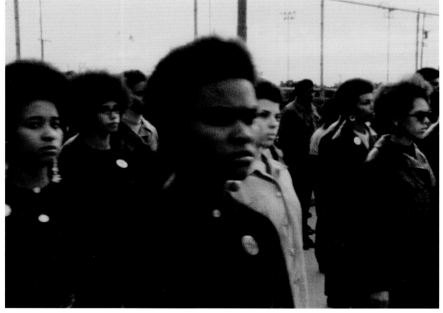

Felix Gonzalez-Torres, *"Untitled" (USA Today)*, 1990

Andy Warhol, *Birmingham Race Riot*, 1964

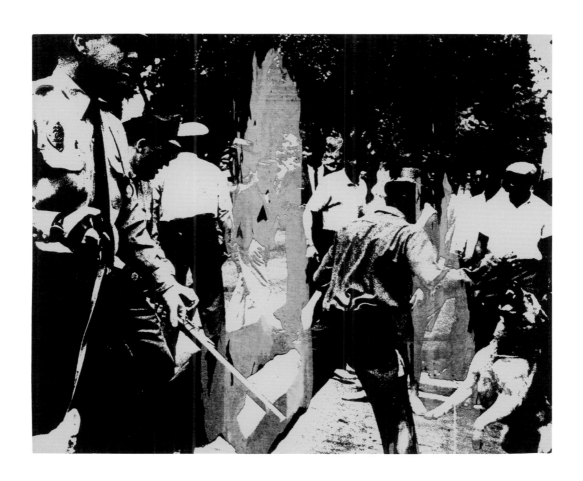

Above: Chris Ofili, *Afro Margin Four*, 2004
Opposite: Chris Ofili, *Afro*, 2000

Above and opposite: Sun Ra, *Oakland*, 1972

Above: Stephen Shames, *At Home, Huey P. Newton Listens to Bob Dylan's Highway 61 Revisited, Berkeley,* 1970
Opposite: Stephen Shames, *Poster of Huey Newton Shot Up After Attack by Police on Panther Office, Berkeley, California,* c. 1968

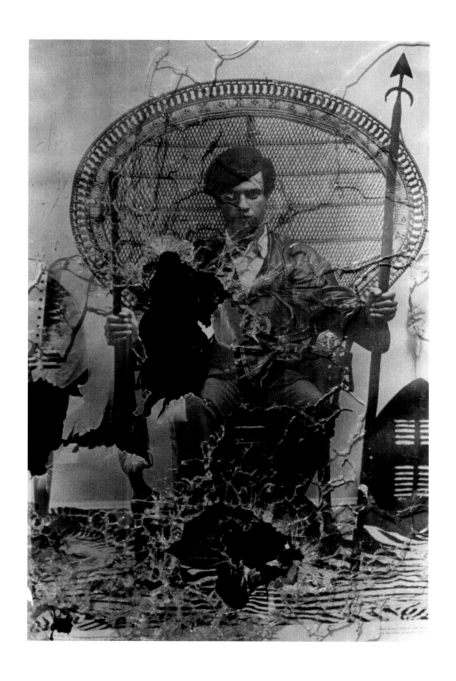

Above: David Hammons, *Untitled (Body Print)*, 1974
Opposite: David Hammons, *Untitled*, 1975

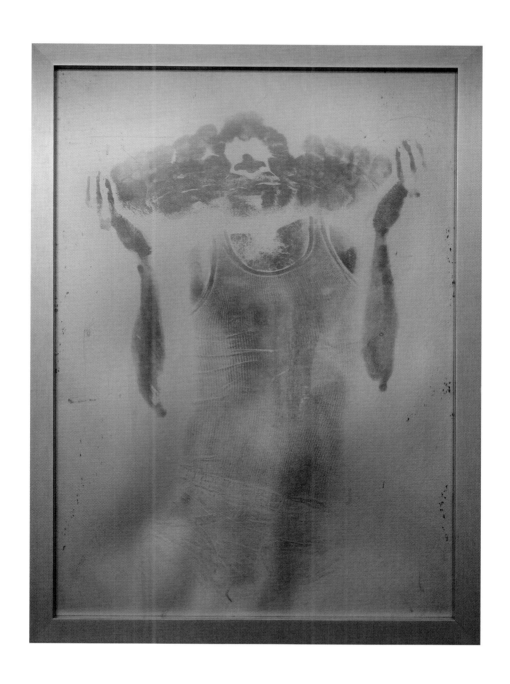

Sula

Toni Morrison

1919

Except for World War II, nothing ever interfered with the celebration of National Suicide Day. It had taken place every January third since 1920, although Shadrack, its founder, was for many years the only celebrant. Blasted and permanently astonished by the events of 1917, he had returned to Medallion handsome but ravaged, and even the most fastidious people in the town sometimes caught themselves dreaming of what he must have been like a few years back before he went off to war. A young man of hardly twenty, his head full of nothing and his mouth recalling the taste of lipstick, Shadrack had found himself in December, 1917, running with his comrades across a field in France. It was his first encounter with the enemy and he didn't know whether his company was running toward them or away. For several days they had been marching, keeping close to a stream that was frozen at its edges. At one point they crossed it, and no sooner had he stepped foot on the other side than the day was adangle with shouts and explosions. Shellfire was all around him, and though he knew that this was something called *it,* he could not muster up the proper feeling—the feeling that would accommodate *it.* He expected to be terrified or exhilarated—to feel *something* very strong. In fact, he felt only the bite of a nail in his boot, which pierced the ball of his foot whenever he came down on it. The day was cold enough to make his breath visible, and he wondered for a moment at the purity and whiteness of his own breath among the dirty, gray explosions surrounding him. He ran, bayonet fixed, deep in the great sweep of men flying across this field. Wincing at the pain in his foot, he turned his head a little to the right and saw the face of a soldier near him fly off. Before he could register shock, the rest of the soldier's head disappeared under the inverted soup bowl of his helmet. But stubbornly, taking no direction from

the brain, the body of the headless soldier ran on, with energy and grace, ignoring altogether the drip and slide of brain tissue down its back.

When Shadrack opened his eyes he was propped up in a small bed. Before him on a tray was a large tin plate divided into three triangles. In one triangle was rice, in another meat, and in the third stewed tomatoes. A small round depression held a cup of whitish liquid. Shadrack stared at the soft colors that filled these triangles: the lumpy whiteness of rice, the quivering blood tomatoes, the grayish-brown meat. All their repugnance was contained in the neat balance of the triangles—a balance that soothed him, transferred some of its equilibrium to him. Thus reassured that the white, the red and the brown would stay where they were—would not explode or burst forth from their restricted zones—he suddenly felt hungry and looked around for his hands. His glance was cautious at first, for he had to be very careful—anything could be anywhere. Then he noticed two lumps beneath the beige blanket on either side of his hips. With extreme care he lifted one arm and was relieved to find his hand attached to his wrist. He tried the other and found it also. Slowly he directed one hand toward the cup and, just as he was about to spread his fingers, they began to grow in higgledy-piggledy fashion like Jack's beanstalk all over the tray and the bed. With a shriek he closed his eyes and thrust his huge growing hands under the covers. Once out of sight they seemed to shrink back to their normal size. But the yell had brought a male nurse.

"Private? We're not going to have any trouble today, are we? Are we, Private?"

Shadrack looked up at a balding man dressed in a green-cotton jacket and trousers. His hair was parted low on the right side so that some twenty or thirty yellow hairs could discreetly cover the nakedness of his head.

"Come on. Pick up that spoon. Pick it up, Private. Nobody is going to feed you forever."

Sweat slid from Shadrack's armpits down his sides. He could not bear to see his hands grow again and he was frightened of the voice in the apple-green suit.

"Pick it up, I said. There's no point to this …" The nurse reached under the cover for Shadrack's wrist to pull out the monstrous hand. Shadrack jerked it back and overturned the tray. In panic he raised himself to his knees and tried to fling off and away his terrible fingers, but succeeded only in knocking the nurse into the next bed.

When they bound Shadrack into a straitjacket, he was both relieved and grateful, for his hands were at last hidden and confined to whatever size they had attained.

Laced and silent in his small bed, he tried to tie the loose cords in his mind. He wanted desperately to see his own face and connect it with the word "private"—the word the nurse (and the others who helped bind him) had called him. "Private" he thought was something secret, and he wondered why they looked at him and called him a secret. Still, if his hands behaved as they had done, what might he expect from his face? The fear and longing were too

151

much for him, so he began to think of other things. That is, he let his mind slip into whatever cave mouths of memory it chose.

He saw a window that looked out on a river which he knew was full of fish. Someone was speaking softly just outside the door …

Shadrack's earlier violence had coincided with a memorandum from the hospital executive staff in reference to the distribution of patients in high-risk areas. There was clearly a demand for space. The priority or the violence earned Shadrack his release, $217 in cash, a full suit of clothes and copies of very official-looking papers.

When he stepped out of the hospital door the grounds overwhelmed him: the cropped shrubbery, the edged lawns, the undeviating walks. Shadrack looked at the cement stretches: each one leading clearheadedly to some presumably desirable destination. There were no fences, no warnings, no obstacles at all between concrete and green grass, so one could easily ignore the tidy sweep of stone and cut out in another direction—a direction of one's one.

Shadrack stood at the foot of the hospital steps watching the heads of trees tossing ruefully but harmlessly, since their trunks were rooted too deeply in the earth to threaten him. Only the walks made him uneasy. He shifted his weight, wondering how he could get to the gate without stepping on the concrete. While plotting his course—where he would have to leap, where to skirt a clump of bushes—a loud guffaw startled him. Two men were going up the steps. Then he noticed that there were many people about, and that he was just now seeing them, or else they had just materialized. They were thin slips, like paper dolls floating down the walks. Some were seated in chairs with wheels, propelled by other paper figures from behind. All seemed to be smoking, and their arms and legs curved in the breeze. A good high wind would pull them up and away and they would land perhaps among the tops of the trees.

Shadrack took the plunge. Four steps and he was on the grass heading for the gate. He kept his head down to avoid seeing the paper people swerving and bending here and there, and he lost his way. When he looked up, he was standing by a low red building separated from the main building by a covered walkway. From somewhere came a sweetish smell which reminded him of something painful. He looked around for the gate and saw that he had gone directly away from it in his complicated journey over the grass. Just to the left of the low building was a graveled driveway that appeared to lead outside the grounds. He trotted quickly to it and left, at last, a haven of more than a year, only eight days of which he fully recollected.

Once on the road, he headed west. The long stay in the hospital had left him weak—too weak to walk steadily on the gravel shoulders of the road. He shuffled, grew dizzy, stopped for breath, started again, stumbling and sweating but refusing to wipe his temples, still afraid to look at his hands. Passengers in dark, square cars shuttered their eyes at what they took to be a drunken man.

The sun was already directly over his head when he came to a town. A few blocks of shaded streets and he was already at its heart—a pretty, quietly regulated downtown.

Exhausted, his feet clotted with pain, he sat down at the curbside to take off his shoes. He closed his eyes to avoid seeing his hands and fumbled with the laces of the heavy high-topped shoes. The nurse had tied them into a double knot, the way one does for children, and Shadrack, long unaccustomed to the manipulation of intricate things, could not get them loose. Uncoordinated, his fingernails tore away at the knots. He fought a rising hysteria that was not merely anxiety to free his aching feet; his very life depended on the release of the knots. Suddenly without raising his eyelids, he began to cry. Twenty-two years old, weak, hot, frightened, not daring to acknowledge the fact that he didn't even know who or what he was ... with no past, no language, no tribe, no source, no address book, no comb, no pencil, no clock, no pocket handkerchief, no rug, no bed, no can opener, no faded postcard, no soap, no key, no tobacco poach, no soiled underwear and nothing nothing nothing to do ... he was sure of one thing only: the unchecked monstrosity of his hands. He cried soundlessly at the curbside of a small Midwestern town wondering where the window was, and the river, and the soft voices just outside the door ...

Through his tears he saw the fingers joining the laces, tentatively at first, then rapidly. The four fingers of each hand fused into the fabric, knotted themselves and zigzagged in and out of the tiny eyeholes.

By the time the police drove up, Shadrack was suffering from a blinding headache, which was not abated by the comfort he felt when the policemen pulled his hands away from what he thought was a permanent entanglement with his shoelaces. They took him to jail, booked him for vagrancy and intoxication, and locked him in a cell. Lying on a cot, Shadrack could only stare helplessly at the wall, so paralyzing was the pain in his head. He lay in this agony for a long while and then realized he was staring at the painted-over letters of a command to fuck himself. He studied the phrase as the pain in his head subsided.

Like moonlight stealing under a window shade an idea insinuated itself: his earlier desire to see his own face. He looked for a mirror; there was none. Finally, keeping his hands carefully behind his back he made his way to the toilet bowl and peeped in. The water was unevenly lit by the sun so he could make nothing out. Returning to his cot he took the blanket and covered his head, rendering the water dark enough to see his reflection. There in the toilet water he saw a grave black face. A black so definite, so unequivocal, it astonished him. He had been harboring a skittish apprehension that he was not real—that he didn't exist at all. But when the blackness greeted him with its indisputable presence, he wanted nothing more. In his joy he took the risk of letting one edge of the blanket drop and glanced at his hands. They were still. Courteously still.

Shadrack rose and returned to the cot, where he fell into the first sleep of his new life. A sleep deeper than the hospital drugs; deeper than the pits of plums, steadier than the condor's wing; more tranquil than the curve of eggs.

The sheriff looked through the bars at the young man with the matted hair. He had read through his prisoner's papers and hailed a farmer. When Shadrack awoke, the sheriff handed him back his papers and escorted him to the back of a wagon. Shadrack got in and in less than three hours he was back in Medallion, for he had been only twenty-two miles from his window, his river, and his soft voices just outside the door.

In the back of the wagon, supported by sacks of squash and hills of pumpkins, Shadrack began a struggle that was to last for twelve days, a struggle to order and focus experience. It had to do with making a place for fear as a way of controlling it. He knew the smell of death and was terrified of it, for he could not anticipate it. It was not death or dying that frightened him, but the unexpectedness of both. In sorting it all out, he hit on the notion that if one day a year were devoted to it, everybody could get it out of the way and the rest of the year would be safe and free. In this manner he instituted National Suicide Day.

On the third day of the new year, he walked through the Bottom down Carpenter's Road with a cowbell and a hangman's rope calling the people together. Telling them that this was their only chance to kill themselves or each other.

At first the people in the town were frightened; they knew Shadrack was crazy but that did not mean that he didn't have any sense or, even more important, that he had no power. His eyes were so wild, his hair so long and matted, his voice was so full of authority and thunder that he caused panic on the first, or Charter, National Suicide Day in 1920. The next one, in 1921, was less frightening but still worrisome. The people had seen him a year now in between. He lived in a shack on the riverbank that had once belonged to his grandfather long time dead. On Tuesday and Friday he sold the fish he had caught that morning, the rest of the week he was drunk, loud, obscene, funny and outrageous. But he never touched anybody, never fought, never caressed. Once the people understood the boundaries and nature of his madness, they could fit him, so to speak, into the scheme of things.

Then, on subsequent National Suicide Days, the grown people looked out from behind curtains as he rang his bell; a few stragglers increased their speed, and little children screamed and ran. The tetter heads tried goading him (although he was only four or five years older then they) but not for long, for his curses were stingingly personal.

As time went along, the people took less notice of these January thirds, or rather they thought they did, thought they had no attitudes or feelings one way or another about Shadrack's annual solitary parade. In fact they had simply stopped remarking on the holiday because they had absorbed it into their thoughts, into their language, into their lives.

Someone said to a friend, "You sure was a long time delivering that baby. How long was you in labor?"

And the friend answered, "'Bout three days. The pains started on Suicide

Day and kept up till the following Sunday. Was borned on Sunday. All my boys is Sunday boys."

Some lover said to his bride-to-be, "Let's do it after New Years, 'stead of before. I get paid New Year's Eve."

And his sweetheart answered, "OK, but make sure it ain't on Suicide Day. I ain't 'bout to be listening to no cowbells whilst the weddin's going on."

Somebody's grandmother said her hens always started a laying of double yolks right after Suicide Day.

Then Reverend Deal took it up, saying the same folks who had sense enough to avoid Shadrack's call were the ones who insisted on drinking themselves to death or womanizing themselves to death. "May's well go on with Shad and save the Lamb the trouble of redemption."

Easily, quietly, Suicide Day became a part of the fabric of life up in the Bottom of Medallion, Ohio.

Some Notes on the Ocean . . .

William Pope.L

Some critics have written about my work in the past and have constructed my project to primarily focus on race or blackness or a sociology of such ...

Hmmm.

* * *

To mark anything is to create a difference; maybe a world, maybe a wound, certainly an act, let's call it a notion ...

Any notion is an ocean.

Any notion has no beginning and no end. No up. No down. No inside and no outside.

A notion is an anything at all. However, when an anything can be an everything such fullness lacks utility. You cannot build a house with everything at once.

If—it is a house you are wanting to build ...

You cannot build a house with everything at once, only a desert of plentitude.

For meaning to be useful it must be marked.

Sometimes this is a sign on a piece of paper.
Sometimes it's a rock against someone's temple.
Sometimes it is the act of throwing the rock.

Sometimes it is the goal of throwing the rock.
Sometimes it's the temple itself. Sometimes it is what's behind the temple.
Sometimes it's what makes the world go round …

I'm not sure.

Most times it's … I'm not sure …

Concomitant with the above, a mark divides the world into this and that.

To say blackness is anything at all is to mark it off from the world as this thing rather than that.

This is an attempt at stemming the tide of the notion which is, by definition, prone to liquescence, leakage, vapor, oxidation, and doubt …

To say that blackness is a subset of race and reactionary has a certain ring to it but it is probably closer to the truth if we call them competing discourses, competing marks on the same map of human possibility.

Both blackness and race are willing things—like throwing a rock at water.

To be raced by another is a choice that can ossify choice.

To race oneself is a choice that can liquefy choice.

To be black today is a choice that has to be made and re-made like a cake or a bed or a contract or a promise or a solar system …

Race was invented by less-blacks to create a power relation that served their own interests.

In the most obvious sense, less-blacks can sometimes be people who are referred to (or refer to themselves) as white. In our way of thinking, less-blacks are people who, if you asked them whether they would prefer to be black or less-black, would say less-black.

Since the 17th century blacks have been about the project of making their own meanings around blackness. Over time, this project has become much more public. Some blacks wanted to create meanings around blackness that would protect it from less-blacks.

Some blacks, for example, the Black Panthers, wanted to expand the meanings of blackness to make it more inclusive.

Interestingly, the Black Panthers believed in violent revolution.

Isn't it possible that there is no protection for anyone from anything?

Isn't it possible that blackness has always contained within itself its own diffusion?

Pure blackness has utility. It attempts to mark itself off from the world via an aggressive campaign of certainty and rigidity.

The mid-20th century found the media in the United States very attracted to this purity idea. Part of the attraction was that it continued an historic status quo: blackness is one true thing usually defined as lack.

Interestingly enough, some black folk in the US were also interested in foregrounding their own notion of black purity.

The notion of blackness and Africa as possessing a necessary relationship became much more public and important at this time.

There was this idea in the air (like a microbe with cilia) that black people in Africa were somehow blacker than those in the US.

And so—because they were blacker, they were the beginning of black people and US blacks had to look back over their shoulders in order to see them, to not miss them.

As you might imagine, this was very comforting to black folks in the US—now they had a beginning!—but simultaneously they also began to have back problems …

It is disorienting to look back over your shoulder at your shadow knowing it is more valid, more substantial than you—you who are the projector has become a less-black in your own right.

The blackness I am after does not know where Africa is located but can point it out on a map.

It is an interesting project this authenticity/Africa thingy: that is, in order to create a wholeness, a thing unto itself, a purity—one must cross an ocean …

This is a very long way to either absurdity, typicality, desperation, or truth, yet even if it is truth, it may not be logical.

Hmmm.

Blackness is a notion, a desert, a nothing ...

And we all seem to have a use for nothing. It is the fantasy we tell ourselves to mark ourselves off from the world and put us to sleep at night. It is what we use to make money. To make people cry. It is our cereal, it is our milk. It is what we use to kill ourselves with. It is our blankie made out of vapor ...

* * *

... while [Max] Weber is concerned with subjective meaning, he also realized that the effects of human actions are typically the obverse of human intentionality.
Bryan S. Turner, *For Weber: Essays On The Sociology of Fate*, 1981

Dear Adrian,

I hope this letter finds you well. I was thinking of you recently because I had lunch with Jason Moran, who said he always finds inspiration in your art and writings. I do as well. After our meal I went home and listened to "Break Down," the cut on Jason's album *Artist in Residence* that samples a lecture you gave about an artist's responsibilities to the public. Your words are brilliant and the music he set them to is as well.

I am writing to tell you about an exhibition I am curating. In the exhibition my aim is to create a space that positions my work as a series of dialogues with other artists and histories, encouraging the viewer to consider how these dialogues make us the artists we become.

Your work is central to the discussions I want to highlight in the exhibition. When I was just starting out in the mid-1980s, struggling with the expectations and presumptions with which viewers approached the work of a black artist, yours was the work that showed me how to resist those limits. Pieces you did in that period like "Self-Portrait Exaggerating My Negroid Features," the "Mythic Being" drawings, and the photo-text work showed me how identity was socially constructed, contingent, and mutable, not primordial and forever fixed. This had a profound impact on me and set me on a path that led to work such as my "Runaways" series and my "Door Paintings," the earliest of which used an essay by Zora Neale Hurston titled "How It Feels to Be Colored Me." It was not only your investigation of the social construction of the self that inspired me, but the way you insisted that the social and the political formed the ground from which your work sprang and that social and political change was the aim of your practice.

It goes without saying but I will say it anyway: My work would not be possible without the rigor, passion, and fearless investigations that you have brought to the field. Whenever I think I have gone far, I look at your work and see I have so much further to go.

Respectfully,

Glenn Ligon

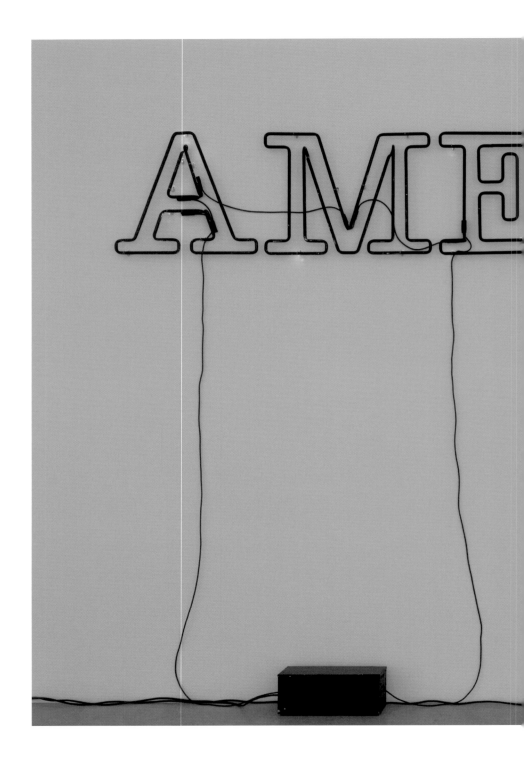

Glenn Ligon, *Untitled*, 2006

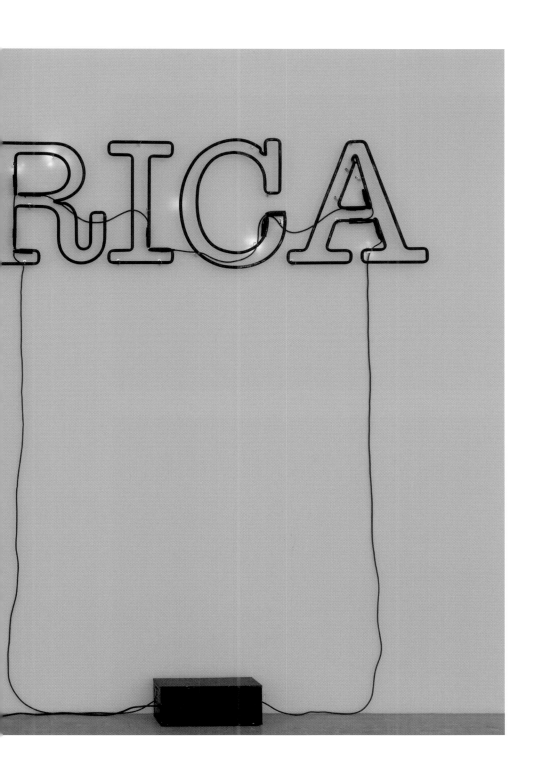

Glenn Ligon, *The Death of Tom*, 2008

Felix Gonzalez-Torres, *"Untitled" (1992)*, 1992

Head Start 1965 L.A. Olympics 1984 Willie Horton 1988 Civil Rights Act 1964
War on Poverty 1964 Trickle Down Economy 1980 L.A. Rebellion 1992 Freedom
Summer 1964 Montgomery Bus Boycott 1955 Watts 1965 EuroDisney 1992

Stephen Andrews, *Dramatis Personae*, 2012

Cady Noland, *Pipes in a Basket*, 1989

Above: William Eggleston, *Untitled*, 1974
Opposite: William Eggleston, *Untitled*, 1972

Giovanni Anselmo, *Invisibile*, 1971

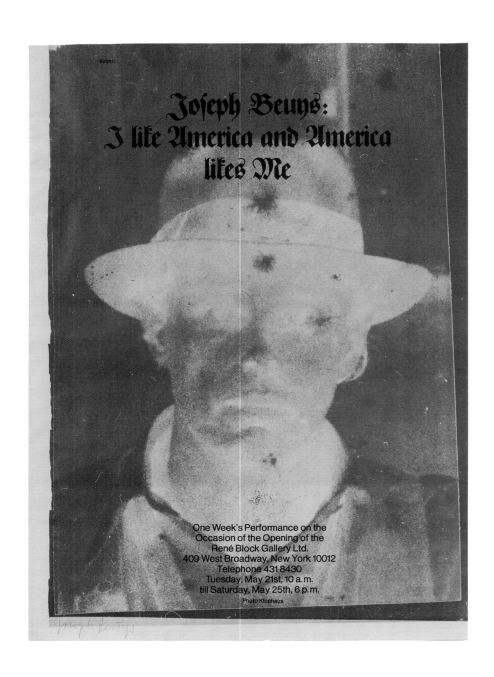

Above: Joseph Beuys, *I Like America and America Likes Me*, 1974
Opposite: Joseph Beuys, *Coyote, I Like America and America Likes Me* (film by Helmut Wietz), 1974

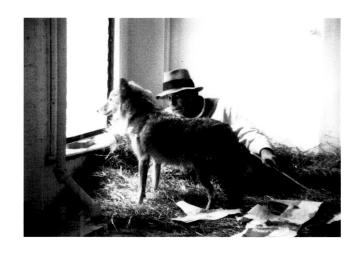

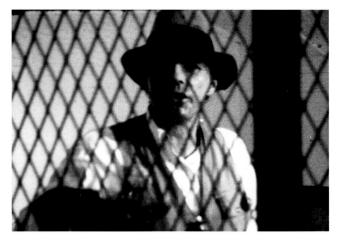

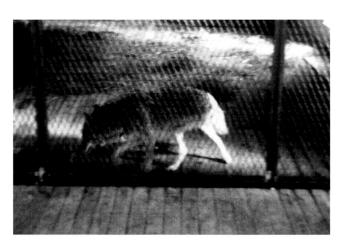

Andy Warhol, *Shadow (Black & White)*, 1979

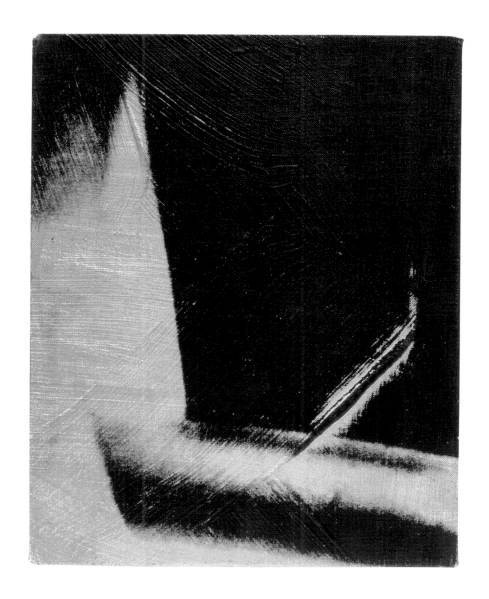

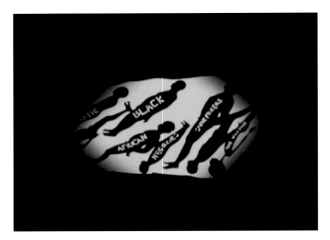

Kara Walker, *8 Possible Beginnings or: The Creation of African-America, a Moving Picture by Kara E. Walker*, 2005

Bruce Nauman, *Flesh to White to Black to Flesh*, 1968

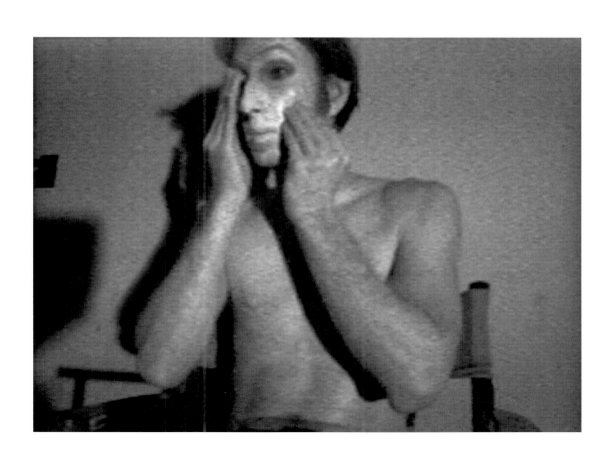

Dave McKenzie, *Babel*, 2006

Above: Adrian Piper, *The Mythic Being*, 1973
Opposite: Adrian Piper, *My Calling (Card) #1 (for Dinners and Cocktail Parties)*, 1986–90

Dear Friend,
 I am black.
 I am sure you did not realize this when you made/laughed at/agreed with that racist remark. In the past, I have attempted to alert white people to my racial identity in advance. Unfortunately, this invariably causes them to react to me as pushy, manipulative, or socially inappropriate. Therefore, my policy is to assume that white people do not make these remarks, even when they believe there are no black people present, and to distribute this card when they do.
 I regret any discomfort my presence is causing you, just as I am sure you regret the discomfort your racism is causing me.

How to See a Work of Art in Total Darkness

Darby English

How to see a work of art in total darkness? One cannot, of course, except in the most extraordinary circumstances, such as when darkness itself forms the condition of the work's visibility. That was the case with *Concerto in Black and Blue*, a 2002 installation by David Hammons that occupied three large rooms in a vast gallery in New York City.[1] At least materially, this site-specific work consisted of nothing more than the physical gallery space, its lights switched off, illuminated only by viewers carrying tiny blue lights (collected upon entry, or not) and the dim glow they generated in tandem. The work's title—equally suggestive of color, violence, music, and race—only amplified the eloquent grace of the physical situation: a cavernous blackness punch-lit by dim cones of light, which partnered with footsteps and whisperings to register the presence of other visitors.[2] To perceive the work, one had literally to become a part of it, all the while carefully negotiating a physically demanding circumstance. Indeed Hammons had not only created a situation from which one could not be fully separate without exiting it altogether; his *Concerto* also produced a dense, inscrutable social space. A sense of kinesthetic saturation in an opaquely symbolic darkness was a requisite part of the experience. One could only know *Concerto*'s peculiar darkness from the inside, not from a position of contemplation but from one of collaboration.

Of course this meant that there was no way to gain from Hammons's *Concerto* a clear, accurate, or extensive picture of its symbolism. A passing familiarity with Hammons's previous work might advise recourse to his blackness, or, more stably, to the fact that since the late 1960s his work has examined the social conditions of black life through an allusive visual poetics of detritus often culled from the streets of Harlem, such as bottles, hair, boom boxes, branches, and the like. A viewer with this knowledge would be hard pressed to understand *Concerto*'s darkness as anything but racially black dark- ness. Yet this prefab reading of Hammons's work denies *Concerto*'s crucially

open formal and symbolic structures. To accept its open structuring is to appreciate its thematization of racial blackness's ultimately discursive character, as well as the spatial aspect of procedures that would fasten its discourses to persons and things by staging its emergence from their "deep structures." *Concerto*'s action is contrary to this in the most literal sense, its blackness falling outside and between bodies and peoples and cultures. In the important conceptual space *Concerto* opens up, we find a remarkably capacious blackness: quite literally discolored, commingled with its contraries, contradictorily populated, the yield of a certain theatricalization. As art, then, *Concerto* accounts for blackness only insofar as it is relationally defined and erratically constituted in the social—not, at last, by reference to a foreknown certainty such as "the black artist" or a "black experience."

Concerto raises a formidable challenge to an old, widely adopted, and ever more cleverly disguised interpretive paradigm, one that sees its defining task as that of establishing or indicating a proper relation between black artists and black art. As if to forestall *Concerto*'s closure within the obvious, limited range of metaphors to do with racially black darkness, Hammons configured the work's structures so that, with each instance of viewer participation, they would undergo meaningful alteration, making *Concerto*'s "blackness" public, participatory, and thereby perpetually innovated, not primordial or preexistent. It is representative of little more than the *idea of black culture*, one given social life in complex interactions, mediated by differently positioned subjects, languages, and forms. In this way, *Concerto* can be seen to stage the contradictory and contested processes whereby racial blackness is conceptualized and represented, and diverse subject positions are assigned, felt, embraced, or contested in relation to it.[3] The properties specific to *Concerto in Black and Blue* through which the visible and knowable appear make any claim to unmediated transparency impossible.[4]

If *Concerto*'s first public showing was understood to represent blackness as an experience on offer in a downtown gallery and available to whomever cared to partake in (or acquire) it,[5] it also made a broader point about viewer complicity in the reproduction of an increasingly inapplicable viewpoint on the nature of the work that black artists do. To acknowledge such viewer complicity is simultaneously to recognize that this viewpoint is often grounded *outside the work of art itself* and beyond the profound intentions of an artist. Unacknowledged, this complicity guarantees the unmodified perpetuation of static icons of black American culture, despite such complex and changing sociopolitical formations as Harlem, to give a pertinent example. To postpone such an acknowledgment is also to assure more inattention to the vastly more ramified presumption that black culture exists nor only as distinct, but as simply available to knowledge in the form of metaphors, pictures, and persons.

To return to one of the predicaments I wish to mark with this book's title, how should we understand the vanishing of this complicity in most contemporary critical accounts of the work? What can explain *Concerto*'s reduction, in such accounts, to a thing of untroubled legibility, whether as "gutsy

public spectacle,"[6] a "confronting darkness," or, still more grossly given the piece's tranquillity, an experience "reminiscent of police cars or bombs over Baghdad"?[7] It is as if such an identification was a requisite exercise in fashioning a public reputation for *Concerto*. These reviews are not simply devoid of any detailed record of the complexities partially accounted above; they appear to commit special critical energy to wishing *Concerto*'s difficulty away, thus relegating Hammons's obdurate design to its metaphors. In a widely read arts blog, a reviewer begins by commending Hammons's light touch on the reins: "Hammons offers us here an opportunity to participate in a practice which the best art affords … in a form whose metaphors are worn lightly and can be treated with whatever gravity the viewer desires."[8] Later, the writer reveals the centrality of this latitude to his understanding of the work. We are told, as this intelligent survey of a few of the implications of *Concerto*'s manifest nothingness concludes, that "there is a sense … in which the entire history of Africans in North America can be told through reference to these two colors [black and blue]."[9] This is precisely how, in the end, *Concerto* is brought to serve this reading: its colors offering the "suggestion of the universality of African American cultural expression, … as that expression is bound up with the contemplation of the colors black and blue."[10] In the highest-profile art world review Hammons's work received, another writer echoed this claim, assuredly stating that "all the 'black and blue' … refers to African-American culture."[11] But if it does, then what, other than racism, can secure this reference?

One part of this book's project is to suggest that in venturing to answer such questions we show a greater willingness to attend to *all that remains unsaid* in a declaration like this one: "social and political events of the past 150 years have exerted a powerful influence on the emergence of African-American art as a distinct form of expression."[12] We do not yet have a way of tending openly and honestly to historical events and developments *on the near side of racism*—that is, exhortations to and about black artists and their work in the name of safeguarding this supposed distinctness—within the framework of dominant patterns of thinking "black art," "racial representation," and other like categories. What I want to insist upon here in the examples provided by the foregoing accounts of Hammons's *Concerto* is that they entail a kind of rhetorical triumph over the disorientations that are most elemental to the work, a triumph that imparts a distinctness that *Concerto* does not have. The visual and spatial effects of its darkness give rise to disorientations, as does its metaphorical suggestiveness, a trait that spatializes *Concerto*'s meaning through dissemination across several clashing idioms.[13] Still, certain "givens" about Hammons's idiom, the idea of black culture in general, or black art dominate the most authorized interpretations of *Concerto*. Paradoxically, the distinctness critics aver on the work's behalf is both sine qua non for these authoritative concepts *and* at odds with the artwork's mechanisms and logics as art. In their efforts to confer upon the work a form that it forcefully disavows, these critics attract considerable attention to the rhetorical work they would oblige *Concerto* to do. In one telling instance, the rhetoric

literally transforms itself beyond the reach of logic, perceptively referring at one moment to *Concerto* as "improvisational social sculpture" generative of "enhanced states of social interactivity," before reducing it in another to a homogenizing reflection of African-American culture.[14] Should this continue, with respect to historical explanation *Concerto* will become indistinct from so many other works by black artists understood to have accepted fully the consequences of their own prior thematization—when in fact it thematizes this very expectation.

I begin with *Concerto* because it brings into focus a problem that has long inhibited understandings of what we call "black art" in the United States: a tendency to limit the significance of works assignable to black artists to what can be illuminated by reference to a work's purportedly racial character. It is a mark of *Concerto in Black and Blue*'s consequentiality that it sets *the experience of black art* at a marked remove from *the artist's actual work* (as in his labor and the balance of its interpretations). Thus *Concerto* points most explicitly to the processes wherein black art is constituted fully in its differ-ence, in scenes of reception organized by interested, structured acts of seeing, interpretation, description, and historicization. On this basis, we might con-sider *Concerto*'s only inarguable subject matter to be the very idea of "a David Hammons show," given this idea's cumulative cultural-historical force—Hammons was fifty-nine and long acknowledged a master by 2002—and the *type* of experience it promises but does not deliver.

In a groundbreaking 1991 essay on historiography, the feminist labor historian Joan W. Scott characterized the peculiar difficulty of experience as a historical category. "Experience," Scott writes, "can both confirm what is already known (we see what we have learned to see) and upset what has been taken for granted (*when different meanings are in conflict, we readjust our vision to take account of the conflict* or to resolve it—that is what is meant by 'learning from experience'...). Experience is a subject's history. Language is the site of history's enactment. Historical explanation, therefore, cannot separate the two."[15] This book aims to extend *Concerto* and Scott's dissimilar but, I think, complementary projects in two directions: first, to the history of American art, in which the respective emergences of the concepts "black art" and the "black artist" are seen as events in need of a new under-standing; and second, to the analysis of five contemporary artistic practices that place versions of "African-American experience" under trenchant scrutiny. This study refuses the contention that "African-American art [is] a distinct form of expression," by isolating specific practices, even specific aspects of them, where the engagement of conventions, themes, problems, and tactics derived from a variety of art historical and sociopolitical contexts does not simply embarrass claims of distinctness but, far more consequently, satisfies the representational demands of artists for whom the question of cultural position is not given, but historically and socially shaped and, to a degree, a matter of preference. *How to See a Work of Art in Total Darkness* aims to diminish somewhat an encumbrance that dominates too many of our

ideas about the kinds of knowledge black artists' work is permitted to reflect and generate.

It is an unfortunate fact that in this country, black artists' work seldom serves as the basis of rigorous, object-based debate. Instead, it is almost uniformly generalized, endlessly summoned to prove its representativeness (or defend its lack of same) and contracted to show-and-tell on behalf of an abstract and unchanging "culture of origin." For all this, the art gains little purchase on the larger social, cultural, historical, and aesthetic formations to which it nevertheless directs itself with increasing urgency. And in the long term, it runs the risk of moving beyond serious thought and debate. Viewed this way, the given and necessary character of black art—as a framework for understanding what black artists do—emerges as a problem in itself.

NOTES

1. The exhibition ran from November 14, 2002, to February 1, 2003, at the Ace Gallery. For a relevant contextualization of *Concerto*, see Glenn Ligon, "Black Light: David Hammons and the Poetics of Emptiness," *Artforum* (September 2004): 242–249.

2. See Peter Schjeldahl, "The Walker: Rediscovering New York with David Hammons," *New Yorker*, 23/30 December 2002, 156–159.

3. See Joan W. Scott, "The Evidence of Experience," in James Chandler, Arnold Davidson, and Harry Harootunian, eds., *Questions of Evidence* (Chicago: University of Chicago Press, 1991), 375, 384.

4. This sentence interpolates a part of Karen Swann's reading of a passage in Samuel Delany's autobiography *The Motion of Light in Water*. Swann, quoted in Scott, "Evidence of Experience," 384.

5. If *Concerto* resisted its own commodification, it did so incompletely: Hammons is said to have priced *Concerto* according to the amount of space, measured in square feet, that its purchaser intended to fill.

6. Calvin Reid, "David Hammons at Ace," *Art in America* 91:3 (March 2003): 114.

7. Charlie Finch, "Lie Down in the Darkness," www.artnet.com/Magazine/features/finch/finch11-15-02, accessed December 2002.

8. Geoffrey Jacques, "'Concerto in Black and Blue' by David Hammons," in *A Gathering of the Tribes*, www.tribes.org/cgi-bin/form.pl?karticle=58, accessed June 2003.

9. Ibid.

10. Ibid.

11. Jan Avgikos, review of David Hammons's *Concerto in Black and Blue*, *Artforum* (February 2003): 137–138.

12. See Guy McElroy et al., *African-American Artists, 1880–1987: Selections from the Evans-Tibbs Collection* (Washington: Smithsonian Institution Traveling Exhibition Service; Seattle: University of Washington Press, 1989), 9.

13. For an invaluable discussion of this sense of spatialization, see "The Spatial Arts: An Interview with Jacques Derrida," in Peter Brunette and David Wills, eds., *Deconstruction in the Visual Arts: Art, Media, Architecture* (Cambridge: Cambridge University Press, 1994), esp. 21–22.

14. Avgikos, review of Hammons's *Concerto*, 137, 138.

15. Scott, "Evidence of Experience," 383; my emphasis.

New Ethnicities

Stuart Hall

I have centred my remarks on an attempt to identify and characterize a significant shift that has been going on (and is still going on) in black cultural politics. This shift is not definitive, in the sense that there are two clearly discernible phases – one in the past which is now over and the new one which is beginning – which we can neatly counterpose to one another. Rather, they are two phases of the same movement, which constantly overlap and interweave. Both are framed by the same historical conjuncture and both are rooted in the politics of anti-racism and the post-war black experience in Britain. Nevertheless I think we can identify two different 'moments' and that the difference between them is significant.

It is difficult to characterize these precisely, but I would say that the first moment was grounded in a particular political and cultural analysis. Politically, this is the moment when the term 'black' was coined as a way of referencing the common experience of racism and marginalization in Britain and came to provide the organizing category of a new politics of resistance, among groups and communities with, in fact, very different histories, traditions and ethnic identities. In this moment, politically speaking, 'the black experience', as a singular and unifying framework based on the building up of identity across ethnic and cultural difference between the different communities, became 'hegemonic' over other ethnic/racial identities – though the latter did not, of course, disappear. Culturally, this analysis formulated itself in terms of a critique of the way blacks were positioned as the unspoken and invisible 'other' of predominantly white aesthetic and cultural discourses.

This analysis was predicated on the marginalization of the black experience in British culture; not fortuitously occurring at the margins, but placed, positioned at the margins, as the consequence of a set of quite specific political and cultural practices which regulated, governed and 'normalized' the representational and discursive spaces of English society. These formed the conditions of existence of a cultural politics designed to challenge, resist and, where possible, to transform

the dominant regimes of representation – first in music and style, later in literary, visual and cinematic forms. In these spaces blacks have typically been the objects, but rarely the subjects, of the practices of representation. The struggle to come into representation was predicated on a critique of the degree of fetishization, objectification and negative figuration which are so much a feature of the representation of the black subject. There was a concern not simply with the absence or marginality of the black experience but with its simplification and its stereotypical character.

The cultural politics and strategies which developed around this critique had many facets, but its two principal objects were: first the question of *access* to the rights to representation by black artists and black cultural workers themselves. Second, the *contestation* of the marginality, the stereotypical quality and the fetishized nature of images of blacks, by the counter-position of a 'positive' black imagery. These strategies were principally addressed to changing what I would call the 'relations of representation'.

I have a distinct sense that in the recent period we are entering a new phase. But we need to be absolutely clear what we mean by a 'new' phase because, as soon as you talk of a new phase, people instantly imagine that what is entailed is the *substitution* of one kind of politics for another. I am quite distinctly not talking about a shift in those terms. Politics does not necessarily proceed by way of a set of oppositions and reversals of this kind, though some groups and individuals are anxious to 'stage' the question in this way. The original critique of the predominant relations of race and representation and the politics which developed around it have not and cannot possibly disappear while the conditions which gave rise to it – cultural racism in its Dewsbury form – not only persists but positively flourishes under Thatcherism.[1] There is no sense in which a new phase in black cultural politics could replace the earlier one. Nevertheless it is true that as the struggle moves forward and assumes new forms, it does to some degree *displace*, reorganize and reposition the different cultural strategies in relation to one another. If this can be conceived in terms of the 'burden of representation', I would put the point in this form: that black artists and cultural workers now have to struggle, not on one, but on *two* fronts. The problem is, how to characterize this shift – if indeed, we agree that such a shift has taken or is taking place – if the language of binary oppositions and substitutions will no longer suffice. The characterization that I would offer is tentative, proposed in the context of this essay mainly to try and clarify some of the issues involved, rather than to pre-empt them.

The shift is best thought of in terms of a change from a struggle over the relations of representation to a politics of representation itself. It would be useful to separate out such a 'politics of representation' into its different elements. We all now use the word representation, but, as we know, it is an extremely slippery customer. It can be used, on the one hand, simply as another way of talking about how one imagines a reality that exists 'outside' the means by which things are represented: a conception grounded in a mimetic theory of representation. On the other hand the term can also stand for a very radical displacement of that unproblematic notion of the concept of representation. My own view is that events,

195

relations, structures do have conditions of existence and real effects, outside the sphere of the discursive; but that it is only within the discursive, and subject to its specific conditions, limits and modalities, that they have or can be constructed within meaning. Thus, while not wanting to expand the territorial claims of the discursive infinitely, how things are represented and the 'machineries' and regimes of representation in a culture do play a *constitutive*, and not merely a reflexive, after-the-event, role. This gives questions of culture and ideology, and the scenarios of representation – subjectivity, identity, politics – a formative, not merely an expressive, place in the constitution of social and political life. I think it is the move towards this second sense of representation which is taking place and which is transforming the politics of representation in black culture.

This is a complex issue. First, it is the effect of a theoretical encounter between black cultural politics and the discourses of a Eurocentric, largely white, critical cultural theory which, in recent years, has focused so much analysis on the politics of representation. This is always an extremely difficult, if not dangerous, encounter. (I think particularly of black people encountering the discourses of post-structuralism, postmodernism, psychoanalysis and feminism.) Second, it marks what I can only call 'the end of innocence', or the end of the innocent notion of the essential black subject. Here again, the end of the essential black subject is something which people are increasingly debating, but they may not have fully reckoned with its political consequences. What is at issue here is the recognition of the extraordinary diversity of subjective positions, social experiences and cultural identities which compose the category 'black': that is, the recognition that 'black' is essentially a politically and culturally *constructed* category, which cannot be grounded in a set of fixed trans-cultural or transcendental racial categories and which therefore has no guarantees in nature. What this brings into play is the recognition of the immense diversity and differentiation of the historical and cultural experience of black subjects. This inevitably entails a weakening or fading of the notion that 'race' or some composite notion of race around the term black will either guarantee the effectivity of any cultural practice or determine in any final sense its aesthetic value.

We should put this as plainly as possible. Films are not necessary good because black people make them. They are not necessarily 'right-on' by virtue of the fact that they deal with the black experience. Once you enter the politics of the end of the essential black subject you are plunged headlong into the maelstrom of a continuously contingent, unguaranteed, political argument and debate: a critical politics, a politics of criticism. You can no longer conduct black politics through the strategy of a simple set of reversals, putting in the place of the bad old essential white subject, the new essentially good black subject. Now, that formulation may seem to threaten the collapse of an entire political world. Alternatively, it may be greeted with extraordinary relief at the passing away of what at one time seemed to be a necessary fiction. Namely, either that all black people are good or indeed that all black people are *the same*. After all, it is one of the predicates of racism that 'you can't tell the difference because they all look the same'. This does not make it any easier to conceive of how a politics can be constructed which works

with and through difference, which is able to build those forms of solidarity and identification which make common struggle and resistance possible but without suppressing the real heterogeneity of interests and identities, and which can effectively draw the political boundary lines without which political contestation is impossible, without fixing those boundaries for eternity. It entails the movement in black politics from what Gramsci called the 'war of manoeuvre' to the 'war of position' – the struggle around positionalities. But the difficulty of conceptualizing such a politics (and the temptation to slip into a sort of endlessly sliding discursive liberal-pluralism) does not absolve us of the task of developing such a politics.

The end of the essential black subject also entails a recognition that the central issues of race always appear historically in articulation, in a formation, with other categories and divisions and are constantly crossed and recrossed by the categories of class, of gender and ethnicity. (I make a distinction here between race and ethnicity to which I shall return.) To me, films like *Territories*, *Passion of Remembrance*, *My Beautiful Launderette* and *Sammy and Rosie Get Laid*, for example, make it perfectly clear that this shift has been engaged, and that the question of the black subject cannot be represented without reference to the dimensions of class, gender, sexuality and ethnicity.

Difference and Contestation

A further consequence of this politics of representation is the slow recognition of the deep ambivalence of identification and desire. We think about identification usually as a simple process, structured around fixed 'selves' which we either are or are not. The play of identity and difference which constructs racism is powered not only by the positioning of blacks as the inferior species but also, and at the same time, by an inexpressible envy and desire; and this is something the recognition of which fundamentally *displaces* many of our hitherto stable political categories, since it implies a process of identification and otherness which is more complex than we had hitherto imagined.

Racism, of course, operates by constructing impassable symbolic boundaries between racially constituted categories, and its typically binary system of representation constantly marks and attempts to fix and naturalize the difference between belongingness and otherness. Along this frontier there arises what Gayatri Spivak calls the 'epistemic violence' of the discourses of the Other – of imperialism, the colonized, Orientalism, the exotic, the primitive, the anthropological and the folk-lore.[2] Consequently the discourse of anti-racism had often been founded on a strategy of reversal and inversion, turning the 'Manichean aesthetic' of colonial discourse upside-down. However, as Fanon constantly reminded us, the epistemic violence is both outside and inside, and operates by a process of splitting on both sides of the division – in here as well as out there. That is why it is a question, not only of 'black-skin' but of '*Black-Skin, White Masks*' – the internalization of the self-as-other. Just as masculinity always constructs femininity as double – simultaneously Madonna and Whore – so racism constructs the black subject: noble savage and violent avenger. And in the doubling, fear and desire

double for one another and play across the structures of otherness, complicating its politics.

Recently I have read several articles about the photographic text of Robert Mapplethorpe – especially his inscriptions of the nude, black male – all written by black critics or cultural practitioners.[3] These essays properly begin by identifying in Mapplethorpe's work the tropes of fetishization, the fragmentation of the black image and its objectification, as the forms of their appropriation within the white, gay gaze. But, as I read, I know that something else is going on as well in both the production and the reading of those texts. The continuous circling around Mapplethorpe's work is not exhausted by being able to place him as the white, fetishistic, gay photographer; and this is because it is also marked by the surreptitious return of desire – that deep ambivalence of identification which makes the categories in which we have previously thought and argued about black cultural politics and the black cultural text extremely problematic. This brings to the surface the unwelcome fact that a great deal of black politics, constructed, addressed and developed directly in relation to questions of race and ethnicity, has been predicated on the assumption that the categories of gender and sexuality would stay the same and remain fixed and secured. What the new politics of representation does is to put that into question, crossing the questions of racism irrevocably with questions of sexuality. That is what is so disturbing, finally, to many of our settled political habits about *Passion of Remembrance*. This double fracturing entails a different kind of politics because, as we know, black radical politics has frequently been stabilized around particular conceptions of black masculinity, which are only now being put into question by black women and black gay men. At certain points, black politics has also been underpinned by a deep absence or more typically an evasive silence with reference to class.

Another element inscribed in the new politics of representation has to do with the question of ethnicity. I am familiar with all the dangers of 'ethnicity' as a concept and have written myself about the fact that ethnicity, in the form of a culturally constructed sense of Englishness and a particularly closed, exclusive and regressive form of English national identity, is one of the core characteristics of British racism today.[4] I am also well aware that the politics of anti-racism has often constructed itself in terms of a contestation of 'multi-ethnicity' or 'multi-culturalism'. On the other hand, as the politics of representation around the black subject shifts, I think we will begin to see a renewed contestation over the meaning of the term 'ethnicity' itself.

If the black subject and black experience are not stabilized by Nature or by some other essential guarantee, then it must be the case that they are constructed historically, culturally, politically – and the concept which refers to this is 'ethnicity'. The term ethnicity acknowledges the place of history, language and culture in the construction of subjectivity and identity, as well as the fact that all discourse is placed, positioned, situated, and all knowledge is contextual. Representation is possible only because enunciation is always produced within codes which have a history, a position within the discursive formations of a particular space and time. The displacement of the 'centred' discourses of the West entails putting in question

with and through difference, which is able to build those forms of solidarity and identification which make common struggle and resistance possible but without suppressing the real heterogeneity of interests and identities, and which can effectively draw the political boundary lines without which political contestation is impossible, without fixing those boundaries for eternity. It entails the movement in black politics from what Gramsci called the 'war of manoeuvre' to the 'war of position' – the struggle around positionalities. But the difficulty of conceptualizing such a politics (and the temptation to slip into a sort of endlessly sliding discursive liberal-pluralism) does not absolve us of the task of developing such a politics.

The end of the essential black subject also entails a recognition that the central issues of race always appear historically in articulation, in a formation, with other categories and divisions and are constantly crossed and recrossed by the categories of class, of gender and ethnicity. (I make a distinction here between race and ethnicity to which I shall return.) To me, films like *Territories*, *Passion of Remembrance*, *My Beautiful Launderette* and *Sammy and Rosie Get Laid*, for example, make it perfectly clear that this shift has been engaged, and that the question of the black subject cannot be represented without reference to the dimensions of class, gender, sexuality and ethnicity.

Difference and Contestation

A further consequence of this politics of representation is the slow recognition of the deep ambivalence of identification and desire. We think about identification usually as a simple process, structured around fixed 'selves' which we either are or are not. The play of identity and difference which constructs racism is powered not only by the positioning of blacks as the inferior species but also, and at the same time, by an inexpressible envy and desire; and this is something the recognition of which fundamentally *displaces* many of our hitherto stable political categories, since it implies a process of identification and otherness which is more complex than we had hitherto imagined.

Racism, of course, operates by constructing impassable symbolic boundaries between racially constituted categories, and its typically binary system of representation constantly marks and attempts to fix and naturalize the difference between belongingness and otherness. Along this frontier there arises what Gayatri Spivak calls the 'epistemic violence' of the discourses of the Other – of imperialism, the colonized, Orientalism, the exotic, the primitive, the anthropological and the folk-lore.[2] Consequently the discourse of anti-racism had often been founded on a strategy of reversal and inversion, turning the 'Manichean aesthetic' of colonial discourse upside-down. However, as Fanon constantly reminded us, the epistemic violence is both outside and inside, and operates by a process of splitting on both sides of the division – in here as well as out there. That is why it is a question, not only of 'black-skin' but of '*Black-Skin, White Masks*' – the internalization of the self-as-other. Just as masculinity always constructs femininity as double – simultaneously Madonna and Whore – so racism contructs the black subject: noble savage and violent avenger. And in the doubling, fear and desire

double for one another and play across the structures of otherness, complicating its politics.

Recently I have read several articles about the photographic text of Robert Mapplethorpe – especially his inscriptions of the nude, black male – all written by black critics or cultural practitioners.[3] These essays properly begin by identifying in Mapplethorpe's work the tropes of fetishization, the fragmentation of the black image and its objectification, as the forms of their appropriation within the white, gay gaze. But, as I read, I know that something else is going on as well in both the production and the reading of those texts. The continuous circling around Mapplethorpe's work is not exhausted by being able to place him as the white, fetishistic, gay photographer; and this is because it is also marked by the surreptitious return of desire – that deep ambivalence of identification which makes the categories in which we have previously thought and argued about black cultural politics and the black cultural text extremely problematic. This brings to the surface the unwelcome fact that a great deal of black politics, constructed, addressed and developed directly in relation to questions of race and ethnicity, has been predicated on the assumption that the categories of gender and sexuality would stay the same and remain fixed and secured. What the new politics of representation does is to put that into question, crossing the questions of racism irrevocably with questions of sexuality. That is what is so disturbing, finally, to many of our settled political habits about *Passion of Remembrance*. This double fracturing entails a different kind of politics because, as we know, black radical politics has frequently been stabilized around particular conceptions of black masculinity, which are only now being put into question by black women and black gay men. At certain points, black politics has also been underpinned by a deep absence or more typically an evasive silence with reference to class.

Another element inscribed in the new politics of representation has to do with the question of ethnicity. I am familiar with all the dangers of 'ethnicity' as a concept and have written myself about the fact that ethnicity, in the form of a culturally constructed sense of Englishness and a particularly closed, exclusive and regressive form of English national identity, is one of the core characteristics of British racism today.[4] I am also well aware that the politics of anti-racism has often constructed itself in terms of a contestation of 'multi-ethnicity' or 'multi-culturalism'. On the other hand, as the politics of representation around the black subject shifts, I think we will begin to see a renewed contestation over the meaning of the term 'ethnicity' itself.

If the black subject and black experience are not stabilized by Nature or by some other essential guarantee, then it must be the case that they are constructed historically, culturally, politically – and the concept which refers to this is 'ethnicity'. The term ethnicity acknowledges the place of history, language and culture in the construction of subjectivity and identity, as well as the fact that all discourse is placed, positioned, situated, and all knowledge is contextual. Representation is possible only because enunciation is always produced within codes which have a history, a position within the discursive formations of a particular space and time. The displacement of the 'centred' discourses of the West entails putting in question

its universalist character and its transcendental claims to speak for everyone, while being itself everywhere and nowhere. The fact that this grounding of ethnicity in difference was deployed, in the discourse of racism, as a means of disavowing the realities of racism and repression does not mean that we can permit the term to be permanently colonized. That appropriation will have to be contested, the term dis-articulated from its position in the discourse of 'multi-culturalism' and transcoded, just as we previously had to recuperate the term 'black' from its place in a system of negative equivalences. The new politics of representation therefore also sets in motion an ideological contestation around the term 'ethnicity'. But in order to pursue that movement further, we will have to re-theorize the concept of *difference*.

It seems to me that, in the various practices and discourses of black cultural production, we are beginning to see constructions of just such a new conception of ethnicity: a new cultural politics which engages rather than suppresses *difference* and which depends, in part, on the cultural construction of new ethnic identities. Difference, like representation, is also a slippery and, therefore, contested concept. There is the 'difference' which makes a radical and unbridgeable separation; and there is a 'difference' which is positional, conditional and conjunctural, closer to Derrida's notion of *différance*, though if we are concerned to maintain a politics it cannot be defined exclusively in terms of an infinite sliding of the signifier. We still have a great deal of work to do to *decouple* ethnicity, as it functions in the dominant discourse, from its equivalence with nationalism, imperialism, racism and the state, which are the points of attachment around which a distinctive British or, more accurately, English ethnicity has been constructed. Nevertheless, I think such a project is not only possible but necessary. Indeed, this decoupling of ethnicity from the violence of the state is implicit in some of the new forms of cultural practice that are going on in films like *Passion* and *Handsworth Songs*. We are beginning to think about how to represent a non-coercive and a more diverse conception of ethnicity, to set against the embattled, hegemonic conception of 'Englishness' which, under Thatcherism, stabilizes so much of the dominant political and cultural discourses, and which, because it is hegemonic, does not represent itself as an ethnicity at all.

This marks a real shift in the point of contestation, since it is no longer only between anti-racism and multi-culturalism but *inside* the notion of ethnicity itself. What is involved is the splitting of the notion of ethnicity between, on the one hand the dominant notion which connects it to nation and 'race' and on the other hand what I think is the beginning of a positive conception of the ethnicity of the margins, of the periphery. That is to say, a recognition that we all speak from a particular place, out of a particular history, out of a particular experience, a particular culture, without being contained by that position as 'ethnic artists' or film-makers. We are all, in that sense, *ethnically* located and our ethnic identities are crucial to our subjective sense of who we are. But this is also a recognition that this is not an ethnicity which is doomed to survive, as Englishness was, only by marginalizing, dispossessing, displacing and forgetting other ethnicities. This precisely is the politics of ethnicity predicated on difference and diversity.

The final point which I think is entailed in this new politics of representation has to do with an awareness of the black experience as a *diaspora* experience, and the consequences which this carries for the process of unsettling, recombination, hybridization and 'cut-and-mix' – in short, the process of cultural *diaspora-ization* (to coin an ugly term) which it implies. In the case of the young black British films and film-makers under discussion, the diaspora experience is certainly profoundly fed and nourished by, for example, the emergence of Third World cinema; by the African experience; the connection with Afro-Caribbean experience; and the deep inheritance of complex systems of representation and aesthetic traditions from Asian and African culture. But, in spite of these rich cultural 'roots', the new cultural politics is operating on new and quite distinct ground – specifically, contestation over what it means to be 'British'. The relation of this cultural politics to the past, to its different 'roots' is profound, but complex. It cannot be simple or unmediated. It is (as a film like *Dreaming Rivers* remind us) complexly mediated and transformed by memory, fantasy and desire. Or, as even an explicitly political film like *Handsworth Songs* clearly suggests, the relation is intertextual – mediated through a variety of other 'texts'. There can, therefore, be no simple 'return' or 'recovery' of the ancestral past which is not re-experienced though the categories of the present: no base for creative enunciation in a simple reproduction of traditional forms which are not transformed by the technologies and the identities of the present. This is something that was signalled as early as a film like *Blacks Britannica* and as recently as Paul Gilroy's important book, *There Ain't No Black in the Union Jack*.[5] Fifteen years ago we didn't care, or at least I didn't care, whether there was any black in the Union Jack. Now not only do we care, we *must*.

This last point suggests that we are also approaching what I would call the end of a certain critical innocence in black cultural politics. And here it might be appropriate to refer, glancingly, to the debate between Salman Rushdie and myself in the *Guardian* some months ago. The debate was not about whether *Handsworth Songs* or *The Passion of Remembrance* were great films or not, because, in the light of what I have said, once you enter this particular problematic, the question of what good films are, which parts of them are good and why, is open to the politics of criticism. Once you abandon essential categories, there is no place to go apart from the politics of criticism and to enter the politics of criticism in black culture is to grow up, to leave the age of critical innocence.

It was not Salman Rushdie's particular judgement that I was contesting, so much as the mode in which he addressed them. He seemed to me to be addressing the films as if from the stable, well-established critical criteria of a *Guardian* reviewer. I was trying, perhaps unsuccessfully, to say that I thought this an inadequate basis for a political criticism and one which overlooked precisely the signs of innovation, and the constraints, under which these film-makers were operating. It is difficult to define what an alternative mode of address would be. I certainly didn't want Salman Rushdie to say he thought the films were good because they were black. But I also didn't want him to say that he thought they weren't good because 'we creative artists all know what good films are', since I no longer believe

we can resolve the questions of aesthetic value by the use of these transcendental, canonical cultural categories. I think there is another position, one which locates itself *inside* a continuous struggle and politics around black representation, but which then is able to open up a continuous critical discourse about themes, about the forms of representation, the subjects of representation, above all, the regimes of representation. I thought it was important, at that point, to intervene to try and get that mode of critical address right, in relation to the new black film-making. It is extremely tricky, as I know, because as it happens, in intervening, I got the mode of address wrong too! I failed to communicate the fact that, in relation to his *Guardian* article, I thought Salman was hopelessly wrong about *Handsworth Songs*, which does not in any way diminish my judgement about the stature of *Midnight's Children*. I regret that I couldn't get it right, exactly, because the politics of criticism has to be able to get both things right.

Such a politics of criticism has to be able to say (just to give one example) why *My Beautiful Laundrette* is one of the most riveting and important films produced by a black writer in recent years and precisely for the reason that made it so controversial: its refusal to represent the black experience in Britain as monolithic, self-contained, sexually stabilized and always 'right-on' – in a word, always and only 'positive', or what Hanif Kureishi has called 'cheering fictions':

> the writer as public relations officer, as hired liar. If there is to be a serious attempt to understand Britain today, with its mix of races and colours, its hysteria and despair, then writing about it has to be complex. It can't apologize or idealize. It can't sentimentalize and it can't represent only one group as having a monopoly on virtue.[6]

Laundrette is important particularly in terms of its control, of knowing what it is doing, as the text crosses those frontiers between gender, race, ethnicity, sexuality and class. *Sammy and Rosie* is also a bold and adventurous film, though in some ways less coherent, not so sure of where it is going, overdriven by an almost uncontrollable, cool anger. One needs to be able to offer that as a critical judgement and to argue it through, to have one's mind changed, without undermining one's essential commitment to the project of the politics of black representation.

NOTES

1. The Yorkshire town of Dewsbury became the focus of national attention when white parents withdrew their children from a local school with predominantly Asian pupils, on the grounds that 'English' culture was no longer taught on the curriculum. The contestation of multi-cultural education from the right also underpinned the controversies around Bradford headmaster Ray Honeyford. See Paul Gordon, 'The New Right, race and education', *Race and Class* XXIX (3), Winter 1987.
2. Gayatri C. Spivak, *In Other Worlds: Essays in Cultural Politics*, Methuen, 1987.
3. Kobena Mercer, 'Imagine the black man's sex', in Patricia Holland *et al.* (eds), *Photography/Politics: Two*, Comedia/ Methuen, 1987, and various articles in *Ten.8* 22, 1986, an issue on 'Black experiences' edited by David A. Bailey.
4. Stuart Hall, 'Racism and reaction', in *Five Views on Multi-Racial Britain*, Commission for Racial Equality, 1978.
5. Paul Gilroy, *There Ain't No Black in the Union Jack: The Cultural Politics of Race and Nation*, Hutchinson, 1988.
6. Hanif Kureishi, 'Dirty washing', *Time Out*, 14–20 November 1985.

The Blob

Wayne Koestenbaum

1.

Susan Sontag wrote eloquently about the moral complexities of looking at photographs of other people's suffering. And then she died. Annie Leibovitz took photos of her dying, and photos of her corpse, and published them. They are difficult to look at. I've never seen a dead body, except at a wake, after the body has been primped and prettied. My friend John, an aesthete, died of AIDS; I saw his corpse. Two other corpses I've seen: the mother of my friend Glenn, a painter; and the brother of my friend Lazarus, an architect. At Anna Moffo's wake, which I attended, the casket was closed. The photos of dead Sontag confused and frightened me. At first I didn't understand that the recumbent object was a dead body; I thought it was an expensive effigy, an Egyptian antiquity, a statue carved out of a tree trunk. Then I realized that this dark lump was Sontag. Here's how her son, David Rieff, in his book *Swimming in a Sea of Death*, described the effect of those photos: his mother was "humiliated posthumously by being 'memorialized' that way in those carnival images of celebrity death taken by Annie Leibovitz." Rieff's use of the word "humiliated" deserves pondering. Can one be humiliated posthumously? If Sontag isn't alive to experience the indignity, is she actually being humiliated? The disfigurements of illness, the bloating and discoloration of death: I understand Rieff's point, I reckon how humiliating it would be to know that someone is seeing my body when it has grown ugly and unrecognizable and not quite human, when it has become a piece of sacred rubbish. Trying to figure out whether dying and death are humiliating, and for whom they are humiliating (the survivors? the witnesses?), I begin to examine my attitudes toward disfigured or impaired bodies, which have, at times, inspired in me a combination of voyeuristic curiosity and physical horror. Recently at the grocery store I saw a woman

whose mottled face was swollen to twice the size of a "normal" face. I don't know the name for her condition, but I know that she wore fashionable shoes and well fitting jeans that showed off her svelte waistline and shapely buttocks. I also noticed the fine material of her sweater—cashmere?—and I wondered how she coped with the stares of other people; I wondered whether I would be doing her more of an injustice by looking away from her face or by neutrally noticing it, perhaps even smiling or establishing friendly eye contact. I felt, wrongly or rightly, that my presence, in the grocery store, as a non-disfigured person, who might have self-conscious and self-lacerating attitudes toward his own appearance but who had no medically acknowledged abnormalities of feature, intensified this woman's humiliation. And I remembered a freakish kid in my neighborhood when I was growing up: my brother and I referred to him as the Blob because he had a lumpy jaw—as if a golf ball had lodged between his lower lip and his chin. I sometimes saw the Blob at Safeway supermarket with his mother; I was afraid to look directly at him, afraid that I would somehow get infected by his deformity if I acknowledged him. Whether he was "retarded" or merely "deformed" I couldn't ascertain, but I knew that I belonged to the social engine that had inadvertently or deliberately humiliated him, even if he'd never heard me say, "Look! There's the Blob!," even if he'd never seen my hilarious Blob impersonation—tongue crammed beneath a distended bottom lip, jaw protruding like a dog's muzzle.

2.

Earlier, I asserted that humiliation is always a triangle: tyrant, victim, witness. In the case of the Sontag photos, the photographer (Leibovitz) is the unwitting tyrant, Sontag is the victim, and we (the viewers) are the witnesses. But the humiliation happens not inside Sontag's body, which no longer exists, but inside our bodies, watching. Indeed, the humiliation doesn't actually happen; it is a cloud of inference and aftermath, a nonlocatable atmosphere of outrage and distress. We use the word "humiliation" sometimes merely rhetorically, to describe a potential for agony, even if the agony is not always, in that instant, an actual experience; in these cases, humiliation can't be touched, measured, visualized, or weighed. When I saw the disfigured woman at the grocery store, humiliation didn't actually exist. It hadn't yet taken form as a scene of violence or insult or rejection; rather, humiliation was merely an imminence—the danger that someone might treat this woman in a hurtful way. Vulnerability cast a cloud over her—call it a storm cloud, a constant threat of rain, and the rain that threatened to fall was humiliation. It never fell, as I far as I could tell, but I was powerless to prevent it from falling. I did not humiliate the woman at the grocery store, though witnessing her vulnerability showered me with discomfort, as if I, the witness, were "catching" humiliation from her—or else wrongfully imputing it to her, burdening a stranger with my own fears.

3.

And now, without apology, but with considerable dread, I turn to lynching photographs—souvenir images taken of the flayed, burned, gouged, dismembered corpses of black men, and sometimes women, in the South. That such grisly photographs exist proves that white people were happy to stand near the disfigured corpses; white perpetrators and bystanders were proud to murder and then to gloat. (I stop writing, and look again at the photographs. I keep looking. The longer I look, the more I lose my grip on words.) These photographs show that white people believed the event— torture and murder—worth commemorating and communicating. The word "humiliation" seems inadequate to describe the atrocity of lynching; and yet, before the torture and mutilation ended (and sometimes it lasted for hours), before the sanctioned exercise of mass sadism came to a conclusion, if the effects of such cruelties ever end, the desire to humiliate must have been among the motives of the murderers. The lynching photographs—limit-case images, which call into question what it means to look at a photograph and what it means to be an American—document and perpetuate the white reign of terror; they continue the work of bringing blacks down, of advertising and entrenching their subordination, of "desubjectifying" blacks, perpetuating their humiliation, and foreclosing liberation. The photos don't merely record acts of humiliation and violence; they perform and extend the damage. They make horror happen again. The photos are of dying and dead bodies, but the photos are alive. They can't be put to sleep. Hilton Als, in his essay "GWTW," included in *Without Sanctuary: Lynching Photography in America*, speaks candidly about the continuities he senses between lynching photographs and his own experiences of being looked at by white people. Als: "Of course, one big difference between the people documented in these pictures and me is that I am not dead, have not been lynched or scalded or burned or whipped or stoned. But I have been looked at, watched, and it's the experience of being watched, and seeing the harm in people's eyes—that is the prelude to becoming a dead nigger like those seen here, that has made me understand, finally, what the word 'nigger' means, and why people have used it, and the way I use it here, now: as a metaphorical lynching before the real one." Cruelly watched, he has seen "the harm in people's eyes." In that eye-to-eye moment of confrontation, he has received the warning. I've called it the Jim Crow gaze—the moment of being seen as naught, of realizing that you aren't being viewed as a person but as rotting meat, as excrescence, as future corpse. When the Jim Crow gaze lands on your devalued body, you have been brought unspeakably, irreversibly low—thrust downward to a point so below the human than you will never again find a chance to rise. After Cambridge police arrested Harvard professor Henry Louis Gates, Jr., caught entering his own house (a neighbor, imagining that Gates was a burglar, had called the police), Bob Herbert wrote, in an editorial in *The New York Times*, that "black people are constantly being stopped, searched, harassed, publicly humiliated,

assaulted, arrested and sometimes killed by police officers in this country for no good reason." Humiliation of black people in the United States is a system; the system includes prisons, police, hospitals, schools, the food chain. The system, an ecology, includes you, whoever you are, and it includes me. I regret that in my eyes it may be possible for a black person to imagine harm and to see nonrecognition, dismissal, fear, dismay, longing, identification, curiosity. I have been guilty of looking at a black person in such a way that my face and my body have registered, however unintentionally and unconsciously, the moral morass of being *the white person watching the black person*; and because my body and my face can't do much to take away the implicit stain of being a *white person looking at a black person*, my gaze becomes the Jim Crow gaze, or an inheritor of the history of that gaze, and my eyes, however kind or inquisitive or disinterested or unaware of their effect, give the wheel of humiliation another fateful turn. Some necessary shame and guilt reside in my gait and gaze, the demeanor of someone who knows he contributes to the problem, who knows he is involved in humiliating others, simply because it is my white face that is doing the watching; and a face, like mine, that anyone could tell from a mile away was Ashkenazi Jewish, doesn't forfeit whiteness, at least not at this moment in the history of prejudice.

4.

From my four years at a public high school in a California suburb, I recall the presence of only one black student. Perhaps there were others—but I remember only one, a quiet girl who wore what I remember as a nice sweater and whose skin was not very dark but only slightly dark. After a year or two, she disappeared. I assume that she transferred to another school, or else that her family moved. I am more surprised at the absence of any emotion or concern from this memory of my high school's demographics than I am by the memory itself.

5.

In first or second grade, unprompted, I wrote a tiny book. I got the idea by reading a biography of Harriet Tubman; the scene when the overseer hits Tubman with an anvil—leaving a dent on her forehead—made a dent on my imagination. I could imagine the weight of that anvil, and the indelibility of its mark on her skull. I could almost imagine the sensation of that heavy anvil falling upon me. And so I wrote a story, drew some pictures, made a cover, stapled the pages together, and deemed it a book. I wanted to call it *Slavery Is Awful*, but I misspelled the adjective. My accidental title became *Slavery Is Aval*. Maybe I was trying to bring "awful" closer to "anvil." I have always been curious about humiliation; certain representative instances of suffering and damage—the anvil hurled at the slave's forehead—struck me as extreme parables for ordinary humiliations. To take Harriet Tubman as allegory of

quotidian punctures to self-esteem is not a morally decent thing to do; but it is exactly what I did. And when, in sixth grade, our teacher, a white woman who'd taught in Harlem (so she told us), recited a Langston Hughes poem ("I, Too, Sing America"), I took the poet's plight personally. When he said, "I am the darker brother," I took notice. I thought, *I have two brothers, and my skin is slightly darker than theirs. So maybe I'm the "darker brother."* The darker brother, Hughes wrote, eats "in the kitchen / When company comes." My whole family ate every meal in the kitchen, at the white Formica kitchen counter, and so I wondered why Hughes considered it exceptional or odd that he must eat in the kitchen when company came. I hadn't yet learned about dining rooms. Nor had I learned about metaphor.

6.

We take other people's ordeals seriously as an emblem for our own, lesser humiliations. A believer notices Christ's crucifixion and takes interpretive, imaginative liberties with it. A believer says, "I'm not being crucified, but this fever—this divorce—this foreclosure—this lawsuit—this insult—feels like Calvary." Maybe just knowing that you will eventually die feels like crucifixion. Maybe knowing that you will become a bloated, disfigured corpse, and that someone who doesn't care about you (hospital attendant, mortician, heir) will move your dead body into the proper position for a dead body to occupy—maybe this knowledge, that a stranger or a lover will one day find your body disgusting and smelly, and will want to dispose of it quickly, is a way of taking Christ's lynching personally. The turn toward religion—and toward the salvific of suffering (imagining that humiliation can be alchemized, redeemed)—reveals a perfectly human wish to seek correspondences between lower and higher, left and right, blighted and whole; whether religious or not, we aren't wrong to ask that small events find their meaning through comparison with larger events.

7.

I read Richard Wright's *Black Boy*, in seventh grade, because my mother suggested it. She was trying to rescue me from a bad choice I'd made. I'd already chosen another book, and read it, and written my report. The book I'd chosen was *See No Evil*, based on a movie starring Mia Farrow, who plays a blind woman. (Shades of Audrey Hepburn in *Wait Until Dark*? I found glamorous thin blind women in movies to be handy emblems of what a terrified soul endures when moored—for a life's sentence—inside an unyielding body.) My mother said, "*See No Evil* isn't a book. It's a novelization. Read *Black Boy* instead." Feeling ashamed that I'd had the poor taste to think *See No Evil* a proper subject for a book report, I buckled down to reading *Black Boy* in our tract house's backyard; lying on the lawn, I immersed myself in the young narrator's sufferings and shames. Identification hit immediately:

when he accidentally sets fire to his house—the first scene in the book—and recognizes, "I had done something wrong, something which I could not hide or deny," merely because he'd "wanted to see how the curtains would look when they burned," I took Richard Wright's accidental act of arson, and his ensuing sense of original sin ("I had done something wrong"), as emblems for a humiliation I believed was intrinsic to the state of being a child. And when Wright learns that the larger humiliations he will encounter are not at the hands of his mother but at the hands of the white world—when he learns "how to watch white people, to observe their every move, every fleeting expression, how to interpret what was said and what left unsaid," I understood his wariness, and felt (no doubt wrongly) that *Black Boy* could be my guide to underdog consciousness, or what it felt like to look at the world with the assumption that the world disapproved of your existence. When, because his white coworkers persecute him, Richard Wright's narrator quits his job at the optical company, he feels humiliated by the gaze of the "white stenographer" watching him. Richard is afraid to tell his boss about the racial assaults of his white coworkers, and so he says nothing to vindicate himself: "The white stenographer looked at me with wide eyes and I felt drenched in shame, naked to my soul. The whole of my being felt violated, and I knew that my own fear had helped to violate it." This is the sensation I've tried to describe earlier as the "inner fold," the sensation of horrid internal reversal or self-revulsion; as a result of this scene of humiliation, Wright notices, "for weeks after that I couldn't believe in my feelings. My personality was numb, reduced to a lumpish, loose, dissolved state. I was a non-man, something that knew vaguely that it was human but felt that it was not." Maybe now we'd call his condition post-traumatic shock. But he's not yet post-traumatic. The trauma will continue for decades. I haven't finished grappling with my possibly immoral use of Richard Wright and Harriet Tubman, in my youth, as extreme magnifications of the petty humiliations I felt; nor have I precisely landed on the "I am a corpse" feeling (or "I am seen as a corpse"), a deathly foretaste that seems woven into the experience of humiliation. When I first read *Black Boy*, I did not consider myself a member of a sexual minority; however, I considered myself the inhabitant of a body that was strange to itself, uncomfortable with its form and appearance, and at once hypersensitive to nuances of sensation (palpation, temperature, texture, taste) and deadened to so much else within and without that body that I don't know how to begin even to give a name to this experience of deathliness-within-life. Or was I aware, as a child, that others around me were also dead to themselves, and thus dead—at least in discontinuous flickers of time—to others, to me?

8.

I've watched several times, on YouTube, a video clip of four male homosexuals throwing a pie in the face of homophobe Anita Bryant at a televised news conference, 1977, Des Moines. Before the pie throwing occurs, she confidently

describes her crusade to do away with gay people. After a bearded activist thrusts—audibly, violently—a pie into Bryant's face, she says, "At least it's a fruit pie," and bows her head and entreats God: "Father ... we're praying for him to be delivered from his deviant lifestyle." But then she starts crying, as gobbets of fruit pie trickle down her face. I'm no fan of Anita Bryant, who did harm to queers. But I cringe, watching the fruit pie slam into her unsuspecting face. Suddenly, she is no longer a wretched antigay activist. Suddenly, she is a victim, a woman physically assaulted by a male stranger. White cream, the pie's topping, covers her features; it resembles shaving foam or whiteface makeup. A few seconds ago, she was a wrong-minded, wrong-acting bigot, but now she has become a humiliated woman, crying in public. I can imagine how wretched I'd feel if someone threw a pie at me; in the capillaries of my cream-coated, humiliated face, I'd sense the aggression and hatred that motivated the pie-hurling hand. That's why I don't believe in capital punishment: any murderer weeping and shivering with humiliated fear at the oncoming electrocution earns my clemency. Anita Bryant put her orange-juice fame ("Come to the Florida Sunshine Tree") to noxious uses, but when the pie hits her face and she weeps, she becomes a horrifying, human spectacle, a white body smeared with white crap. During the awful instant when Anita Bryant breaks down crying, I suddenly feel guilty for my own aggression against her. Even when I want to see someone punished, I feel remorse when the disciplining occurs. I remember how sickening it felt to hear my brother and sister crying. I remember how like an "inner fold" (a twisted seam of revulsion) it felt to hear my brother and sister weeping because they had been punished, whatever "punishment" meant, and it was never corporal; I remember hearing my mother cry because she felt her life was no longer her own. For her disenfranchisement I felt responsible. I may have momentarily hated her and wanted her to die, but when she cried, even if her sadness was mixed with rage, I believed that my misbehavior had ruined her, and I felt humiliated by that knowledge, dragged into the mucus and muck of her tears, tears that I'd provoked, witnessed, relished, and rued.

Dear David,

I am writing for a couple of reasons. First is to tell you how brilliant your recent show at White Cube in London was. When I saw the show, I was reminded of when the pianist Jason Moran took me backstage with him after hearing a Cecil Taylor concert. When Cecil heard that Jason had an upcoming gig at the Village Vanguard, he said, "Jazz musicians turned that bunker into a citadel." I felt the same way when I saw your exhibition. It's not that White Cube is a bunker, exactly, but its exhibition spaces are mostly underground and they are a bit sterile, and I have never seen an artist so completely transform a space with such subtle moves. From handwriting your name at the entrance of the gallery instead of printing it, to removing the covers from the overhead lighting and turning them into a pedestal for a sculpture, to funking up the rooms by leaving construction debris and doing one of your "dirt" drawings on the wall, you read the space and you read it well.

The mix of work in the show was incredible. I have long admired the basketball drawings, and I especially love the new tarp paintings and how they pull gestural abstraction back to the realm of the social through your choice of abject materials and the seeming nonchalance with which those materials are used. I was proud (and a bit intimidated) to have a show up at Camden Arts Centre in London at the same time. The bar was raised very high indeed.

I am writing to tell you about an exhibition I am curating for Nottingham Contemporary and Tate Liverpool called *Encounters and Collisions*. It juxtaposes a small selection of my work with a much larger selection of work by artists whom I admire and consider myself to be in dialogue with. Thelma and I often joke about "adjacency," a word we use when someone claims that they know you really well because they shook your hand once at an opening or are friends with someone you vaguely know. This show is a little bit like that. I don't know you well, but I do feel "adjacent" to your work: I have seen every exhibition of yours that I could, I am fortunate enough to own one of your body prints from the '70s, and I have written articles and essays tracing the impact of your practice on the work of many artists, including myself.

For *Encounters and Collisions* I have borrowed a rock head sculpture and a couple of other pieces from a collector in Europe. While there is nothing specific that I am asking you to do, I just wanted to let you know about the exhibition and say that seeing your work has launched many, many trajectories I have pursued in mine. For instance, after seeing your installation "Concerto in Black and Blue" in 2002, with its focus on light and darkness, I started working in neon. This is just one of many examples I could cite.

I would love to send you a catalogue of the show when it's done. Let me know what address is best.

Sincerely,
Glenn Ligon

Glenn Ligon, *Malcolm X #1 (small version #2)*, 2003

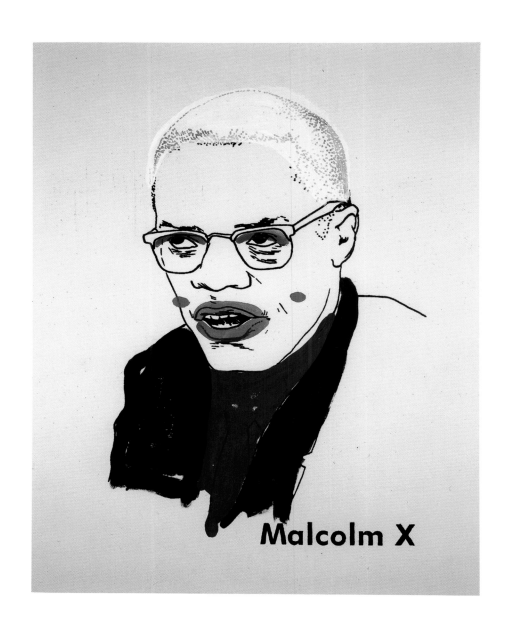

Malcolm X

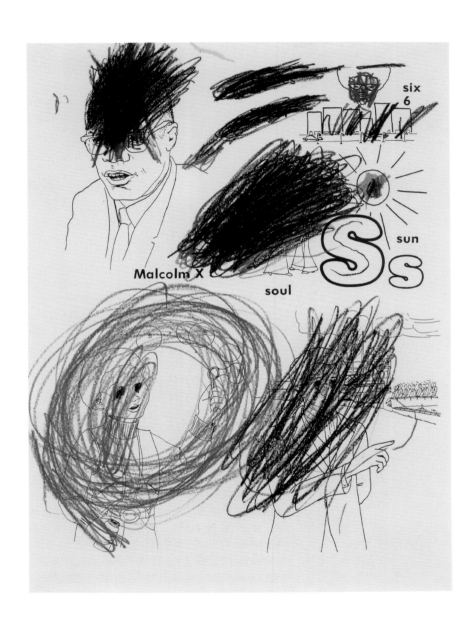

Above: Glenn Ligon, *Malcolm X, Sun, Frederick Douglass, Boy With Bubbles #5 (Version 2)*, 2001
Opposite: Glenn Ligon, *Malcolm X, Sun, Frederick Douglass, Boy With Bubbles #5 (Version 3)*, 2001

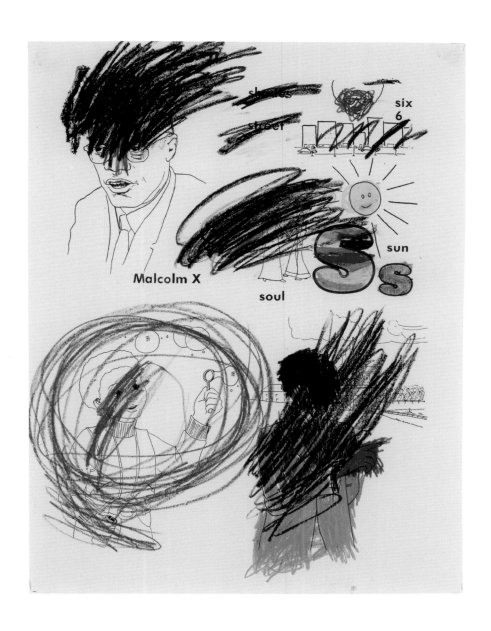

Malcolm X

sheer

six
6

soul

sun
Ss

215

Robert Gober, *Newspaper*, 1992

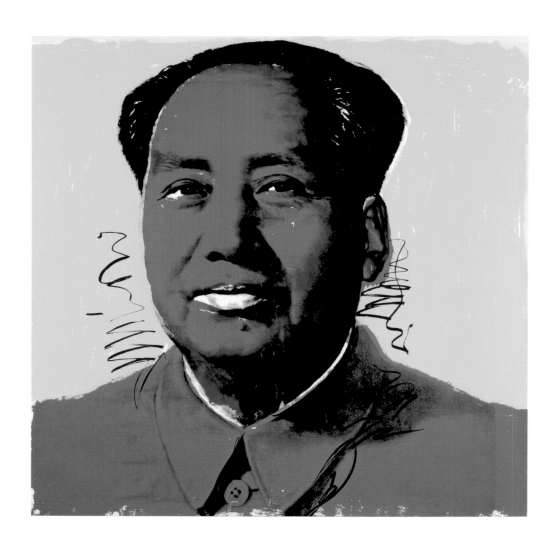

Above and opposite: Andy Warhol, *[no title], from Mao-Tse Tung*, 1972

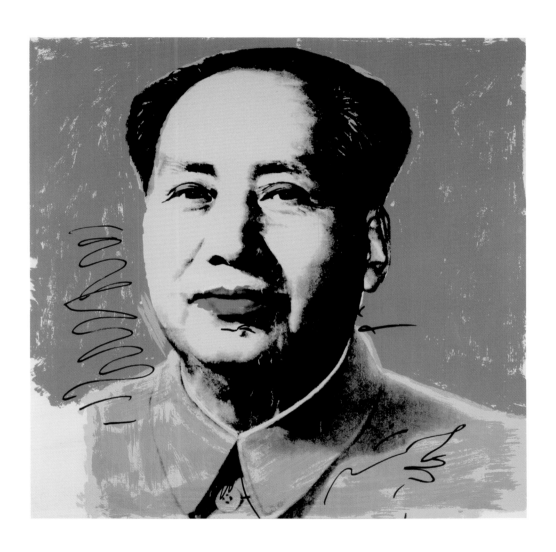

219

Alighiero Boetti, *Gemelli*, 1968

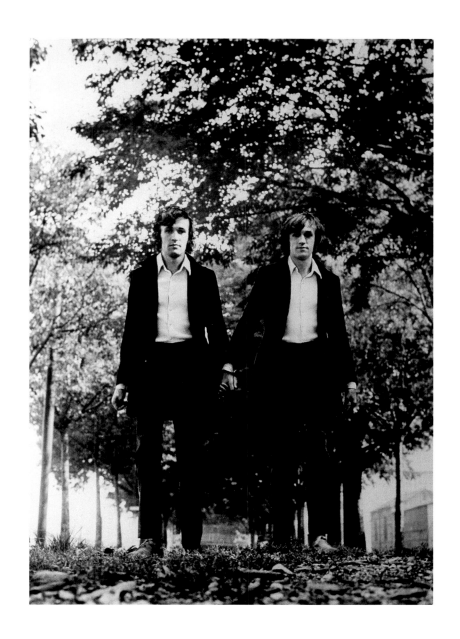

Cy Twombly, *Untitled (Rome)*, 1960

223

Cady Noland, *Tanya Disintegration*, 1992

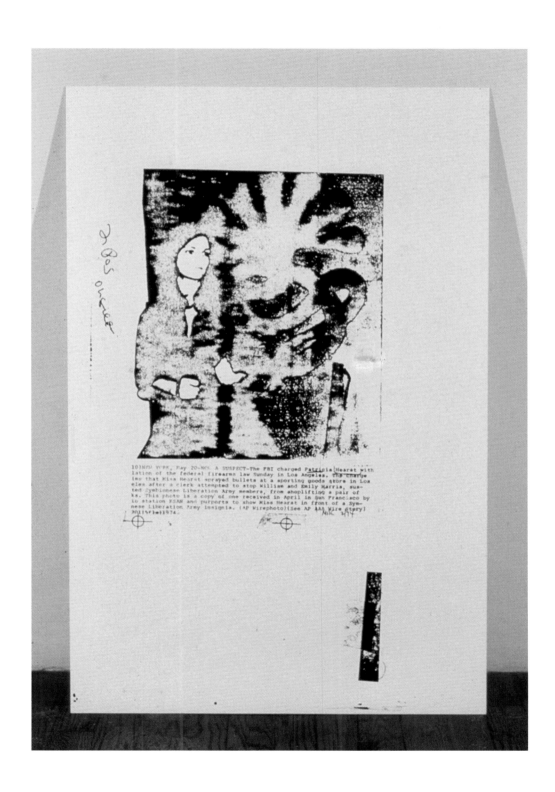

Above: Jean-Michel Basquiat, *Untitled (Cheese Popcorn)*, 1983
Opposite: Jean-Michel Basquiat, *Untitled (Mostly Old Ladies)*, 1982

227

Jasper Johns, *Painting with Two Balls II*, 1962

Martin Wong, *Stanton near Forsyth Street*, 1983

RIENALDO HABIA LLEGADO
AL DEPARTAMENTO DONDE
VIVIA ESTEBAN QUE AGO-
BIADO ABRIO LA PUERTA

David Wojnarowicz, *Untitled (One day this kid...)*, 1990–1/2012

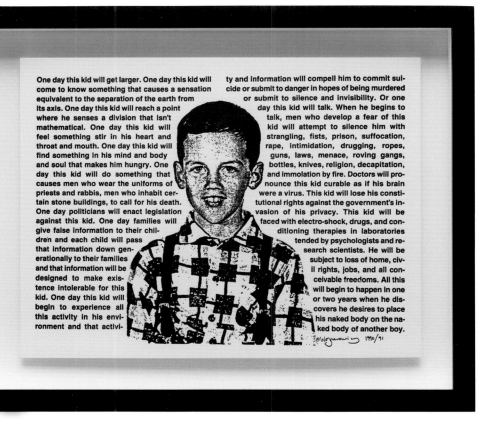

One day this kid will get larger. One day this kid will come to know something that causes a sensation equivalent to the separation of the earth from its axis. One day this kid will reach a point where he senses a division that isn't mathematical. One day this kid will feel something stir in his heart and throat and mouth. One day this kid will find something in his mind and body and soul that makes him hungry. One day this kid will do something that causes men who wear the uniforms of priests and rabbis, men who inhabit certain stone buildings, to call for his death. One day politicians will enact legislation against this kid. One day families will give false information to their children and each child will pass that information down generationally to their families and that information will be designed to make existence intolerable for this kid. One day this kid will begin to experience all this activity in his environment and that activity and information will compell him to commit suicide or submit to danger in hopes of being murdered or submit to silence and invisibility. Or one day this kid will talk. When he begins to talk, men who develop a fear of this kid will attempt to silence him with strangling, fists, prison, suffocation, rape, intimidation, drugging, ropes, guns, laws, menace, roving gangs, bottles, knives, religion, decapitation, and immolation by fire. Doctors will pronounce this kid curable as if his brain were a virus. This kid will lose his constitutional rights against the government's invasion of his privacy. This kid will be faced with electro-shock, drugs, and conditioning therapies in laboratories tended by psychologists and research scientists. He will be subject to loss of home, civil rights, jobs, and all conceivable freedoms. All this will begin to happen in one or two years when he discovers he desires to place his naked body on the naked body of another boy.

© Wojnarowicz 1990/91

Notes on the Mythic Being I

Adrian Piper

I.

A person frees himself from himself in the very act by which he makes himself an object for himself.

Jean-Paul Sartre, *Being and Nothingness*

1. Each month, I select a passage from the journal which I have been keeping for the last fourteen years. This is done on a systematic basis. The passage is called a "mantra."

The visual image of the Mythic Being appears publicly on a monthly basis in the *Village Voice* on the Gallery page. The mantra is reascribed to the personal history of the Mythic Being by appearing as the content of his thought in the thought balloon.

During that month, the mantra and the autobiographical situation that provoked it become an object of meditation for me. I repeat it, reexperience it, examine and analyse it, infuse myself with it until I have wrung it of personal meaning and significance. It becomes an object for me to contemplate and simultaneously loses its status as an element in my own personality or subjecthood. As my subjecthood weakens, the meaning of the object thus weakens, and vice versa.

The end result is that I am freer for having exhausted it as an important determinant in my life, while it simultaneously gains public status in the eyes of the many who apprehend it. The experience of the Mythic Being thus becomes part of public history and is no longer a part of my own.

2. I began by dressing in the guise of the Mythic Being and appearing publicly several times during the month (reascription of my thoughts and history, sentence by sentence, to a masculine version of myself; myself in drag). I now consider shelving this aspect of the piece for fear that the Mythic Being will gradually acquire a personal autobiography of experiences and feelings as particular and localized—and limited—as my own. This was the misfortune of Rrose Selavy.

My behavior changes. I swagger, stride, lope, lower my eyebrows, raise my shoulders, sit with my legs wide apart on the subway, so as to accommodate my protruding genitalia.

My sexual attraction to women flows more freely, uninhibited by my fear of their rejection in case my feelings should show in my face; unencumbered by my usual feminine suspicions of them as ultimately hostile competitors for men. I follow them with my eyes on the street, fantasizing vivid scenes of lovemaking and intimacy.

My sexual attraction to men is complicated and altered by my masculine appearance. I envision the possibility of deep love relationships based on friendship, trust, camaraderie, masculine empathy; but I instinctively suppress expression of my sexual feeling for fear of alienating the comparatively tenuous feelings of kinship with men I now have.

How might I be different if the history I chronicled in my journal had happened to a man? My adolescent preoccupations with men would have been infused with guilt; my conflicting feelings and behavior toward my girl friends would have been viewed with alarm by my parents; my stints as model and discotheque dancer would have schooled me in the subtle art of transvestism; my drug experiences might have been more traumatic and conflict-ridden, perhaps more sexually than mystically oriented.

Has this part of the piece taught me about myself, or about the Mythic Being?

3. The Mythic Being is, or may be:

An unrealized but possible product of the particular history of events I in fact underwent, a necessary alternative to the limits of my sense of self;

An abstract entity of mythic proportions, whose history is a matter of public knowledge and whose presence and thoughts are dispersed over the totality of individuals who apprehend him in the *Voice*;

A nonmaterial art object, unspecified with regard to time or place, the bearer of a finite number of properties, the number and quality of which are

circumscribed by my own life, and acquired coextensively with my growth into a *different* person;

A product of my own self-consciousness, and unlike other pieces I have done in not being the generator of my self-consciousness;

A therapeutic device for freeing me of the burden of my past, which haunts me, determines all my actions, increasingly habituates me to the limitations of my personality and physical appearance.

4. A conceptual problem: I find it difficult to figure out what this piece is really about, if it is really about anything, because it is not one in a series of similar pieces over which I can generalize. Because this is the only one of its kind that I have worked on since last September, I have no way of finding out what it has in common with other such pieces (although I can say things about its relationship to everything I've done in the last few years), thus no way of knowing what directions it represents to me, nor what I intend by doing it. All my speculations about it thus seem inconclusive to me; I have the feeling that I will never be sure of what it is I'm really up to.

Buddy Ebsen

Hilton Als

It's the queers who made me. Who sat with me in the automobile in the dead of night and measured the content of my character without even looking at my face. Who—in the same car—asked me to apply a little strawberry lip balm to my lips before the anxious kiss that was fraught because would it be for an eternity, benday dots making up the hearts and flowers? Who sat on the toilet seat, panties around her ankles, talking and talking, girl talk burrowing through the partially closed bathroom door and, boy, was it something. Who listened to opera. Who imitated Jessye Norman's locutions on and off the stage. Who made love in a Queens apartment and who wanted me to watch them making love while at least one of those so joined watched me, dressed, per that person's instructions, in my now dead aunt's little-girl nightie. Who wore shoes with no socks in the dead of winter, intrepid, and then, before you knew it, was incapable of wiping his own ass—"gay cancer." Who died in a fire in an apartment in Paris. Who gave me a Raymond Radiguet novel when I was barely older than Radiguet was when he died, at twenty, of typhoid. Who sat with me in his automobile and talked to me about faith—he sat in the front seat, I in the back—and I was looking at the folds in his scalp when cops surrounded the car with flashlights and guns: They said we looked suspicious, we were aware that we looked and felt like no one else.

It's the queers who made me. Who didn't get married and who said to one woman, "I don't hang with that many other women," even though or perhaps because she herself was a woman. Who walked with me along the West Side piers in nineteen eighties Manhattan one summer afternoon and said, apropos the black kids vogueing, talking, getting dressed up around us, "I got it; it's a whole style." Who bought me a pair of saddle shoes and polished them while sitting at my desk, not looking up as I watched his hands work the leather. Who knew that the actor who played the Ghost of Christmas Past in the George C. Scott version of *A Christmas Carol* was an erotic draw for me as

a child—or maybe it was the character's big beneficence. Who watched me watching Buddy Ebsen dancing with little Shirley Temple in a thirties movie called *Captain January* while singing "At the Codfish Ball," Buddy Ebsen in a black jumper, moving his hands like a Negro dancer, arabesques informed by thought, his ass in the air, all on a wharf—and I have loved wharfs and docks, without ever wearing black jumpers, ever since.

It's the queers who made me. Who talked to me about Joe Brainard's *I Remember* even though I keep forgetting to read it. Who keep after me to read *I Remember* even though perhaps my reluctance has to do with Brainard's association with Frank O'Hara, who was one queer who didn't make me, so interested was he in being a status quo pet, the kind of desire that leads a fag to project his own self-loathing onto any other queer who gets into the room—How dare you. What are you doing here? But the late great poet-editor Barbara Epstein—who loved many queers and who could always love more—was friendly with Brainard and O'Hara and perhaps the Barbara who still lives in my mind will eventually change my thinking about all that, because she always could.

It's the queers who made me. Who introduced me to Edwin Denby's writings, and George Balanchine's "Serenade," and got me writing for *Ballet Review*. Who wore red suspenders and a Trotsky button; I had never met anyone before who dressed so stylishly who wasn't black or Jewish. Who, even though I was "alone," watched me as I danced to Cindy Wilson singing "Give Me Back My Man" in the basement of a house that my mother shared with her sister in Atlanta. Who took me to Paris. Who let me share his bed in Paris. Who told my mother that I would be okay, and I hope she believed him. Who was delighted to include one of my sisters in a night out—she wore a pink prom dress and did the Electric Slide, surrounded by gay boys and fuck knows if she cared or saw the difference between herself and them—and he stood by my side as I watched my sister dance in her pink prom dress, and then he asked what I was thinking about, and I said, "I'm just remembering why I'm gay." It's the queers who made me. Who laughed with me in the pool in Lipari. Who kicked me under the table when I had allotted too much care for someone who would never experience love as such. Who sat with me in the cinema at Barnard College as *Black Orpheus* played, his bespectacled eyes glued to the screen as I weighed his whiteness against the characters' blackness and then my own. Who squatted down in the bathtub and scrubbed my legs and then my back and then the rest of my body the evening of the day we would start to know each other for the rest of our lives. Who lay with me in the bed in Los Angeles, white sheets over our young legs sprinkled with barely-there hair. Who coaxed me back to life at the farmers' market later the same day, and I have the pictures to prove it. Who laughed when I said, "What's J. Lo doing in the hospital?" as he stood near his bed dying of AIDS, his beautiful Panamanian hair—a mixture of African, Spanish and Indian textures—no longer held back by the white bandanna I loved. Who gave me Michael Warner's *The Trouble with Normal* and let me find much in it that

was familiar and emotionally accurate, including the author's use of the word *moralism* to describe the people who divide the world into "us" and "them," and who brutalize the queer in themselves and others to gain a foothold on a moralist perch.

It's the queers who made me. Who introduced me to a number of straight girls who, at first, thought that being queer was synonymous with being bitchy, and who, after meeting me and becoming friends kept waiting and waiting for me to be a bitchy queen, largely because they wanted me to put down their female friends and to hate other women as they themselves hated other women, not to mention themselves, despite their feminist agitprop; after all, I was a queen, and that's what queens did, right, along with getting sodomized, just like them, right—queens were the handmaidens to all that female self-hatred, right? And who then realized that I didn't hate women and so began to join forces with other women to level criticism at me.

It's the queers who made me. Who said: Women and queers get in the way of your feminism and gay rights. Who listened as I sat, hurt and confused, describing the postfeminist or postqueer monologue that had been addressed to me by some of the above women and queers, who not only attacked my queer body directly—You're too fat, you're too black, the horror, the horror!—but delighted in hearing about queers flinging the same kind of pimp slime on one another, not to mention joining forces with their girlfriends of both sexes to establish within their marginalized groups the kind of hierarchy straight white men presumably judge them by, but not always, not really. Who asked, "Why do you spend so much time thinking about women and queers?" And who didn't hear me when I said, "But aren't we born of her? Didn't we queer her body being born?" It's the queers who made me. Who introduced me to the performer Justin Bond, whose various characters, sometimes cracked by insecurity, eaglets in a society of buzzards, are defined by their indomitability in an invulnerable world. Who told me about the twelve-year-old girl who had been raised with love and acceptance of queerness in adults, in a landscape where she could play without imprisoning herself in self-contempt, and who could talk to her mother about what female bodies meant to her (everything), which was a way of further loving her mother, the greatest romance she had ever known, and who gave me, indirectly, my full queer self, the desire to say "I" once again.

It's my queerness that made me. And, in it, there is a memory of Jackie Curtis. She's walking up Bank Street, away from the river, a low orange sun behind her like the ultimate stage set.

It's my queer self that goes up to Jackie Curtis—whom I have seen only in pictures and films; I am in my twenties—and it is he who says, "Oh, Miss Curtis, you're amazing," and she says, in front of the setting sun, completely stoned but attentive, a performer to her queer bones, snapping to in the light of attention and love, "Oh, you must come to my show!" as she digs into her big hippie bag to dig out a flyer, excited by the possibility of people seeing her for who she is, even in makeup.

Dear Jean-Michel,

I was flipping through a catalogue the other day and saw pictures of a birthday party of yours at Mr. Chow's restaurant. You were there with your mother, Matilda, who was helping you cool down some sticky buns by blowing on them. You both seemed very happy.

My friend Lorna has a small drawing by you, red crayon text on a scrap of paper. I don't remember what the words say but I remember being envious that she knew you back in the day.

We met once. It was on the street outside a gallery on the Lower East Side. You rode by on a tricycle with an improbably large front wheel. I was shy and you were famous, so although Lorna could have introduced us, I don't know if I would have had anything to say besides "I like your work."

I first saw your paintings at Annina Nosei Gallery in 1982. I was just back in the city after college and had decided I wanted to be an artist. Actually, becoming an artist was a long way off (and since I didn't know any black artists, they were a long way off as well). I was familiar with SoHo because I had gone to see Warhol's shadow paintings at Heiner Friedrich Gallery when I was in high school and had eaten brown rice with tahini for the first time at Food, the restaurant Gordon Matta-Clark ran. I knew when I first saw them that Warhol's paintings were important, I just didn't know why. When I saw your work for the first time I knew that it was important too, even though I wouldn't start making text paintings for many years. No one looking at my work would think of yours, but the space you opened up with your use of repeating text and phenomenal color (my Richard Pryor joke paintings owe both you and Warhol a great debt) continues to reverberate in my work.

I am curating a project called *Encounters and Collisions* that includes some of your drawings. I wanted you in the show because you were part of the community I longed to be part of when I was young; you lived in that exciting, bad neighborhood I was afraid to visit. Life didn't frighten you at all, but it had a toll. I watched all that from the edge of the stage and now, all these years later, I suppose I am re-creating that community, that neighborhood, through this exhibition. Perhaps this show is just a way to say hello to you the way I was too shy to do back in the day.

Best,

Glenn

Glenn Ligon, *Untitled (I am drawn to sleaze...)*, 1985

I am drawn to sleaze, Its
as simple as that It can
be in a bar, a person on the
yet some dim lit room other...
...covered with ...
...
rammed up

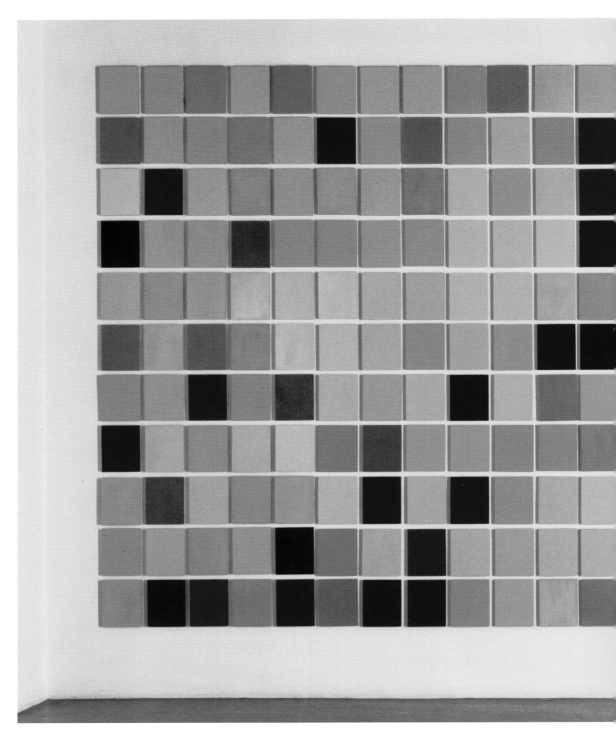

Byron Kim, *Synecdoche*, 1991-present

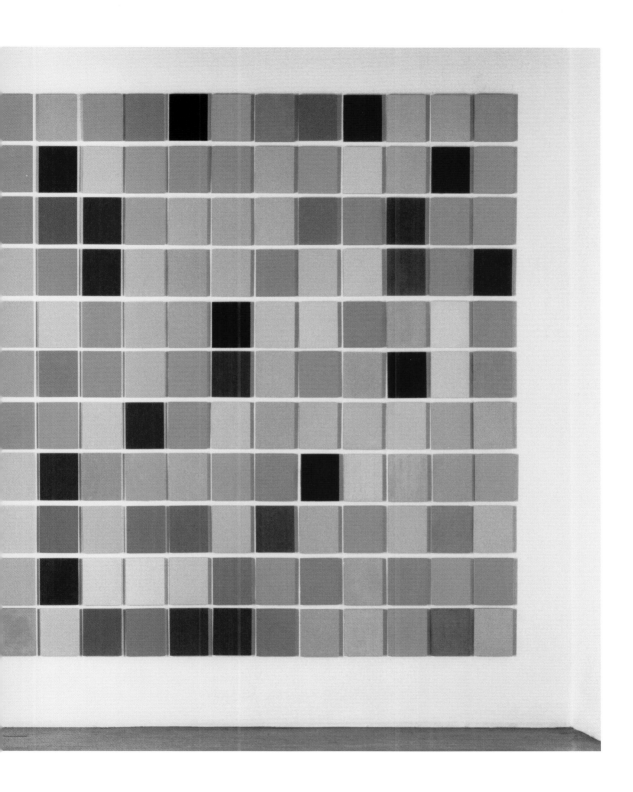

Robert Morris, *Untitled*, 1967–68, remade 2008

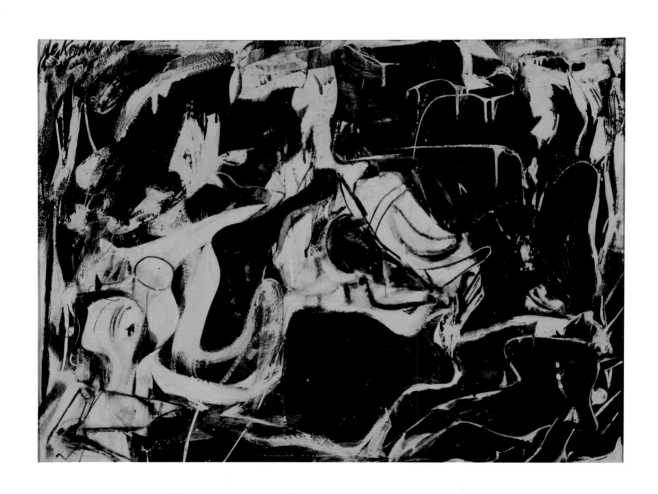

Above: Willem de Kooning, *Black Untitled*, 1948
Opposite: Willem de Kooning, *Valentine*, 1947

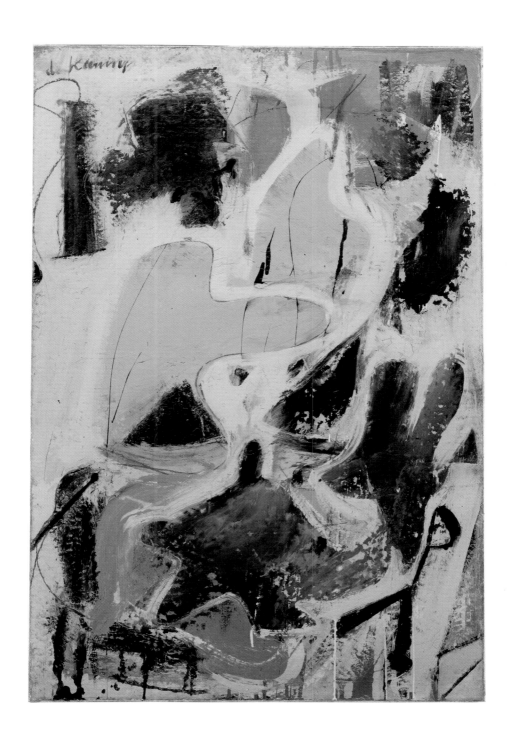

Robert Gober, *Drains*, 1990

Above: Jennie C. Jones, *Shhh #14*, 2013
Opposite: Jennie C. Jones, *Shhh #15*, 2013

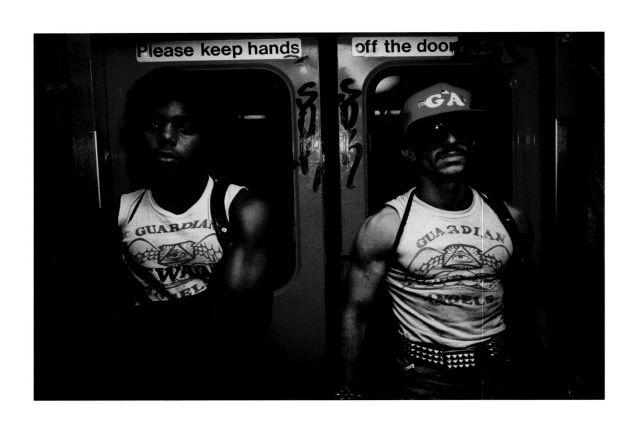

Above and opposite: Bruce Davidson, *Untitled, Subway, New York, early 1980s*, 1980, printed 2006

Bruce Nauman, *Run from Fear, Fun from Rear*, 1972

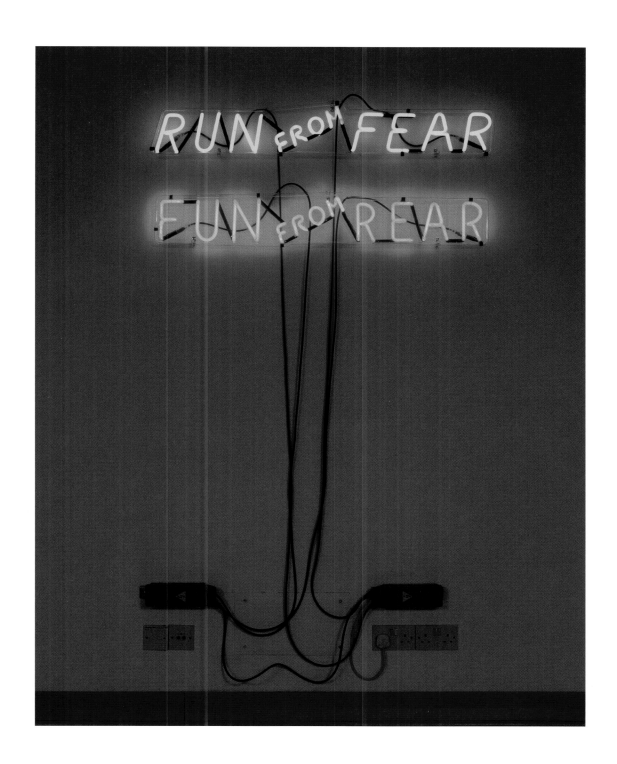

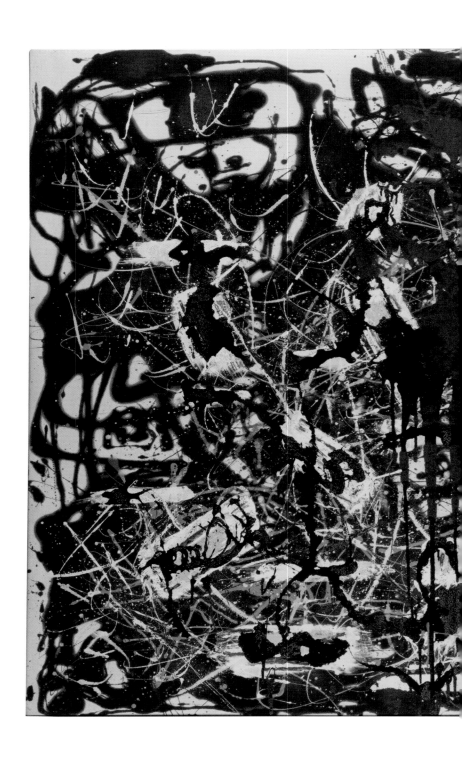

Jackson Pollock, *Yellow Islands*, 1952

On Reading

Marcel Proust

On no days of our childhood did we live so fully perhaps as those we thought we had left behind without living them, those that we spent with a favourite book. Everything that seemed to fill them for others, but which we brushed aside as a vulgar impediment to a heavenly pleasure – the game for which a friend came to fetch us at the most interesting passage, the troublesome bee or shaft of sunlight which forced us to look up from the page or to change our position, the provisions for tea that we had been made to bring and had left beside us on the seat, untouched, while, above our heads, the sun was declining in strength in the blue sky, the dinner for which we had had to return home and during which our one thought was to go upstairs straight away afterwards, and finish the chapter that had been interrupted: reading should have prevented us from seeing anything but importunity in all this, but, on the contrary, so sweet is the memory it engraved in us (and so much more precious in our present estimation than what we then read so lovingly) that if still, today, we chance to leaf through these books from the past, it is simply as the only calendars we have preserved of the days that have fled, and in the hope of finding reflected on their pages the homes and the ponds that no longer exist.

Who cannot recall as I can the reading done during the holidays, that one would conceal successively in all those hours of the day peaceful and inviolable enough to be able to afford it refuge. In the mornings, on returning from the park, when everyone had gone out for a walk, I would slip into the dining-room, into which, until the still-distant hour for lunch, no one would be entering except for the old, relatively silent Félicie, and where I would have for companions, most respectful of reading, only the painted plates hanging on the wall, the calendar from which the previous day's leaf had been newly torn, the clock and the fire which speak without demanding to be answered and whose quiet remarks are devoid of meaning and, unlike human speech, do not substitute a different meaning for that of the words you are reading. I would

settle myself on a chair, near to the small log fire of which, during lunch, my early-rising uncle, the gardener, would say: 'There's nothing wrong with that! I can put up with a bit of fire; it was jolly cold in the vegetable garden at six a.m., I can assure you. And to think Easter's only a week away!' Before lunch, which would, alas, put a stop to my reading, I still had two whole hours. From time to time there came the sound of the pump out of which the water was about to flow and which caused you to look up and gaze at it through the closed window, nearby on the little garden's solitary path, whose beds of pansies were edged with bricks and half-moons of pottery: pansies gathered so it seemed in those too-beautiful skies, those versicoloured skies that were as if reflected from the stained-glass windows of the church sometimes to be seen between the roofs of the village, the sad skies that appeared before a storm, or afterwards, too late, when the day was about to end. Unfortunately the cook would come in well ahead of time to set the table; if only she could have set it without speaking! But she felt it her duty to say: 'You're not comfortable like that; supposing I moved a table nearer you?' And merely to answer, 'No, thank you,' one had abruptly to stop one's voice dead and bring it back from far away, the voice which, inside one's lips, had been repeating soundlessly, at a run, all the words the eyes had been reading; one had to halt it, to bring it out and, in order to say an appropriate 'No, thank you,' give it a semblance of ordinary life, the intonation of a reply, which it had lost. Time was passing; often, there would start to arrive in the dining-room long before lunchtime those who, feeling tired, had cut short their walk, had 'taken the Méréglise way', or those who had not gone out that morning, having 'some writing to do'. They would say, admittedly, 'I don't want to disturb you,' but immediately began to approach the fire, to look at the time, to declare that lunch would not be unwelcome. Whoever had 'stayed behind to write' was surrounded by a particular deference and they would say to him or her: 'You've been keeping up your little correspondence,' with a smile in which were mingled respect, mystery, ribaldry and circumspection, as if this 'little correspondence' were at once a state secret, a prerogative, an amorous liaison and an indisposition. Some could wait no longer and took their place at the table ahead of time. This was heart-breaking, for it would set a bad example to the other arrivals, would make them think it was already midday, and cause my parents to utter too soon the dreaded words: 'Come on, close your book, we're going to have lunch.' Everything was ready, the places were fully laid on the tablecloth, where all that was missing was what would only be brought in at the end of the meal, the glass apparatus in which my uncle, the horticulturalist and cook, himself made the coffee at the table, tubular and complicated like a piece of physics equipment that smelt good and in which it was highly agreeable to watch the sudden ebullition rise into the glass dome and then leave a fragrant brown ash on the steamed-up sides; and also the cream and the strawberries which this same uncle would mix, always in identical proportions, stopping at the exact pink he required, with the experience of a colourist and the powers of divination of a gourmand. How long the lunch

seemed to me! My great-aunt did no more than sample the dishes in order to give her opinion with a mildness that tolerated but did not admit contradiction. Over a novel, or a poem, things of which she was a very good judge, she would always defer, with a woman's humility, to the opinion of those more competent. That, she believed, was the uncertain domain of caprice, where the taste of an individual cannot establish the truth. But over matters the rules and principles of which had been taught to her by her mother, the way of making certain dishes, of playing Beethoven's sonatas or of entertaining graciously, she was sure she knew what perfection was and of telling how close or not others had come to it. In these three instances, moreover, perfection was almost the same thing: a sort of simplicity of means, of sobriety and charm. She rejected with horror the spicing of dishes that did not absolutely demand it, that anyone play affectedly or with too much pedal, that when entertaining one should be other than perfectly natural or talk exaggeratedly about oneself. From the very first mouthful, the first notes, a simple message, she claimed to know whether she was dealing with a good cook, a real musician, a woman who had been well brought up. 'Her fingering may be far in advance of mine, but she has no taste to play that very simple andante with so much emphasis.' 'She may be a very brilliant woman and full of good qualities, but it is lacking in tact to speak of oneself in such circumstances.' 'She may be a very knowledgeable cook, but she doesn't know how to do a *bifteck aux pommes.*' *Bifteck aux pommes*! The ideal competition piece, difficult by its very simplicity, a sort of 'Pathétique' sonata of the kitchen, the gastronomic equivalent of, in social life, the visit of the lady who comes to ask you for information about a servant and who, in this simple act, is able to display, or to lack, so much tact and education. Such was my grandfather's amour-propre that he wanted every dish to be a success, but he knew so little about cooking that he could never tell when they were a failure. He was quite ready to allow on occasions that they were so, but rarely and only as the pure effect of chance. My great-aunt's always well-founded criticisms, implying on the contrary that the cook had not known how to make such and such a dish, could not fail to seem especially intolerable to my grandfather. Often, to avoid arguing with him, my great-aunt, having tasted it with the tip of her tongue, would not give an opinion, which at once let us know that it was unfavourable. She remained silent, but in her kindly eyes we could read an unshakeable and considered disapproval which had the power of sending my grandfather into a rage. He would ask her ironically to give her opinion, grow impatient at her silence, press her with questions, lose his temper, but one sensed that she might have been led off to martyrdom rather than be made to confess what my grandfather believed: that the dessert had not been over-sweetened.

After lunch, my reading resumed immediately; especially if the day was at all warm, everyone withdrew upstairs into their rooms, which enabled me at once to gain my own, by the little flight of close-set stairs, on the solitary upper storey, so low that once astride the windowsill a child could have jumped down into the street. I would go to close my window without having

been able to escape the greeting of the gunsmith opposite who, under the pretext of lowering his awning, would come every day after lunch to smoke his pipe in front of his door and say good afternoon to the passers-by, who would sometimes stop to chat. The theories of William Morris, which have been so consistently applied by Maple and the English interior designers, decree that a room is beautiful solely on condition that it contain objects that are useful to us and that every useful object, be it a simple nail, should be not concealed but visible. Above the brass bedstead, entirely coverless, on the bare walls of these hygienic rooms, a few reproductions of masterpieces. Judged by which aesthetic principles, my room was in no way beautiful, for it was full of objects that could serve no purpose and which modestly concealed, to the point of making them extremely hard to use, those that did serve a purpose. But for me my room derived its beauty precisely from those objects which were not there for my convenience, but seemed to have come there for their own pleasure. The tall white curtains which hid from view the bed, set back as if in a sanctuary; the scatter of marceline quilts, flowered counterpanes, embroidered bedspreads and batiste pillow-cases, beneath which it vanished during the day, like an altar beneath its festoons and flowers during the month of May, and which, in the evening, so as to be able to go to bed, I would lay carefully down on an armchair, where they had agreed to spend the night; beside the bed, the trinity of the glass with the blue design, the matching sugar bowl and the carafe (always empty since the day after my arrival, on the orders of my aunt, who was afraid to find me 'overturning' it), like the implements of a religion – almost as holy as the precious orange-blossom liqueur sitting next to them in a glass phial – which I would have no more thought it permissible to profane nor even possible to make use of for my personal ends than if they had been consecrated ciboria, but which I contemplated at length before getting undressed, for fear of overturning them by some false movement; the little crochet-work stoles that cast a mantle of white roses over the backs of the chairs and which cannot have been thornless because each time I had finished reading and wanted to stand up, I noticed I was still attached to them; the glass dome beneath which, insulated against vulgar contact, the clock chattered intimately away for the benefit of the seashells brought from afar and for an old sentimental flower, but which was so heavy to raise that, when the clock stopped, no one except the clockmaker would have been unwise enough to undertake to rewind it; the white point-lace cloth, thrown like an altar-covering over the commode, which was decorated with two vases, a picture of the Saviour and a palm frond, making it look like the Communion table (the evocation of which was completed by a prie-dieu, put away there each day when the 'room was done'), but whose frayed ends were forever catching in the cracks of the drawers and preventing them working so completely that I could never take out a handkerchief without all at once bringing down the picture of the Saviour, the holy vases, and the palm frond, and myself stumbling and catching hold of the prie-dieu; the triple layer finally of small cheesecloth curtains, large muslin curtains and larger dimity curtains, white as the hawthorn,

always cheerful and often sunlit, yet essentially infuriating in their clumsy obstinacy as they slipped on their parallel wooden rods and got caught up in one another, with all of them together in the window the moment I wanted to open or close it, a second one always ready, should I have succeeded in freeing a first, at once to take its place in the joins, which they stopped up as completely as a real hawthorn bush might have done or the nests of any swallows that had taken it into their heads to build there, with the result that I could never manage the operation, apparently so simple, of opening or closing my casement without the help of a member of the household; all these objects which not only could not answer to any of my needs, but even formed an obstacle, albeit slight, to their satisfaction, and which had obviously never been put there to be useful to anyone, peopled my room with thoughts that were somehow personal, with that air of predilection, of having chosen to live and amuse themselves there such as trees often have in a clearing, or flowers by the roadside or on old walls. They filled it with a diverse and silent life, with a mystery in which my person was at once lost and enthralled; they made that room into a sort of chapel where the sunlight – once it had passed through the little red panes that my uncle had let into the tops of the windows – having turned the hawthorn of the curtains pink, speckled the walls with gleams as strange as if the little chapel had been enclosed within a larger stained-glass nave; and where the sound of the bells reached us so resonantly because of the proximity of our house to the church, to which moreover, on high feast days, we were joined by the floral path of the chapels of rest, that I could imagine they were being rung in our roof, just above the window from where I would often greet the *curé* with his breviary, my aunt returning from vespers, or the choirboy bringing us consecrated bread. As for Brown's photograph of Botticelli's 'Spring' or the cast of the 'Unknown Woman' from the museum in Lille, which were William Morris's concessions to a useless beauty on the walls and above the fireplace in Maple's bedrooms, I have to admit that they had been replaced in my room by a sort of engraving showing Prince Eugene, handsome and terrible in his dolman, which I was greatly astonished to notice one night, amidst a great crashing of locomotives and hailstones, handsome and terrible still, at the entrance to a station buffet, where he was advertising a make of biscuits. Today I suspect my grandfather of having received it in the old days as a bonus from a generous manufacturer, before installing it permanently in my bedroom. But at the time I was unconcerned by its origins, which seemed to me both historical and mysterious, and I did not imagine that there might exist several copies of what I looked on as a person, as a permanent inhabitant of the room which I did no more than share with him and where I rediscovered him each year, forever the same. It is a very long time now since I saw him, and I suppose I shall never see him again. But were such good fortune to befall me, I believe he would have many more things to say to me than Botticelli's 'Spring'. I leave it to people of taste to decorate their homes with reproductions of the masterpieces they admire and relieve their memories of the trouble of preserving a precious image for them by entrusting

it to a carved wooden frame. I leave it to people of taste to make their rooms into the very image of that taste and fill them only with objects of which it can approve. For myself, I only feel myself to be alive and to be thinking in a room where everything is the creation and the language of lives profoundly different from my own, of a taste the opposite of my own, where I discover nothing of my conscious thought, where my imagination is exalted by feeling itself plunged into the heart of the non-self; I only feel happy when I set foot – in the Avenue de la Gare, overlooking the harbour or the Place de l'Eglise – in one of those provincial hotels with long cold corridors where the wind from outside is battling successfully against the efforts of the central heating, where the detailed map of the area is still the one decoration on the walls, where each sound serves only to bring out the silence it is displacing, where the bedrooms preserve a musty fragrance which the air from outside washes but does not efface, and which the nostrils breathe in a hundred times so as to carry it to the imagination, which is enchanted by it, which makes it pose like a model in order to try and recreate it within itself, with all that it contains by way of thoughts and memories; where in the evening, when you open the door to your room, you have the feeling you are violating all the life that has remained scattered about in there, of taking it boldly by the hand as, the door once closed, you enter further in, up to the table or up to the window; of sitting in a sort of free promiscuity with it on the settee made up by the upholsterer in the departmental capital in what he believed to be the taste of Paris; of everywhere touching the bareness of this life in the intention of disturbing yourself by your own familiarity, putting your things down in one place or another, playing the proprietor in a room filled to overflowing with the souls of others and which preserves the imprint of their dreams in the very shape of the firedogs and the pattern on the curtains, walking barefoot on its unknown carpet; then, you have the feeling you are locking this secret life in with you as you go, trembling all over, to bolt the door; of pushing it ahead of you into the bed and finally of lying down with it in the great white sheets which come up over your face, while, close by, the church strikes for the whole town the hours that are sleepless for lovers and for the dying.

I had not been reading in my room for very long before having to go to the park, a kilometre from the village. But this enforced playtime over, I would cut short the end of tea, brought in baskets and handed out to the children by the river bank, on the grass where my book had been laid with orders not to pick it up yet. A little further on, in certain rather overgrown and rather mysterious depths of the park, the river ceased from being an artificial, rectilinear watercourse, covered with swans and bordered by walks and pleasant statues, and now and again alive with leaping carp, but gathered speed, flowing rapidly on past the enclosure of the park to become a river in the geographical sense of the term – a river that must have had a name – and lost no time in spreading out (was it really the same river as between the statues and beneath the swans?) between grasslands where cattle were sleeping and whose buttercups it had drowned, a sort of meadowland it had made quite

marshy, attached on one side to the village by some shapeless towers, relics, it was said, of the Middle Ages, and joined on the other, along mounting paths of eglantine and hawthorn, to 'nature', which extended to infinity, villages that had other names, the unknown. I would leave the others to finish having tea at the bottom of the park, beside the swans, and run up into the maze as far as one or other arbour and there sit, undiscoverable, leaning against the pruned hazelnut trees, aware of the asparagus bed, the edgings of strawberry plants, the ornamental lake into which, on certain days, the water was pumped by circling horses, the white gate at the top which was 'the end of the park', and beyond, the fields of cornflowers and poppies. In this arbour the silence was profound, the risk of being discovered negligible, my security made all the sweeter by the distant shouts that vainly summoned me from below, which sometimes even came closer, climbed the first banks, searching everywhere, then turning back, defeated; then, no further sound: only from time to time the golden sound of the bells which, in the distance, beyond the plains, seemed to be ringing out behind the blue sky, and might have warned me that time was passing; but surprised by its softness and troubled by the deeper silence that followed, emptied of its final notes, I was never certain of the number of strokes. These were not the thunderous bells one heard on re-entering the village – approaching the church which, from close to, had resumed its full, rigid height, its slate cowl punctuated by corbels standing up against the blue of the evening – whose sound flew in splinters across the square 'for the good things of the earth'. They were soft and feeble by the time they reached the far end of the park and addressed themselves not to me but to the whole countryside, to all the villages, to the country people isolated in their fields; they did not at all force me to look up, but passed close to me, carrying the time to distant regions, without seeing me, without knowing me, without disturbing me.

And sometimes in the house, in my bed, long after dinner, the last hours of the evening would also afford shelter to my reading, but this only on days when I had got to the final chapters of a book, when there was not much more to read before coming to the end. Then, at the risk of being punished if I was discovered, and of an insomnia that might go on all through the night once the book was finished, as soon as my parents were in bed I would relight my candle; while in the street nearby, between the gunsmith's house and the post office, both bathed in silence, the dark yet blue sky was full of stars, and to the left, above the raised alleyway where the winding, elevated ascent to it began, one could sense the apse of the church to be watching, black and monstrous, whose sculptures did not sleep at night, the village church, yet a historic one, the magic dwelling-place of the Good Lord, of the consecrated loaf, of the multicoloured saints and of the ladies from the neighbouring châteaux who set the hens clacking and the gossips staring as they crossed the marketplace on feast days, when they came to mass 'in their carriages', and who, on their way home, just after they had emerged from the shadows of the porch, where the faithful scattered the errant rubies of the nave as they pushed open the door of the vestibule, did not fail to buy from the pâtissier on the square some of those cakes

in the shape of towers, protected from the sunlight by a blind – '*manqués*', '*saint-honorés*' and 'genoa cakes' – whose lazy, sugary aroma has remained mingled for me with the bells for high mass and the gaiety of Sundays.

Then the last page had been read, the book was finished. I had to halt the mad rush of my eyes and of the voice that followed them noiselessly, stopping only to catch my breath, in a deep sigh. Then, so as to give the tumult, let loose inside me for too long to be able to still itself, other movements to control, I would stand up, would begin walking up and down by my bed, my eyes still fixed on some point that it would have been vain to seek for inside the room or without, for it was a soul's distance away, one of those distances that are not measured in metres or leagues, as others are, and which it is impossible to mistake for them when one sees the 'remote' stare of those whose thoughts are 'elsewhere'. Was there no more to the book than this, then? These beings to whom one had given more of one's attention and affection than to those in real life, not always daring to admit to what extent one loved them, and even when our parents found us busy reading and seemed to be smiling at our emotion, closing the book with a studied indifference or pretence of boredom: one would never again see these people for whom one had yearned and sobbed, would never again hear of them. Already, in the last few pages, the author, in his cruel 'Epilogue', had taken care to 'distance' them with an indifference not to be credited by anyone who knew the interest with which he had followed them hitherto, step by step. We had been told how they spent each hour of their lives. Then suddenly: 'Twenty years after these events an old man might have been met with in the streets of Fougères, still erect, etc.' And the marriage, the delightful possibility of which we have been made to foresee through two volumes, fearful then overjoyed as each obstacle was raised and then smoothed away, we learn from a casual phrase by some minor character that it has been celebrated, we do not know exactly when, in this astonishing epilogue written, it would seem, from up in heaven, by someone indifferent to our momentary passions who has taken the author's place. One would have so much wanted the book to continue or, if that was impossible, to learn other facts about all these characters, to learn something of their lives now, to employ our own life on things not altogether alien to the love they had inspired in us, whose object was now suddenly gone from us, not to have loved in vain, for an hour, beings who tomorrow will be no more than a name on a forgotten page, in a book without connection with our life and about whose worth we were certainly mistaken since its fate here below, as we could now understand and as our parents had taught us when need arose by a dismissive phrase, was not at all, as we had believed, to contain the universe and our destiny, but to occupy a very narrow space in the lawyer's bookcase, between the lacklustre archives of the *Journal de modes illustré* and *La Géographie d'Eure-et-Loir*.

The Wall and the Books

Jorge Luis Borges

He, whose long wall the wand'ring Tartar bounds …

<div align="right">

Dunciad, II, 76

</div>

I read, some days past, that the man who ordered the erection of the almost infinite wall of China was that first Emperor, Shih Huang Ti, who also decreed that all books prior to him be burned. That these two vast operations—the five to six hundred leagues of stone opposing the barbarians, the rigorous abolition of history, that is, of the past—should originate in one person and be in some way his attributes inexplicably satisfied and, at the same time, disturbed me. To investigate the reasons for that emotion is the purpose of this note.

Historically speaking, there is no mystery in the two measures. A contemporary of the wars of Hannibal, Shih Huang Ti, King of Tsin, brought the Six Kingdoms under his rule and abolished the feudal system; he erected the wall, because walls were defenses; he burned the books, because his opposition invoked them to praise the emperors of olden times. Burning books and erecting fortifications is a common task of princes; the only thing singular in Shih Huang Ti was the scale on which he operated. Such is suggested by certain Sinologists, but I feel that the facts I have related are something more than an exaggeration or hyperbole of trivial dispositions. Walling in an orchard or a garden is ordinary, but not walling in an empire. Nor is it banal to pretend that the most traditional of races renounce the memory of its past, mythical or real. The Chinese had three thousand years of chronology (and during those years, the Yellow Emperor and Chuang Tsu and Confucius and Lao Tzu) when Shih Huang Ti ordered that history begin with him.

Shih Huang Ti had banished his mother for being a libertine; in his stern justice the orthodox saw nothing but an impiety; Shih Huang Ti, perhaps, wanted to obliterate the canonical books because they accused him; Shih

Huang Ti, perhaps, tried to abolish the entire past in order to abolish one single memory: his mother's infamy. (Not in an unlike manner did a king of Judea have all male children killed in order to kill one.) This conjecture is worthy of attention, but tells us nothing about the wall, the second part of the myth. Shih Huang Ti, according to the historians, forbade that death be mentioned and sought the elixir of immortality and secluded himself in a figurative palace containing as many rooms as there are days in the year; these facts suggest that the wall in space and the fire in time were magic barriers designed to halt death. All things long to persist in their being, Baruch Spinoza has written; perhaps the Emperor and his sorcerers believed that immortality is intrinsic and that decay cannot enter a closed orb. Perhaps the Emperor tried to recreate the beginning of time and called himself The First, so as to be really first, and called himself Huang Ti, so as to be in some way Huang Ti, the legendary emperor who invented writing and the compass. The latter, according to the *Book of Rites*, gave things their true name; in a parallel fashion, Shih Huang Ti boasted, in inscriptions which endure, that all things in his reign would have the name which was proper to them. He dreamt of founding an immortal dynasty; he ordered that his heirs be called Second Emperor, Third Emperor, Fourth Emperor, and so on to infinity … I have spoken of a magical purpose; it would also be fitting to suppose that erecting the wall and burning the books were not simultaneous acts. This (depending on the order we select) would give us the image of a king who began by destroying and then resigned himself to preserving, or that of a disillusioned king who destroyed what he had previously defended. Both conjectures are dramatic, but they lack, as far as I know, any basis in history. Herbert Allen Giles tells that those who hid books were branded with a red-hot iron and sentenced to labor until the day of their death on the construction of the outrageous wall. This information favors or tolerates another interpretation. Perhaps the wall was a metaphor, perhaps Shih Huang Ti sentenced those who worshiped the past to a task as immense, as gross and as useless as the past itself. Perhaps the wall was a challenge and Shih Huang Ti thought: "Men love the past and neither I nor my executioners can do anything against that love, but someday there will be a man who feels as I do and he will efface my memory and be my shadow and my mirror and not know it." Perhaps Shih Huang Ti walled in his empire because he knew that it was perishable and destroyed the books because he understood that they were sacred books, in other words, books that teach what the entire universe or the mind of every man teaches. Perhaps the burning of the libraries and the erection of the wall are operations which in some secret way cancel each other.

The tenacious wall which at this moment, and at all moments, casts its system of shadows over lands I shall never see, is the shadow of a Caesar who ordered the most reverent of nations to burn its past; it is plausible that this idea moves us in itself, aside from the conjectures it allows. (Its virtue may lie in the opposition of constructing and destroying on an enormous scale.) Generalizing from the preceding case, we could infer that *all* forms have their

virtue in themselves and not in any conjectural "content." This would concord with the thesis of Benedetto Croce; already Pater in 1877 had affirmed that all arts aspire to the state of music, which is pure form. Music, states of happiness, mythology, faces belabored by time, certain twilights and certain places try to tell us something, or have said something we should not have missed, or are about to say something; this imminence of a revelation which does not occur is, perhaps, the aesthetic phenomenon.

<div align="right">Translated by James E. Irby</div>

Borges and I

Jorge Luis Borges

The other one, the one called Borges, is the one things happen to. I walk through the streets of Buenos Aires and stop for a moment, perhaps mechanically now, to look at the arch of an entrance hall and the grillwork on the gate; I know of Borges from the mail and see his name on a list of professors or in a biographical dictionary. I like hourglasses, maps, eighteenth-century typography, the taste of coffee and the prose of Stevenson; he shares these preferences, but in a vain way that turns them into the attributes of an actor. It would be an exaggeration to say that ours is a hostile relationship; I live, let myself go on living, so that Borges may contrive his literature, and this literature justifies me. It is no effort for me to confess that he has achieved some valid pages, but those pages cannot save me, perhaps because what is good belongs to no one, not even to him, but rather to the language and to tradition. Besides, I am destined to perish, definitively, and only some instant of myself can survive in him. Little by little, I am giving over everything to him, though I am quite aware of his perverse custom of falsifying and magnifying things. Spinoza knew that all things long to persist in their being; the stone eternally wants to be a stone and the tiger a tiger. I shall remain in Borges, not myself (if it is true that I am someone), but I recognize myself less in his books than in many others or in the laborious strumming of a guitar. Years ago I tried to free myself from him and went from the mythologies of the suburbs to the games with time and infinity, but those games belong to Borges now and I shall have to imagine other things. Thus my life is a flight and I lose everything and everything belongs to oblivion, or to him.

 I do not know which of us has written this page.

<div align="right">Translated by James E. Irby</div>

Exhibition Checklist

Stephen Andrews, *Dramatis Personae*, 2012, video, colour, black & white, sound, 6 min © Stephen Andrews, courtesy of the Ryerson Images Centre

Giovanni Anselmo, *Invisibile*, 1971, projector, slide with the word "visibile", photo © Paolo Mussat Sartor, courtesy Archivio Anselmo

Jean-Michel Basquiat, *Untitled (Cheese Popcorn)*, 1983, oil stick and ink on paper, 49.53 x 38.74 cm, Private Collection © The Estate of Jean-Michel Basquiat / ADAGP, Paris and DACS, London 2015

* Jean-Michel Basquiat, *Untitled (Jackson)*, 1983, crayon, oil stick and ink on paper, 48.9 x 38.74 cm, Private Collection © The Estate of Jean-Michel Basquiat / ADAGP, Paris and DACS, London 2015

Jean-Michel Basquiat, *Untitled (Mostly Old Ladies)*, 1982, crayon and ink on paper, 49.85 x 39.37 cm, Private Collection © The Estate of Jean-Michel Basquiat / ADAGP, Paris and DACS, London 2015

* Jean-Michel Basquiat, *Untitled (Olive Oil)*, 1982, oil stick and ink on paper, 48.9 x 39.05 cm, Private Collection © The Estate of Jean-Michel Basquiat / ADAGP, Paris and DACS, London 2015

* The Black Panther Party, *Huey Newton, Minister of Defenses, Black Panther Party*, 1970, black and white poster, 71.7 x 58.4 cm, Private Collection, photograph by Ron Amstutz

* The Black Panther Party, *"The racist dog policemen must withdraw immediately from our communities"*, 1968, black and white poster, 86.3 x 60.3 cm (framed), Private Collection, photograph by Ron Amstutz

Joseph Beuys, *I Like America and America Likes Me*, 1974, print on paper, 93.9 x 63.5 cm, Private Collection, photograph by Ron Amstutz © DACS 2015

Joseph Beuys, *Coyote, I Like America and America Likes Me* (film by Helmut Wietz), 1974, 16 mm film, black and white, sound, 37 min, courtesy of René Block Gallery and Helmut Wietz, photo © DACS 2015

Alighiero Boetti, *Gemelli*, 1968, photomontage, 15 x 10 cm, Private Collection, photo courtesy Fondazione Alighiero e Boetti, Rome © Alighiero Boetti by SIAE 2015

Alighiero Boetti, *Incontri e Scontri*, 1988, embroidery on fabric, 16.5 x 17.7 cm, Private Collection, photograph by Ron Amstutz © DACS 2015

Alighiero Boetti, *Mappa*, 1990–91, embroidery, 114.3 x 214 x 2 cm, Fondazione Alighiero e Boetti, Rome © Alighiero Boetti by SIAE 2015

Bruce Davidson, *Untitled, Subway, New York, early 1980s*, 1980, printed 2006, photograph, colour on paper, 37.5 x 56.3 cm, Tate. Lent by the American Fund for the Tate Gallery, courtesy of Jane and Michael Wilson 2010 © Bruce Davidson / Magnum Photos

Bruce Davidson, *Untitled, Subway, New York, early 1980s*, 1980, printed 2006, photograph, colour on paper, 37.5 x 56.3 cm, Tate. Lent by the American Fund for the Tate Gallery, courtesy of Jane and Michael Wilson 2010 © Bruce Davidson / Magnum Photos

* Bruce Davidson, *Untitled, Subway, New York, early 1980s*, 1980, printed 2006, photograph, colour on paper, 37.5 x 56.3 cm, Tate. Lent by the American Fund for the Tate Gallery, courtesy of Jane and Michael Wilson 2010 © Bruce Davidson / Magnum Photos

* Bruce Davidson, *Untitled, Subway, New York, early 1980s*, 1980, printed 2006, photograph, colour on paper, 37.5 x 56.3 cm, Tate. Lent by the American Fund for the Tate Gallery, courtesy of Jane and Michael Wilson 2010 © Bruce Davidson / Magnum Photos

* Bruce Davidson, *Untitled, Subway, New York, early 1980s*, 1980, printed 2006, photograph, colour on paper, 37.5 x 56.3 cm, Tate. Lent by the American Fund for the Tate Gallery, courtesy of Jane and Michael Wilson 2010 © Bruce Davidson / Magnum Photos

* Bruce Davidson, *Untitled, Subway, New York, early 1980s*, 1980, printed 2006, photograph, colour on paper, 37.5 x 56.3 cm, Tate. Lent by the American Fund for the Tate Gallery, courtesy of Jane and Michael Wilson 2010 © Bruce Davidson / Magnum Photos

* Bruce Davidson, *Untitled, Subway, New York, early 1980s*, 1980, printed 2006, photograph, colour on paper, 37.5 x 56.3 cm, Tate. Lent by the American Fund for the Tate Gallery, courtesy of Jane and Michael Wilson 2010 © Bruce Davidson / Magnum Photos

* Bruce Davidson, *Untitled, Subway, New York, early 1980s*, 1980, printed 2006, photograph, colour on paper, 37.5 x 56.3 cm, Tate. Lent by the American Fund for the Tate Gallery, courtesy of Jane and Michael Wilson 2010 © Bruce Davidson / Magnum Photos

* Bruce Davidson, *Untitled, Subway, New York, early 1980s*, 1980, printed 2006, photograph, colour on paper, 37.5 x 56.3 cm, Tate. Lent by the American Fund for the Tate Gallery, courtesy of Jane and Michael Wilson 2010 © Bruce Davidson / Magnum Photos

* Bruce Davidson, *Untitled, Subway, New York, early 1980s*, 1980, printed 2006, photograph, colour on paper, 37.5 x 56.3 cm, Tate. Lent by the American Fund for the Tate Gallery, courtesy of Jane and Michael Wilson 2010 © Bruce Davidson / Magnum Photos

Beauford Delaney, *James Baldwin*, c.1955, oil on canvas board, 60.96 x 45.72 cm, Collection of halley k harrisburg and Michael Rosenfeld

Beauford Delaney, *Untitled*, c.1958, oil on canvas, 76.2 x 63.5 cm, Private Collection. courtesy of Michael Rosenfeld Gallery, LLC, New York, photo by Joshua Nefsky

Melvin Edwards, *Art Education*, 2002, welded steel, 25.4 x 20.3 x 15.2 cm, courtesy of the Artist, Alexander Gray Associates, New York and Stephen Friedman Gallery, London © 2014 Melvin Edwards / Artist Rights Society (ARS), New York

Melvin Edwards, *Chain and Diamond?*, 1979, welded steel, 30 x 30.5 x 15.2 cm, courtesy of the Artist, Alexander Gray Associates, New York and Stephen Friedman Gallery, London © 2014 Melvin Edwards / Artist Rights Society (ARS), New York

* Melvin Edwards, *Now*, 2002, welded steel, 19 x 16 x 10.2 cm, courtesy of the Artist, Alexander Gray Associates, New York; Stephen Friedman Gallery, London © 2014 Melvin Edwards / Artist Rights Society (ARS), New York

* William Eggleston, *Huntsville, Alabama*, 1969, dye transfer print, 22.4 x 34.4 cm, The Museum of Modern Art, New York © Eggleston Artistic Trust, courtesy Cheim & Read, New York

* William Eggleston, *Memphis*, c.1975, dye transfer print, edition 7/9, 48.3 x 57.8 cm © Eggleston Artistic Trust, courtesy Cheim & Read, New York

William Eggleston, *Untitled*, 1972, dye transfer print, 49.8 x 39.4 cm © Eggleston Artistic Trust, courtesy Cheim & Read, New York

William Eggleston, *Untitled*, 1974, pigment print, Edition 4 of 10, 76.2 x 61 cm © Eggleston Artistic Trust, courtesy of the Artist, Cheim & Read, New York and Victoria Miro, London

* William Eggleston, *Untitled (From the Troubled Waters Portfolio)*, 1980, dye transfer print, edition 17/30, 29.5 x 43.8 cm © Eggleston Artistic Trust, courtesy Cheim & Read, New York

* William Eggleston, *Untitled (Tallahatchie County, Mississippi)*, 1972, printed 1986, dye transfer print, edition 3/5, 34.6 x 53.3 cm © Eggleston Artistic Trust, courtesy Cheim & Read, New York

Jean Genet, *Un Chant d'Amour*, 1950, 16mm film, digital transfer, 32 min © Jean Genet

Robert Gober, *Drains*, 1990, pewter, 9.4 x 9.4 x 4.2 cm, Tate. Purchased 1992 © Robert Gober

Robert Gober, *Newspaper*, 1992, photolithograph on archival paper, twine, 15 x 42.5 x 33.6 cm D.Daskalopoulos Collection © Robert Gober, photograph by Adam Reich, courtesy of the Artist and Matthew Marks Gallery

Felix Gonzalez-Torres, *"Untitled" (1992)*, 1992, framed photostat, 32.1 x 42.2 cm, edition of 4, 1 AP, Private Collection, photograph by Ron Amstutz © The Felix Gonzalez-Torres Foundation, courtesy of Andrea Rosen Gallery, New York

Felix Gonzalez-Torres, *"Untitled" (Perfect Lovers)*, 1987-1990, wall clocks, 34.29 x 68.58 x 3.18 cm overall, two parts: 34.29 cm diameter each, edition of 3, 1 AP, Glenstone © The Felix Gonzalez-Torres Foundation, courtesy of Andrea Rosen Gallery, New York

Felix Gonzalez-Torres, *"Untitled" (USA Today)*, 1990, candies individually wrapped in red, silver, and blue cellophane, endless supply, overall dimensions vary with installation, ideal weight: 300 lbs, installation view of: *Rhetorical Image*. The New Museum of Contemporary Art, New York, 9 Dec. 1990 – 3 Feb. 1991, The Museum of Modern Art, New York. Gift of the Dannheisser Foundation, 1996 © The Felix Gonzalez-Torres Foundation, courtesy of Andrea Rosen Gallery, New York

Philip Guston, *Untitled*, 1968, acrylic on panel, 76.2 x 81.3 cm, Private Collection, London © Estate of Philip Guston, courtesy Timothy Taylor Gallery, London

David Hammons, *John Henry*, 1990, steel rail track, stone, human hair and metal stand, 113.7 x 14.6 x 15.2 cm, D.Daskalopoulos Collection

David Hammons, *Untitled*, 1975, body print, 106.7 x 78.7 cm, D.Daskalopoulos Collection

David Hammons, *Untitled (Body Print)*, 1974, pigment on paper, 46.5 x 41.8 cm, D.Daskalopoulos Collection, photograph by Alexandros Filippidis

Jasper Johns, *Painting with Two Balls II*, 1962, lithograph, 77.7 x 57.3 cm, The Museum of Modern Art, New York; Gift of the Celeste and Armand Bartos Foundation, 1962 © Jasper Johns / VAGA, New York/ DACS, London 2015, photo SCALA, Florence

* Jennie C. Jones, *Shhh #12*, 2012, professional noise canceling instrument cable, wire and felt, dimensions variable, plug holes 162.56 cm apart, courtesy of the Artist and Sikkema Jenkins & Co, photograph by Jason Wyche

Jennie C. Jones, *Shhh #14*, 2013, professional noise canceling instrument cable, wire and felt, dimensions variable, plug holes 129.54 cm apart, courtesy of the Artist and Sikkema Jenkins & Co, photograph by Jason Wyche

Jennie C. Jones, *Shhh #15*, 2013, professional noise canceling instrument cable, wire and felt, dimensions variable, plug holes 118.11 cm apart, courtesy of the Artist and Sikkema Jenkins & Co, photograph by Jason Wyche

On Kawara, *NOV. 22, 1978*, 1978, from *Today* Series, 1966-2013, acrylic on canvas, 25.4 x 33 cm, Private Collection, photograph by Ron Amstutz, courtesy David Zwirner, New York/London

Byron Kim, *Synecdoche*, 1991-present, oil and wax on wood, each panel: 25.4 x 20.32 cm, overall installed: 305.44 x 889.64 cm, Collection of the National Gallery of Art, Washington, installed at the Whitney Museum of American Art, New York, photograph by Dennis Cowley © the Artist, image courtesy James Cohan Gallery, New York and Shanghai

Franz Kline, *Meryon*, 1960-1961, oil paint on canvas, 235.9 x 195.6 cm, Tate. Purchased 1967 © ARS, NY and DACS, London 2015

Willem de Kooning, *Black Untitled*, 1948, oil and enamel on paper, mounted on wood, 75.9 x 102.2 cm, lent by The Metropolitan Museum of Art. From the Collection of Thomas B. Hess, Gift of the heirs of Thomas B. Hess, 1984 © The Willem de Kooning Foundation, New York/ ARS, NY and DACS, London 2014, photo SCALA, Florence

Willem de Kooning, *Valentine*, 1947, oil and enamel and paper on board, 92.2 x 61.5 cm, The Museum of Modern Art, New York. Gift of Mr. and Mrs. Gifford Phillips © The Willem de Kooning Foundation, New York/ ARS, NY and DACS, London 2014, photo SCALA, Florence

* Zoe Leonard, *Frontal View, Geoffrey Beene Fashion Show*, 1990, silver gelatin print, 124.1 x 96.8 cm © Zoe Leonard, courtesy Galerie Gisela Capitain, Cologne

Zoe Leonard, *One Woman Looking at Another*, 1990, silver gelatin print, 93.3 x 64.1 cm © Zoe Leonard, courtesy Galerie Gisela Capitain, Cologne

* Zoe Leonard, *Two Women Looking at Another*, 1990, silver gelatin print, 99 x 68.6 cm © Zoe Leonard, courtesy Galerie Gisela Capitain, Cologne

Zoe Leonard, *View From Below, Geoffrey Beene Fashion Show*, 1990, silver gelatin print, 70.8 x 104.1 cm © Zoe Leonard, courtesy Galerie Gisela Capitain, Cologne

Glenn Ligon, *The Death of Tom*, 2008, 16 mm film transferred to video, black and white, sound, edition of 3 + 1 AP, 23 min, courtesy of the Artist and Regen Projects, Los Angeles, photograph: installation at Regen Projects, Los Angeles

Glenn Ligon, *Malcolm X #1 (small version #2)*, 2003, silkscreen and flashe paint on canvas, 111.8 x 91.4 cm, courtesy the Rodney M. Miller Collection

Glenn Ligon, *Malcolm X, Sun, Frederick Douglass, Boy With Bubbles #5 (Version 2)*, 2001, silkscreen and oil crayon on paper, 58.4 x 41.9 cm, Collection of the Artist, photograph by Farzad Owrang

Glenn Ligon, *Malcolm X, Sun, Frederick Douglass, Boy With Bubbles #5 (Version 3)*, 2001, silkscreen and oil crayon on paper, 58.4 x 41.9 cm, Collection of the Artist, photograph by Farzad Owrang

Glenn Ligon, *Mudbone (Liar)*, 1993, oil stick, synthetic polymer, and graphite on canvas, 81.3 x 81.3 cm, Collection of Raymond J. McGuire, New York

Glenn Ligon, *Niggers Ain't Scared*, 1996, oil stick, synthetic polymer, and graphite on linen, 76.5 x 76.5 cm, Collection of the Artist, photograph by Ron Amstutz

Glenn Ligon, *Stranger #23*, 2006, coal dust, synthetic polymer, oil stick, oil, and glue on canvas, 243.8 x 182.9 cm, Cranford Collection, London

Glenn Ligon and Michael Duffy, *Study for Condition Report*, 2000, ink on coloured photocopy, 27.9 x 21.5 cm, Collection of the Artist, photograph by Ron Amstutz

Glenn Ligon, *Untitled*, 2006, neon, paint, and powder-coated aluminum, 61 x 426.7 cm, Tate. Purchased with funds provided by the American Fund for the Tate Gallery 2008

Glenn Ligon, *Untitled (I am drawn to sleaze...)*, 1985, oil, enamel, and graphite on paper, 76.2 x 55.8 cm, Collection of the Artist, photograph by Ron Amstutz

Glenn Ligon, *Untitled (I Lost My Voice I Found My Voice)*, 1991, oil stick, gesso and graphite on wood, 203.2 × 76.2 cm, Collection of Emily Fisher Landau/Amart Investments LLC

Glenn Ligon, *When Black Wasn't Beautiful #2*, 2004, oil stick, synthetic polymer and graphite on canvas, 81.3 x 81.3 cm, Betsy Witten, Brooklyn NY

Dave McKenzie, *Babel*, 2006, video, 13 min 48 seconds, courtesy of the Artist and Susanne Vielmetter Los Angeles Projects

Steve McQueen, *Bear*, 1993, 16mm film, shown as video, 9 min 2 seconds, Tate. Presented by the Patrons of New Art (Special Purchase Fund) through the Tate Gallery Foundation 1996

* Steve McQueen, *Exodus*, 1992-97, super 8 mm colour film, transferred to video, no sound, 1 min 5 seconds, continuous play, monitor presentation, edition AP, courtesy of the Artist and Thomas Dane Gallery, London

Charles Moore, *Alabama Fire Department Aims High-Pressure Water Hoses at Civil Rights Demonstrators, Birmingham*, May 1963, gelatin silver, printed 2007, 27.9 x 35.5 cm, courtesy Steven Kasher Gallery, New York

* Charles Moore, *Birmingham Protests*, May 1963, gelatin silver, printed later, 50.8 x 60.9 cm, courtesy Steven Kasher Gallery, New York

* Charles Moore, *Birmingham Protests*, May 1963, vintage gelatin silver, printed c. 1963, 30.4 x 25.4 cm, courtesy Steven Kasher Gallery, New York

Charles Moore, *Demonstrators Lie on the Sidewalk While Firemen Hose Them, Birmingham Protests*, May 1963, gelatin silver, printed later, 40.6 x 50.8 cm, courtesy Steven Kasher Gallery, New York

Charles Moore, *Protests*, May 1963, gelatin silver, printed c. 1975, 27.9 x 35.5 cm, courtesy Steven Kasher Gallery, New York

Charles Moore, *Young Demonstrator Evading Policemen, Birmingham Protests*, May 1963, vintage gelatin silver, printed ca. 1963, 22.8 x 33 cm, courtesy Steven Kasher Gallery, New York

Robert Morris, *Untitled*, 1967-1968, remade 2008, felt, dimensions variable, Tate. Presented by the American Fund for the Tate Gallery 2013 © ARS, NY and DACS, London 2015

Bruce Nauman, *Flesh to White to Black to Flesh*, 1968, video, black and white, sound, 51 min, courtesy Electronic Arts Intermix (EAI), New York © 2015 Bruce Nauman / Artists Rights Society (ARS), New York and DACS, London

Bruce Nauman, *Run from Fear, Fun from Rear*, 1972, neon tubing with clear glass tubing suspension frame, two parts: 20.3 x 116.8 x 5.7 cm and 18.4 x 113 x 5.7 cm, Private Collection © 2015 Bruce Nauman / Artists Rights Society (ARS), New York and DACS, London

Cady Noland, *Pipes in a Basket*, 1989, mixed media with wire basket, 58.5 x 60 x 20 cm, installation view Anthony Reynolds Gallery, 1989, Collection Peter Fleissig, © Cady Noland, courtesy Anthony Reynolds Gallery, London

Cady Noland, *Tanya Disintegration*, 1992, silkscreen on metal, 86.36 x 55.88 cm, edition 1 of 3, Collection of the Artist © Cady Noland

Chris Ofili, *Afro*, 2000, graphite on paper, 56.5 x 46 cm, Tate. Presented by Victoria Miro Gallery 2000 © Chris Ofili, courtesy Victoria Miro Gallery, London

Chris Ofili, *Afro Margin Four*, 2004, pencil on paper, 102 x 67.2 cm, Private Collection © Chris Ofili, courtesy David Zwirner, New York / London

Adrian Piper, *My Calling (Card) #1 (for Dinners and Cocktail Parties)*, 1986-1990, performance prop: business card with printed text on cardboard, 9 x 5.1 cm, Private Collection © APRA Foundation Berlin

Adrian Piper, *The Mythic Being*, 1973, video performance and interview, 8 min, detail: video still #14, Collection Adrian Piper Research Archive Foundation © APRA Foundation, Berlin

Jackson Pollock, *Yellow Islands*, 1952, oil paint on canvas, 143.5 x 185.4 cm, Tate. Presented by the Friends of the Tate Gallery (purchased out of funds provided by Mr and Mrs H.J. Heinz II and H.J. Heinz Co. Ltd) 1961 © The Pollock-Krasner Foundation ARS, NY and DACS, London 2015

William Pope.L, *Set Drawing: Black People Are the Glory of a Shared Piece of Candy*, 2004, pen and marker on paper, 32.1 x 25.4 cm, The Studio Museum in Harlem; Museum purchase made possible by a Gift from Barbara Karp Schuster, New York

* William Pope.L, *Skin Set Drawing: Black People Are the Window and the Breaking of the Window*, 2004, pen and marker on paper, 31.9 x 25.4 cm, The Studio Museum in Harlem; Museum purchase made possible by a Gift from Barbara Karp Schuster, New York

William Pope.L, *Skin Set Drawing: Green People Are Hope Without Reason*, 2004, pen and marker on paper, 31.7 x 25.4 cm, the Studio Museum in Harlem; Museum purchase made possible by a Gift from Barbara Karp Schuster, New York

William Pope.L, *Skin Set Drawing: White People Are Angles On Fire*, 2004, pen and marker on paper, 32 x 25.4 cm, The Studio Museum in Harlem; Museum purchase made possible by a Gift from Barbara Karp Schuster, New York

William Pope.L, *Skin Set Drawing: Yellow People are Black People With Tragic Genitalia*, 2004, pen and marker on paper, 31.8 x 25.4 cm, The Studio Museum in Harlem; Museum purchase made possible by a Gift from Barbara Karp Schuster, New York

Sun Ra, Oakland, 1972, 1972, photographer unknown, Collection of John Corbett and Terri Kapsalis

Sun Ra, Oakland, 1972, 1972, photographer unknown, Collection of John Corbett and Terri Kapsalis

Sun Ra, Oakland, 1972, 1972, photographer unknown, Collection of John Corbett and Terri Kapsalis

* *Sun Ra, Oakland, 1972*, 1972, photographer unknown, Collection of John Corbett and Terri Kapsalis

* *Sun Ra, Oakland, 1972*, 1972, photographer unknown, Collection of John Corbett and Terri Kapsalis

* *Sun Ra, Oakland, 1972*, 1972, photographer unknown, Collection of John Corbett and Terri Kapsalis

* *Sun Ra, Space is the Place*, 1974, video, DVD, lent by Jim Newman for North American Star System

Ad Reinhardt, *Abstract Painting No. 5*, 1962, oil paint on canvas, 152.4 x 152.4 cm, Tate. Presented by Mrs Rita Reinhardt through the American Federation of Arts 1972 © ARS, NY and DACS, London 2015

Richard Serra, *Solid #2*, 2007, paintstick on handmade paper, 101.6 x 101.6 cm, Collection of Joe and Marie Donnelly © Richard Serra / ARS, NY and DACS, London, 2015

Stephen Shames, *At Home, Huey P. Newton Listens to Bob Dylan's Highway 61 Revisited, Berkeley*, 1970, gelatin silver, printed 2006, 50.8 x 40.6 cm, courtesy Steven Kasher Gallery, New York

* Stephen Shames, *Free Huey/ Free Bobby Rally. San Francisco*, February 1970, gelatin silver, printed 2006, 50.8 x 40.6 cm, courtesy Steven Kasher Gallery, New York

* Stephen Shames, *Free Huey Rally in front of the Alameda County Courthouse, Oakland*, September 1968, gelatin silver, printed 2006, 40.6 x 50.8 cm, courtesy Steven Kasher Gallery, New York

Stephen Shames, *Poster of Huey Newton Shot Up After Attack by Police on Panther Office, Berkeley, California*, ca. 1968, vintage gelatin silver, printed ca. 1968, 24.1 x 15.8 cm, courtesy Steven Kasher Gallery, New York

* Stephen Shames, *Rally for Seale and Newton in Front of Federal Court Building, San Francisco*, 1970, vintage gelatin silver, printed 1970, 15.2 x 22.2 cm, courtesy Steven Kasher Gallery, New York

* Stephen Shames, *Sandbags Line the Walls of the New Haven Party Office, New Haven, Connecticut*, 1970, vintage gelatin silver, printed 1970, 16.5 x 22.8 cm, courtesy Steven Kasher Gallery, New York

Lorna Simpson, *Photo Booth*, 2008, 100 works on paper, photographs and ink, dimensions variable, Tate. Purchased using funds provided by the 2008 Outset / Frieze Art Fair Fund to benefit the Tate Collection 2009

Cy Twombly, *Untitled (Rome)*, 1960, lead pencil, wax crayon and oil paint on canvas, 50.2 x 60 cm, Private Collection, London © Cy Twombly Foundation, photograph by Richard Ivey

* Cy Twombly, *Untitled I*, 1967, etching and aquatint on paper, 59.6 x 71.7 cm, Tate. Purchased 1995 © Cy Twombly Foundation

* Cy Twombly, *Untitled II*, 1967, etching on paper, 59.7 x 71.8 cm, Tate. Purchased 1981 © Cy Twombly Foundation

Agnès Varda, *Black Panthers*, 1968, 16mm transfer to DVD, colour, 31 min, Black Panthers © Agnès Varda 1968

Kara Walker, *8 Possible Beginnings or: The Creation of African-America, a Moving Picture by Kara E. Walker*, 2005, digital video and 16mm film transferred to video, 15 min 57 seconds, courtesy of the Artist and Sikkema Jenkins & Co

Kelley Walker, *Black Star Press (triptych)*, 2005, scanned image and silkscreened white, milk and dark chocolate on digital print laid down on canvas, 91 x 213 cm, Private Collection © Kelley Walker, photograph © by Richard Ivey

Andy Warhol, *Birmingham Race Riot*, 1964, screenprint on paper, 50.8 x 60.9 cm, Private Collection, photograph by Ron Amstutz © 2015 The Andy Warhol Foundation for the Visual Arts, Inc. / Artists Rights Society (ARS), New York and DACS, London

Andy Warhol, *Shadow (Black & White)*, 1979, silkscreen ink, acrylic pane on canvas, 35.56 x 27.94 cm, Private Collection © 2015 The Andy Warhol Foundation for the Visual Arts, Inc. / Artists Rights Society (ARS), New York and DACS, London

Andy Warhol, *[no title]*, from *Mao-Tse Tung*, 1972, screenprint on paper, 91.4 x 91.4 cm, Tate. Purchased 1984 © 2015 The Andy Warhol Foundation for the Visual Arts, Inc. / Artists Rights Society (ARS), New York and DACS, London

Andy Warhol, *[no title]*, from *Mao-Tse Tung*, 1972, screenprint on paper, 91.5 x 91.4 cm, Tate. Purchased 1984 © 2015 The Andy Warhol Foundation for the Visual Arts, Inc. / Artists Rights Society (ARS), New York and DACS, London

David Wojnarowicz, *Untitled (One day this kid...)*, 1990-1991/2012, letterpress print, 21.5 x 27.9 cm, Private Collection. Courtesy of the Estate of David Wojnarowicz and P.P.O.W Gallery, New York

Martin Wong, *Stanton near Forsyth Street*, 1983, synthetic polymer paint on canvas, 121.9 x 162.6 cm, The Museum of Modern Art, New York. Gift of the Contemporary Arts Council of The Museum of Modern Art, Steven Johnson and Walter Sudol, and James Keith Brown and Eric Diefenbach, 2011, photo SCALA, Florence

Lynette Yiadom-Boakye, *11pm Tuesday*, 2010, oil on canvas, 200 x 130 cm, courtesy Corvi-Mora, London and Jack Shainman Gallery, New York

Anthology Credits

Acknowledgements

This publication is generously supported by Thomas Dane Gallery, London, Luhring Augustine Gallery, New York and Regen Projects, Los Angeles.

The exhibition at Nottingham Contemporary is sponsored by Christie's.

The exhibition at Tate Liverpool is sponsored by the European Regional Development Fund 2007-2013.

Nottingham Contemporary, Tate Liverpool and Glenn Ligon would like to warmly thank the following individuals for their contributions to *Glenn Ligon: Encounters and Collisions*:

The exhibition's generous lenders and contributors:

Acquavella Galleries Inc.
Alexander Gray Associates LLC
APRA Foundation Berlin
Fondazione Alighiero e Boetti, Rome
Cheim & Read
CINÉ TAMARIS
John Corbett and Terri Kapsalis
Corvi-Mora
Cranford Collection
D.Daskalopoulos Collection
Electronic Arts Intermix
The Felix Gonzalez-Torres Foundation
Fisher Landau Center for Art
Peter Fleissig
Gagosian Gallery
Galerie Gisela Capitain GmbH
Glenstone
halley k harrisburg
Hauser & Wirth
James Cohan Gallery
The Metropolitan Museum of Art
Raymond J. McGuire
Rodney M. Miller Collection
The Museum of Modern Art
Jim Newman
Michael Rosenfeld
Alex Sainsbury
Sikkema Jenkins & Co.
Steven Kasher Gallery
The Studio Museum in Harlem
Susanne Vielmetter Los Angeles Projects
Timothy Taylor Gallery
Lisa e Antonio Tucci Russo, Tucci Russo Studio per l'Arte Contemporanea
Victoria Miro Gallery
Vtape
Helmut Wietz
Betsy Witten

And those individuals who wish to remain anonymous

Others who supported the development of the exhibition in various ways:

Nicholas Acquavella
Simon Baker
Chloe Barter, Gagosian Gallery
Claire Bishop
Achim Borchardt-Hume
Ivor Braka
The British Film Institute
Angela Choon, David Zwirner
Kathy Curry
Jocelyn Davis, Zoe Leonard Studio
Elizabeth Dee
Angelika Felder, Hauser and Wirth
Regina Fiorito, Galerie Gisela Capitain
Mark Francis, Gagosian Gallery
Francesca Franco, Fondazione Alighiero e Boetti
Mark Godfrey
Thelma Golden
Steven Kasher
Emilie Keldie and Andrew Blackley, The Felix Gonzalez-Torres Foundation
Zoe Larson, The Brant Foundation Art Study Center
Andreas Leventis
James Lindon
Sue McDiamid
Emma Mee and Erin Manns, Victoria Miro Gallery
Sophie Oppenheimer
Dimitris Paleocrassas
Claudia Pascolini, Cass Foundation
Christian Rattemeyer
Andrea Rosen
Adam Scheffer, Cheim & Read
Victoria Sidall
John Stachiewicz, Tate Publishing
Timothy Taylor
Roger Thorp
Ioanna Vryzaki, Daskalopoulos Collection
Sheena Wagstaff, Metropolitan Museum
Angela Westwater

Nottingham Contemporary

Nottingham Contemporary would like to thank our generous Benefactors and Supporters:

CONTEMPORARY CIRCLE

Benefactors
James Lindon
Jack Kirkland
Michael Kirkland
Alex Sainsbury and Elinor Jansz
Karsten Schubert
Adam Cohen
Eirian Bell
Valeria Napoleone

Supporters
David Tilly
Francois Chantala and Victoria Siddall
Kate Robertson
Paul Greatrix
Alan Dodson and Heather Dodson
Tony Shelley
James Burgess

BUSINESS CIRCLE

Platinum
Christie's
The Garcia Family Foundation
NET
Sotheby's

Gold
Browne Jacobson
CPMG Architects
Savills
Hugo Boss

Silver
Daniel Hanson
Innes England
TDX Group
Polestar
Ryley Wealth Management
Cartwright Communications
RizkMcCay
EY
Smith Cooper
Universal Works
Belmacz
JLT Specialty Limited
The Mercure Hotel
Experian

Gallery Circle
David Zwirner Gallery
Maureen Paley Gallery
Sadie Coles HQ
Thomas Dane Gallery
Victoria Miro Gallery

Tate Liverpool

Tate Liverpool thanks for their generous support:

SPONSORS AND DONORS

The Art Fund
Art+Text Budapest
The Austin and Hope Pilkington Trust
János Bartók
The Bloxham Charitable Trust
British Council Northern Ireland
Camp and Furnace
The City of Liverpool College
Concorde Securities Ltd
Corvi-Mora, London
The Clore Duffield Foundation
Culture Ireland
The Creative Europe programme of the European Union
The Daiwa Anglo-Japanese Foundation
The Danish Arts Council Committee for International Visual Arts
DLA Piper
The Duchy of Lancaster Benevolent Fund
Edge Hill University
The Eleanor Rathbone Charitable Trust
The Embassy of Denmark, London
The Embassy of the Netherlands
European Regional Development Fund (ERDF)
Károly Gerendai
The Government of Mexico
The Great Britain Sasakawa Foundation
The Granada Foundation
The Henry Moore Foundation
Miklós Kóbor
Peter Kulloi
Liverpool City Council
Liverpool John Moores University
Liverpool Vision
Markit
Mersey Care NHS Mental Health Trust
Merseytravel
The Modern Institute/Toby Webster LTD

National Lottery through Arts Council England
The Office for Contemporary Art Norway (OCA)
Paul Hamlyn Foundation
The Pollock-Krasner Foundation
The Rennie Collection
András Réti
Richard Telles Fine Art, Los Angeles
The Steel Charitable Trust
The Swiss Arts Council Pro Helvetia
Péter Szauer
Tate Americas Foundation
Tate Liverpool Members
Terra Foundation for American Art
Vintage Galéria, Budapest
Winchester School of Art, University of Southampton
Xavier Hufkens

CORPORATE PARTNERS

The City of Liverpool College
David M Robinson (Jewellery) Ltd
DLA Piper
Edge Hill University
Liverpool & Sefton Health Partnership
Liverpool Hope University
Liverpool John Moores University
The University of Liverpool

CORPORATE MEMBERS

The Art School Restaurant
Cheetham Bell
DTM Legal
DWF
EY
Gower Street Estates
Grant Thornton
Hilton Liverpool
Kirwans
Lime Pictures
Mazars
Rathbone Investment Management
Tilney Bestinvest
Unilever R&D Port Sunlight

PATRONS

Elkan Abrahamson
Diana Barbour
David Bell
Lady Beverley Bibby
Jo & Tom Bloxham MBE
Ben Caldwell
Bill Clark
Jim & Shirley Davies
Jonathan Falkingham MBE
Julie Falkingham
Olwen McLaughlin
Barry Owen OBE
Sue & Ian Poole
Andy Pritchard & Patricia Koch
Jim & Jackie Rymer
Alan Sprince
Roisin Timpson

First published 2015 by Nottingham Contemporary and by order of the Tate Trustees by Tate Liverpool in association with Tate Publishing, a division of Tate Enterprises Ltd, Millbank, London SW1P 4RG www.tate.org.uk/publishing

On the occasion of the exhibition
Glenn Ligon: Encounters and Collisions

Nottingham Contemporary
3 April – 14 June 2015

Tate Liverpool
30 June – 18 October 2015

A catalogue record for this book is available from the British Library

ISBN 978 1 84976 356 1

Distributed in the United States and Canada by ABRAMS, New York

Library of Congress Control Number applied for

Curated by Glenn Ligon in dialogue with Alex Farquharson, Director, Nottingham Contemporary and Francesco Manacorda, Artistic Director, Tate Liverpool

Exhibition project managed and organised by Laura Clarke and Stephanie Straine

Publication edited by Glenn Ligon, Alex Farquharson and Francesco Manacorda

New essays by Gregg Bordowitz, Glenn Ligon, Alex Farquharson and Francesco Manacorda

Proofing by Andrew Kirk and Sara Marcus

Publication collation and delivery by Irene Aristizábal

Image and texts copyright acquisition by Irene Aristizábal, Laura Clarke, Mercè Santos and Stephanie Straine

Design by Joseph Logan, assisted by Rachel Hudson

Printed in Belgium by die keure

Front cover: Eric Sutherland for Walker Art Center

Measurements of artworks are given in centimetres, height before width

Note on use of UK and US English in the publication:
All reprinted texts and exhibition titles follow the version of English they originally appeared in. Bordowitz's, Farquharson's and Manacorda's essays appear in UK English, while Ligon's letters remain in US English.